Praise for *New King*

"A probing look at some of the shifting tides of global culture . . .
Witty and packed with detail, this is an intercultural shot that
should be heard around the world." **—Kirkus Reviews**

"A delight, a must-read. Fatima Bhutto is the modern renais-
sance woman: after a searing memoir and an exploration of
'ISIS brides,' she turns her diagonal gaze across global pop cul-
ture, away from and beyond the lingua franca of English. The
result is as effervescent as her subject matter: a hilarious and
intelligent understanding of pop as primal need in contem-
porary life from Peshawar to Istanbul, Seoul to Lima—replete
with characters, differences, and common rip-tides—and of
the global economy that creates, and manipulates, that need."
—Ed Vulliamy

"Fatima Bhutto is one of the most stylish, thoughtful writers in
the world today. This book will make you gurgle with cultural
pleasure." **—Johann Hari**

"Bhutto carefully dissects the guts of our popular culture . . .
Essential to understand the soul of our times."
—Ece Temelkuran

Praise for *The Runaways*

"Highly topical . . . *The Runaways* offers an unflinching look at
the key subjects of our time and the riveting story of three
memorable characters." **—Financial Times**

"Every page of this is priceless." **—Gary Shteyngart**

"This is a bold and probing novel, from a writer strikingly alert to something small and true." —*The Guardian*

Praise for *The Shadow of the Crescent Moon*

"[An] elegant début . . . Bhutto . . . delineates the politics of this cruel battlefield in stark, sinewy prose . . . Out of this bleakness come moments of singular beauty." —*The New Yorker*

"Bhutto works with the delicacy of a poet and the prime-time urgency of a front-line correspondent in order to capture these tortured cries of her beloved country."

—NPR's *All Things Considered*

"*The Shadow of the Crescent Moon* complicates all the expected narratives of the war on terror . . . Engrossing."

—*The Wall Street Journal*

**Praise for *Songs of Blood and Sword:*
*A Daughter's Memoir***

"Moving, witty . . . a uniquely fascinating, wonderfully well-constructed memoir." —**William Dalrymple**

"An important and timely book offering a rare insight into the violent world of Pakistani politics told by a direct witness."

—**Sir Bob Geldof**

"A story with dazzling twists and turns told by a true-blue member of the Bhutto fold." —*The Independent*

New Kings
of the World
Dispatches from
Bollywood, Dizi,
and K-Pop

COLUMBIA GLOBAL REPORTS
NEW YORK

New Kings
of the World
Dispatches from
Bollywood, Dizi,
and K-Pop

Fatima Bhutto

For my uncle Suhail Sethi, who has watched over me for many years
And forever for the Beloved, who taught me how to see

Published with support from the Andrew W. Mellon Foundation

New Kings of the World
Dispatches from Bollywood, Dizi, and K-Pop
Copyright © 2019 by Fatima Bhutto

Published by Columbia Global Reports
91 Claremont Avenue, Suite 515
New York, NY 10027
globalreports.columbia.edu
facebook.com/columbiaglobalreports
@columbiaGR

Library of Congress Cataloging-in-Publication Data
Names: Bhutto, Fatima, 1982- author.
Title: New kings of the world : dispatches from Bollywood, Dizi, and K-Pop
 / Fatima Bhutto.
Description: New York : Columbia Global Reports, [2019] | Includes
 bibliographical references.
Identifiers: LCCN 2019030258 | ISBN 9781733623704 (paperback) | ISBN
 9781733623711 (ebook)
Subjects: LCSH: Popular culture--Asia. | Culture and globalization--Asia. |
 Mass media and culture--Asia. | Asia--Civilization--21st century. |
 United States--Civilization--1945- | United States--Relations--Asia. |
 Asia--Relations--United States. | East and West.
Classification: LCC DS12 .B48 2019 | DDC 306.095--dc23

LC record available at https://lccn.loc.gov/2019030258

Book design by Strick&Williams
Map design by Jeffrey L. Ward
Author photograph by Jessie Craig

Printed in the United States of America

In a country, the road to reform travels through culture.

Ayatollah Khomeini

CONTENTS

Warning: This book contains spoilers.

Gharbzadegi (*Persian:* غرب‌زدگی) is a pejorative Persian term variously translated as "Westernized," "West-struck-ness," "Westoxification," "Westitis," "Euromania," or "Occidentosis."

Introduction

The old city of Peshawar on the Afghan—Pakistan border was once encircled by sixteen gates. Travelers from the surrounding tribal areas were required to surrender their pistols upon entering the city and abide by an oath to leave before sunset. Kabuli *darwaza,* one of the famous sixteen, guards the entrance to Qissa Khawani, Peshawar's legendary bazaar of storytellers. Long ago, Central Asian merchants and Russian spies visited Qissa Khawani to drink cardamom-spiced green tea and trade stories. Today, the bazaar sells everything from underwear to electronics; unboxed mobile phones, their screens covered by thin films of plastic; and old-fashioned electric heaters with bright orange broiler rods. In late summer, as motorcycles roar through the bazaar's narrow lanes, women in long chadors come to buy *kharbooza*, lifting the yellow melon to smell its perfumed skin. Wires everywhere dangle overhead like a canopy of deadly ivy.

Dilip Kumar, one of India's earliest film stars, whose real name was Muhammad Yusuf Khan, was born in a small gulley in

Mohalla Khuda Dad near Qissa Khawani bazaar, in what is now
Pakistan, where his father, a merchant, sold fruit. In 1937, the All
India League of Censorship, a self-designated Hindu cultural
police, announced its objective to cleanse "the film industry of
all its non-Hindu elements," and many aspiring Muslim stars—
including Meena Kumari, who was born Mahjabeen Bano; Mad-
hubala, *nee* Mumtaz Jehan Dehlavi; and Dilip Kumar—changed
their names in order to avoid being blackballed.

Raj Kapoor, who lived in a family *haveli* in nearby Dakhi Nal-
bandi, would go on to become Indian cinema's greatest screen
icon in the 1950s and '60s, adored from the Soviet Union to
Latin America. Both Kumar and Kapoor, who knew each other
as children, left the cramped alleyways of Qissa Khawani for
Bombay before Partition tore undivided India apart in 1947.
Though the two actors are fondly remembered in Peshawar,
it is not their legends that draw the faithful to Qissa Khawani
in the twenty-first century. Today's visitors are enchanted by
a more recent luminary. Somewhere between Kumar's and
Kapoor's two homes, floating in the winding alleyways of the
bazaar, is Lahori Sweets (est. 1925), which sells syrupy *jalebi* the
color of marigolds used in wedding garlands. Outside, a man
sits cross-legged on a raised counter and fries brains and diced
green chilies on a black *tawa*. And there, down a dark, tunneled
walkway, is Shah Wali Qatal.

As salam alaikum! An elderly man with a snowy white beard
steps out of his shop when he sees me. He knows why I am here:
He knows why everyone walks down the dark tunnel to Shah
Wali Qatal. "You know, he even came to my shop once," the old
man boasts as he beckons me to follow him. "Even though he
was born in India, he's been here twice as a young man." It's

18 Sunday and the passage is quiet. Old tins of canola oil, fraying carpets, and even an old generator have been heaved off to one side, resting against rusted shop shutters. At the very end, in the corner, is a freshly painted mud-brown-and-white house. The door is bolted shut and a lady's name is neatly painted on a wooden plaque. This is the home in which the father of Shah Rukh Khan, the world's most famous film actor, was born.

"Take a picture," the old man cheerfully advises.

Khan, Bollywood's most enduring heartthrob and hero, hasn't been here in decades and isn't likely to visit any time soon, given the political climate across the border in India where the right wing routinely suspects Muslims of acting as fifth-columnists for Pakistan.* This is a cruel irony, since Khan's father was an anti-colonial activist, courting arrest under Mahatma Gandhi's 1942 Quit India Movement against British imperialists and demonstrating alongside the Congress Party and Khudai Khidmatgar, the nonviolent Pashtun movement led by Abdul Ghaffar Khan, otherwise known as "Frontier Gandhi."

My elderly guide says he has a picture with the actor known as King Khan somewhere. He points to the shop opposite his own, where a slight man with sad eyes sits with his arm slung over the back of a plastic chair. His floor is piled with metal pans and large *bartans,* big enough for frying industrial amounts of brains and chilies. That's Syed, the old man whispers; he's Khan's cousin.

As I leave Qissa Khawani bazaar, between the live wires strung from balcony to balcony and the jungle green and white

*"Go back to Pakistan" is frequently employed by the Indian right wing against their critics.

Pakistani flags fluttering from recent Independence Day celebrations, I see Khan's face everywhere: rising out of a sea of electric blue paint advertising Pepsi, in a bubble next to a bearded man's face selling leather *chappals*, his eyes half-closed in painful longing as he presses his forehead against a beautiful Pakistani starlet in a movie poster for a film titled *Raees*, a trickle of blood running down his cheek.

If you are a candle, the movie poster reads in Romanized Urdu, *remember that I am a moth.*

Today, Khan, though still little known in the West, is one of the icons of a vast cultural movement emerging from the Global South, including Turkish soap operas and Korean pop music. Truly global in its range and allure, it is the biggest challenge to America's monopoly of soft power since the end of the Second World War.

This is a book about these new arbiters of mass culture arising from the East. Carefully packaging not-always-secular modernity with traditional values in urbanized settings, they have created a new global pop culture that can be easily consumed, especially by the many millions coming late to the modern world and still negotiating its overwhelming challenges. Though this is a book primarily focused on India, it will also briefly touch upon two other cultural industries at the forefront of the challenge to American soft power: Turkey and South Korea.

America's popular culture was not universally appealing, but for many decades, it was the only global pop culture available. Libertine and flashy, it spoke mainly to a Third World elite. Those

20 who spoke English, possessed the means to travel and study abroad, and were international in their consumerism were particularly glamored by American culture and longed for all things American: their habits, style, knowledge—and, most of all, their power. This elite, myself included, may have been the first to be infected, but eventually this worship of American popular culture spread, facilitated by massive migration to urban areas, the rise of the middle class across the Global South, and increased connectivity.

American culture was spread not just by the power of its inherent coolness but also by the American defense complex. The American military is the most widely deployed army in world history. Quite like a modern-day British Raj, the American military maintains a massive infrastructure outside its borders with bases across all continents and an enormous machinery to support its presence. At its height, in 1968, more than one million American troops were deployed in fifty-four countries. Today, just under 200,000 personnel are overseas, marking the lowest American troop deployment in six decades. One might argue that as troop numbers decrease, so too does American cultural dominance.

Global affinity for Coca-Cola, blue jeans, and rock and roll was born out of America's military bases. In 1953, there were 326,863 American troops in South Korea alone.* Hollywood movies were wildly popular on the peninsula; in the 1930s, Korea was a bigger market for American movies than Japan or China. Even Hyundai traces its origin story to the bases, as

* As of 2017, South Korea "hosts" more American military personnel than Iraq and Afghanistan combined.

the two brothers who set up the car company did mechanical
work for the American military. Before the Korean War, the
most popular music was "trot," a mix of foxtrot and Japanese
songs, which was booted out by something exciting coming out
of the Yankee bases: rock music. Young Korean musicians saw
the bases as a mecca. Clubs and music halls would only play trot,
the soundtrack of an older, stodgier generation. If you wanted to
wear leather jackets and play the electric guitar, you could only do
so on the bases. With hundreds of thousands of troops to enter-
tain, the bases became ground zero for aspiring singers across
the country. Today, long after the American military occupation
of South Korea has ended, the military bases still remain.

Coca-Cola and other pioneering symbols of Americana
ultimately made it beyond a rarefied elite class, but though the
larger world now saw glimpses of American culture, they never
managed to have equal access to it. It is those same forces that
promoted American cool—migration, connectivity, urbaniza-
tion, and American military might—that eventually paved the
way for nativist revolts against American cultural hegemony.

Plummeting American prestige, the belated rediscovery
that local cultures are valuable in and of themselves, and the
rise of classes with different tastes and backgrounds emerging
out of the turbulence of globalization have marginalized the old
guard of "Westoxified" elites and created a vast new landscape
of cultural power. Villagers uprooted from their homes and cul-
tures and living in the crowded outskirts of big cities found
no comfort in *Sex and the City* or the twangy music of Britney
Spears. On the contrary, they resented those who conducted
lives in English and appeared rootless and indifferent to their
struggles. Indian, Turkish, and even Korean pop culture offer a

22 much better fit for this majority's self-image and aspirations of sovereignty and dignity.

By 1991, America had won the Cold War, and she celebrated with a spectacular display of power. Free market capitalism vanquished communism, and a new world order, one whose axis spun on the unrestrained, unregulated movement of capital, emerged. Neo-liberalism, aided by hyper-connectivity and communication technology, radically reengineered global economies and altered society to benefit the rich. Even as inequality deepened, accompanied by protests and violence, it managed to socialize a rising middle class into adherents and worshippers of consumerist capitalism.

The production of culture, sociologist Jyotsna Kapur writes, was second only to war in the neo-liberal economy. It is not coincidental that *Mission Impossible*'s Ethan Hunt, the parachuting hero now played on the big screen by Tom Cruise, works for an agency called the Impossible Missions Force, or the IMF. Not much is made of Daddy Warbucks's name, the orphan-saving billionaire in the film version of *Annie*, but should be. A global generation was reared on icons of American cool, triumphal and unapologetic: Rambo, who defeated the weaklings of Vietnam and Afghanistan; Bruce Springsteen, who made even a backwater like New Jersey seem exciting; and shows like *Friends*, which educated audiences on how to be white, affluent, and carefree in an American century. Previous generations had also been indoctrinated in Americana, and there's a trinity for every era from the 1950s onward: Elvis, blue jeans, and the brooding allure of James Dean; Butch Cassidy, Motown, and miniskirts; *Star Wars*, disco, and *Dallas*. It didn't matter which middle-class

generation in Asia, Africa, or Latin America you were born to,
America was the undisputed paragon of modernity, the exemplar of political liberty and cultural supremacy.

This run of American pop culture was uninterrupted for decades, unhindered by any serious global competition. Growing up in 1980s Damascus, there was a period when we couldn't find bananas because isolationist Syria didn't grow the fruit, but we somehow still managed to get a hold of bootleg Tom Selleck films, Madonna albums, and episodes of *Cheers* from our local video rental shop in Mezzeh. In Pakistan, where I spent my teenage years, satellite television owned by Rupert Murdoch had started in the early 1990s to beam *Santa Barbara* and *The Bold and the Beautiful* across the subcontinent every night. It didn't matter that it was bad television, it was American television, and we Americaphiles were grateful to receive it.

American pop culture was worshipped by a Third World elite that wanted to modernize so badly, they built big dams, took extortionate loans in order to industrialize, and empowered cabals of bureaucrat-technocrats in their top-heavy governments. But they had no sense of how to reimagine their own selves and were left to mimic the codes and mores of posh Westerners. "We pretended to be free just like them," Jalal Al-i Ahmad, the Iranian novelist, wrote in *Gharbzadagi*, his searing critique of Westernized Third Worlders. "We sort the world into good and bad along the lines they lay out. We dress like them. We write like them. Night and day are night and day when they confirm it." The East no longer competed with the West, Ahmad lamented in 1978, but merely copied her.

But new cultural industries have flattened the playing field. Today, it is not only American soap operas that families in

24 Karachi gather around their television to watch. *The Bold and the Beautiful*'s loyal audience was an English-speaking, metropolitan elite with access to satellite connections—rare in the 1990s. Its usurper has transcended all those class divisions. When *Mera Sultan* (*My Sultan*), the Urdu-dubbed version of Turkey's explosively popular television show *Muhteşem Yüzyıl*, or *Magnificent Century*, aired in the early 2010s, Karachi's streets would empty and shops that stayed open late through the night would pull their shutters halfway down.* Netflix aired the first season of its first original Turkish drama—*Hakan: Muhafiz* (*The Protector*)—in 2018 to great success. Within a month of streaming, the series had been watched by 10 million households across 190 countries, with Brazil, Argentina, and Canada among the most enthusiastic viewers. Netflix has commissioned a second series while beginning production on another Turkish original drama, and Amazon Prime is rumored to be hot on their heels.

Kara Sevda (*Endless Love*) won Best Telenovela at the International Emmy Awards in 2017. The year before, NBC aired *Game of Silence*, a crime drama adapted from the Turkish original, *Suskunlar*. It only ran for a season, but it was the first American adaptation of a Turkish show, with others, such as *Olene Kadar* (*Eternal*), to follow. Even Fox has gotten in on the game, adapting *Runner* for their Hispanic audiences. Istanbul-based screenwriter Ece Yörenç, famous for series like *Fatmagül'ün Suçu Ne?* (*What Is Fatmagul's Fault?*) and *Aşk-ı Memnu* (*Forbidden Love*), has had meetings with ABC and the producers of *House of Cards*, who paid to reserve adaptation rights to one of her shows, *Kuzey*

* Since the show has so many different titles, I will refer to it henceforth by its English name: *Magnificent Century*.

Güney (*North and South*), which they wanted to remake and set
in Chicago. "Before, we couldn't even sell Turkish spaghetti to
other countries," Yörenç reminded me. "Not Turkish cars, we
couldn't sell anything. And now we have co-producers around
the world."

By 2008, according to Guinness World Records, *The Bold and
the Beautiful* was watched by a peak of 26.2 million people world-
wide. By 2016, *Magnificent Century* had been seen by upward of
200 million people, though its distributors estimate the actual
number of viewers to be more than double that today.

Changing demographics, more than better cable connections,
explains this dramatic shift. In 2015, over one billion people left
their homes in search of a better life. Only a small percentage,
244 million, migrated abroad. The majority, some 763 million,
moved from rural to urban areas within their own countries.
Most modern migrants move voluntarily, but displacement, at a
post–World War II high, is increasingly an urban phenomenon.
In the first fifteen years of the twenty-first century, annual
migration growth has moved at double the speed of population
growth.

In 1990, there were only ten "mega cities" that had pop-
ulations of 10 million or more. But by 2030, the number of
people living in cities is expected to balloon to 60 percent of the
world's total population. Some claim we are already far ahead
of that figure. Using geospatial technology, Europe Commis-
sion researchers found that, as of 2018, 84 percent of the world
already live in urban areas. We transformed from a majority-rural
to majority-urban world for the first time around 2008 and
have moved at breakneck speed since then. Urban populations

26 grow approximately three times faster than rural populations—
between 1.5 and 3 million people move to cities every week. By
2050, 2.5 billion people will join the world's urban population,
90 percent of whom will be in Asia and Africa.

The psychological disorientation caused by these shifts
cannot be underestimated. The journey from tradition to
modernity is neither inevitable nor painless; on the contrary,
it is accompanied by profound turbulence. People leaving their
families and villages are unmoored in the big, soulless city. It is
a geography without anchors, full of sexual and material depri-
vations, injustices, and inequalities. Men and women raised
in rural, conservative, familial networks, where marriages are
arranged by elders, are often shocked by the depravity of the
city. Men find ostensibly liberated city women difficult to take
and are humiliated by the alien codes of desire that determine
romance in the metropolis. Women, for their part, are vul-
nerable, deprived of protection and easily preyed upon and
exploited by the rich and the powerful.

Who can defeat the city without intimate knowledge of
the signs and symbols of the elite? The architecture of power
excludes all those who don't speak its language, depriving them
of social mobility and agency. Even those urban migrants who
triumph, becoming rich and consumerist and happy in love,
must fight to reconcile their inherited values of kinship and
duty with the new standards of competitive, capitalistic life.
These human dilemmas unique to the latecomers to moder-
nity are not addressed by the exuberantly promiscuous ladies of
Sex and the City or the sarcastic roommates of *Friends* but by the
new cultural industries who offer temporary, but comforting,
resolutions.

How does one thrive in a modern, competitive environment while still retaining traditional values? How does one participate in a dog-eat-dog world without sacrificing one's identity, family, or culture? And what space is there for narratives of struggle and displacement in an ever-expanding terrain devoted to easy celebrity, riches, and supremacy? These questions are no longer satisfactorily answered by American or Western pop culture.

To be American is no longer to belong to a vaunted, cultural elite. After the Trump White House used *Game of Thrones* imagery to announce renewed sanctions on Iran—"Sanctions are Coming"—Ayatollah Ali Khamenei, the country's supreme leader, dismissed the American decision by choosing to focus on America's declining cultural, rather than military, cache. "The United States is much weaker today than it was forty years ago," Khamenei told a gathered crowd in Tehran. "Most of the world's politicians and global affairs analysts believe that the United States' soft power is worn out. It's been destroyed."

As the world struggles with the tensions of globalization—the shock waves of neo-liberal economic adjustments, the ferocious speed at which information travels, and the turbulence caused by urbanization and mass migration from villages to the cities—American pop culture seems less and less reflective of this new, uncertain present. A poor young woman in Guatemala has a much harder time relating to the millennials in *Girls* than she does with Bihter, the protagonist of *Aşk-ı Memnu*, the popular Turkish soap opera about a young Istanbul woman who marries a much older, wealthy man as she reels from the death of her father and her family's insolvency.

America's cinematic products, redolent or at least suggestive of Western fancies, turn out to have left millions outside a

28 very distinct and peculiar dream of near-pornographic mate-
rialism. Audiences from Syria to Sudan can hardly identify
with, let alone aspire to, Hollywood's white fantasies of power,
wealth, and sex. Meanwhile, the travails and modest glories of
struggling Turkish heroines are universally accessible. All that's
been proven between 1991's Desert Storm and 2001's Opera-
tion Enduring Freedom is that there is nothing enduring about
American power.

Part One

I think I'm able to fulfill each latent desire of a woman in whatever role she comes in front of. I'm able to make a mother feel nice, I'm able to make a sister feel nice, I'm able to make a sexy girl feel nice, I'm able to make a girl who doesn't love me—and tells me—feel nice. I think I'm able to make a daughter feel nice. I think I, somehow, stand for every emotion a woman can't express in this world, they can express it to me and I will understand it.

—Shah Rukh Khan

Chapter One

Every day, 14 to 15 million Indians go to the movies. India produces between 1,500 and 2,000 films a year—more than any country in the world, and in over twenty languages. The number of cinema tickets sold is the highest national total on the planet; in 2012, India sold 2.6 billion tickets compared to Hollywood's 1.36 billion. Bollywood boasts the highest growth rate in the movie industry, barreling ahead at 11.5 percent a year. By 2020, Indian cinema, exported to over seventy countries, is expected to bring in close to $4 billion in terms of gross box office realizations. India loses the battle of revenues to Hollywood, but with average multiplex tickets costing $4 and many of India's cinemas divided into classes like airplanes, you can see a movie for under a dollar if you don't mind sitting uncomfortably right in front of the screen.

India's cinematic origins are deeply entrenched in the history and fabric of Indian life. Bollywood was born in the plays performed in the Mughal court. Though the artisanal skills came from the Muslim community, the elaborate narratives were taken

from Hindu holy books and mythology. *Padmaavat*, the 2018 film that caused a violent furor in India with right-wing mobs calling for the lead actress to be beheaded and the Supreme Court intervening to roll back state censorship of the film, comes from this culturally syncretic legacy: *Padmaavat*, the story of an imaginary Hindu queen, was written by a Muslim Sufi poet. Bollywood is a meeting point of this prism, a communion of Islam and Hinduism.

In 1914, Hollywood released Cecil B. DeMille's directorial debut, *The Squaw Man*, which some consider to be the first feature film ever made.* However, the first fully Indian feature film, *Raja Harishchandra*, based on stories of Hindu gods from the Mahabharata, was released a full year before DeMille's film. *The Jazz Singer*, Hollywood's first talkie, was a musical, and though India released its first non-silent film, *Alam Ara*, four years later, they would never let go of the song and dance formula.† "We don't make talkies," the writer, director, and actor Girish Karnad has said, "we make singies." Ashis Nandy, the psychologist and social theorist, similarly recalls seeing films advertised as "dancicals" and "fighticals."

Though the films of the 1930s and '40s would have as many as forty songs—the world record for most songs in a movie belongs to *Indrasabha* (1932), which had seventy-one—mercifully, today the standard is only five or six. The songs are accompanied by choreographed dance routines, which can have as many as a hundred backup dancers. Though much is made of Bollywood's devotion to endless musical numbers, its genesis is culture,

* *Birth of a Nation*, the three-hour silent film that heroized and revived the Ku Klux Klan, would follow the next year.
† The film's tagline is pure Bollywood: "Seventy-eight dead people have come back to life. Watch them speak."

32 not kitsch. In Hinduism, when a priest addresses the gods, he
seldom talks. He sings. *Ragas, Bhajans,* even *Bharat Natyam,* a
type of Indian classical dance, were originally performed in tem-
ples as devotional offerings to beloved deities. In the Muslim or
Christian tradition, supplicants address God via his prophet, his
son, his clergy, or else his books; prayer is performed internally,
in silence. In Hinduism, while there are intermediaries such as
the pundit, or priest, devotees address their gods through the
spectacular—song, dance, ceremony, and sacrifice.

Although the term "Bollywood," a portmanteau word
blending "Bombay" and "Hollywood," was first seen in print in
1976 (when a British crime fiction writer, H. R. F. Keating, who
had never set foot in India, used the term in his detective novel
Filmi, Filmi Inspector Ghote), the rules were established right
from the start. Bollywood films are epic extravaganzas, often
lasting as long as three hours. They are lush, unadulterated fan-
tasy. Cinema, no matter its provenance, is built on the abiding
principle of dreams. Most of us go to the movies to get away
from the banality and disappointment of real life, not to be
reminded of it. Hollywood, of course, is no more realistic than
Bollywood and is also loyal to its own particular fantasies—
wherein humankind is forever fighting off monsters and aliens,
American wars are never lost, members of U.S. intelligence ser-
vices are valiant, noble servants of mankind, and it is easy, if
not effortless, to fall quickly and meaningfully in love.* It is an

* Bollywood's version of this includes the protagonist who coughs in the first
ten minutes and inevitably dies of brain cancer; an orphan who discovers the
identity of his birth father/brother, usually after he has killed him; and love
interests who are always betrothed to someone else. Invariably there is a
mother who, if she doesn't die, manages to ruin everyone else's life instead.

industry built on a "dictatorship of good intentions," as Joan Didion said, with a fierce attachment to happy endings. Bollywood's tropes are no more absurd than Hollywood's. Rather, they connect to a repository of longings and sorrows for millions of people around the world.

Bollywood plotlines introduced in the first half hour can be abandoned midway through the film with no explanation. No matter the level of violence, there is only ever mild profanity, no sex, and—only very recently—some kissing.* In the films of the 1980s and '90s, in lieu of snogging, there was a lot of deep exhaling, chest throbbing, and moaning. Without fail, regardless of the season, a monsoon shower would break out, and the frustrated couple would splash about in the rain wearing their tightest, most see-through clothing. When sex was to be implied, the camera would leave the amorous couple and turn instead to roses blooming, birds nuzzling (swans, parrots), and things exploding (pillows, light bulbs).

There is always a villain who never sings, and a vamp who performs what is known as an "item number," a sexy song and dance that, once upon a time, the love interest, a pure and chaste woman, would never do. (In the early days of Bollywood, mainly Anglo-Indians performed item numbers.) The hero's characteristics change through the decades, evolving as a mirror of contemporary politics, but even if he's just a college student or chartered accountant, the hero can single-handedly beat up

* In 2018 and 2019, Netflix and Amazon Prime hosted several original Indian television shows—*Made in Heaven*, *Breathe*, and *Sacred Games*, to name a few—that markedly diverged from Bollywood both in their willingness to do away with traditional morality when it came to depictions of sex, profanity, and violence, and in their transgressive themes and topics.

34 a gang of armed thugs. Audiences understand this as normal; he simply has better karma. The nation is beloved and beyond question. If there is snow, preferably situated in Switzerland or Kashmir, it will be danced upon by the heroine wearing as little clothing as possible, while the hero is snug in a down parka. And love, no matter how passionate and honorable, is always secondary to duty, family, and country.

From its inception, Bollywood's political sensibilities mirrored India's. Emerging from centuries of British colonial rule and the bloodiest partition in modern history, India's vision of its newly independent future as constructed by its first prime minister, Jawaharlal Nehru, was one of social justice, liberty, and fraternity. This romantic Nehruvian nationalism found its cultural expression in the idealistic films of the 1950s in which nation-building is emphasized and utopian social realism is the dominant aesthetic. The stars of the day, Raj Kapoor, Dilip Kumar, and Dev Anand, were all inspired by Nehru's ideals.

Kapoor, arguably the greatest actor of his generation, was at the forefront of this early national expression, and exemplified the hope, virtues, and inclusive patriotism of the era. One of the most beloved Bollywood songs of all time is from Kapoor's *Shree 420* (1955), where his Charlie Chaplin—esque character sings, "*mera jhoota hai Japani, yeh patloon Englistani, sar pe lal topi Russi, phir bhi dil hai Hindustani.*" ("My shoes are Japanese, these trousers are English, on my head is a red Russian cap, but still my heart is Indian.")

By the 1970s, though, pervasive corruption and growing inequality had corroded the archetypal Bollywood hero's romance with the nation. The Angry Young Man of this period,

personified by Amitabh Bachchan, is still socialist in spirit, 35
driven by a fierce desire for justice, and unafraid to fight the two
forces abusing the common man: the state's violent represen-
tatives and the big city's corrupt, Westernized oligarchs. Bach-
chan represented an attack on *babudom*, the stifling power of
Indian bureaucracy, or the establishment. For the poor, he was
a hero. For the rich, he represented the barbarians at the gate,
armed and dangerous. Bachchan's characters of this period
were not the lovable tramps of Kapoor's time, but homeless
shoeshine boys who were no longer willing to be insulted by
men in bell-bottomed suits discussing the stock market. Bach-
chan's heroes were never associated with the rich, marked by
their cruelty and brittle, Anglicized Hindi accents, but always
with the displaced and downtrodden.*

The heroes of 1970s Bollywood were at home in both
India's villages and discotheques. They drive their motorcycles
through sugarcane fields and revel in the bonds of brotherhood
and community. Rural India was so welcoming that even a Cath-
olic schoolteacher like Mary, played by Simi Garewal in 1970's
Mera Naam Joker (*My Name Is Joker*), can turn up and dance

* Capitalism gets everyone at the end. Nearly eighty years old, today Bachchan
has shilled for everyone from Cadbury's chocolate, to ICICI Bank, to Max
New York Life Insurance. In 2010, Bachchan became the brand ambassador
for the state of Gujarat, a job he apparently suggested for himself when pro-
moting a film alongside then–chief minister Narendra Modi. When asked
whether he thought Modi, eight years after the infamous 2002 Gujarat mas-
sacres in which nearly two thousand people, the vast majority of whom were
Muslims, were murdered, was the Amitabh Bachchan of politics, Bachchan
replied, "I can't compare myself with Modi. *Inke baare main kya bolu?* ["What
can I say about this man?"] . . . He is doing a good job as a chief minister in
Gujarat. His efforts are commendable." ["Amitabh Bachchan offers to become
brand ambassador of Gujarat." *The Times of India*, January 6, 2010.]

around a field in her short mod dress without the villagers batting an eye. The village was a place of values and traditions; it is the city that destroys the hero, with its corruption built upon the broken backs of the migrant poor.

Bachchan's successor in the 1980s was a young Bengali actor who had once been a Naxalite, a member of the leftist guerilla movement that rose up against the Indian state. Mithun Chakraborty, known simply by his first name, played more heroes than any other star that decade, notably portraying the silver jumpsuit–clad Jimmy in 1982's blockbuster *Disco Dancer*. As Mithun pranced about onstage in his cult classic song "I Am a Disco Dancer," he was the embodiment of conservative, socialist values. "What are huge palaces, wealth, and property?" Jimmy's child avatar sings as a wealthy girl invites him to play his drums in her bungalow garden rather than on the footpath. "Those who have the wealth of heart are affluent."

Jimmy wants to be a disco dancer not for fame or money, but so that he can exact revenge on the rich businessman who had unjustly jailed his mother. The absolute humiliation and ostracization of India's poor was at the center of the films of the 1970s and '80s. The rich, with their wide lapels and uncreased suits, lie and cheat and steal from the most vulnerable, while the poor, ever anxious to defend against threats to their dignity, have only their *izzat*, or honor, which cannot be taken from them. The rich of 1970s and '80s Bollywood are anti-heroes; they are villains, the destroyers of dignity and dreams. Those who are rich and not evil were tragic figures, eventually destroyed by the venality and cruelty of their class.

There was nothing sleazy or subversive about India's 1980s disco fixation—Mithun became a beloved icon from

Afghanistan to the Soviet Union, where *Disco Dancer* was the
number one movie the year it came out. Nazia Hassan, the Pakistani teenage pop star, was another nascent sign of a culturally multipolar world in the 1980s. Hassan, the first modern pop star to come out of the subcontinent with her own disco-loving album, *Disco Dewane* (*Crazy for Disco*), was the first Pakistani to enter the British charts or win a Bollywood Filmfare award. She was a hit from Brazil to the West Indies.

It is only in the 1990s that Bollywood's historic left-of-center ideal is finally defeated. The '90s hero no longer danced in sugarcane fields with farmers but in London's Trafalgar Square with a gang of leather miniskirted blondes. As the Soviet Union broke apart, leftist ideals encompassing equality, fairness, and justice that had been present in Bollywood since its birth also collapsed. America had won the Cold War, and the upper castes that had traditionally run India's cinema industry, both by funding it and by designing its narratives, were released from the confines of India's centralized socialist economy.

In 1991, India liberalized its previously protectionist economy. Import tariffs were cut, state licenses were slashed, large corporations were given free range to compete, a few important state-owned industries were privatized, and multinationals swarmed India's previously closed borders. India's growth rate jumped, hitting over 11 percent at its peak. But though its GDP rose, until 2018 it continued to have the largest population of desperately poor people in the world.

Unleashed into unfettered capitalism, Bollywood was uninterested in the fallout of India's neo-liberal experiment. India had suffered a severe agrarian crisis, an epidemic of farmer suicides, millions migrating to urban centers that could not

38 support them, and drastic declines in social indicators.* One of
the most visible and visceral fallouts of India's economic lib-
eralization and experiments in unbridled capitalism came from
the emergence of millions from poverty into the lower middle
class. Large populations of young men uprooted from villages
and transplanted to big cities found themselves adrift and
unmoored, faced with what Pankaj Mishra calls "a desperately
sought after but infuriatingly unattainable modernity." With
their aspirations largely unmet and taunted by the unreach-
able lives of plenty promised by globalization, these men were
consumed by rage, vulnerable not only to violence but also to
the seduction of demagogues who parlayed this economic and
social ressentiment into false notions of nationalism, religious
chauvinism, and communalism.

On-screen, the story lines of India's poor that once pulled
at the heartstrings of Bollywood's films were swiftly abandoned.
Instead, the industry reformed itself to chronicle the elite's
accelerated economic prowess and privilege. By 1992, an average
of 2.5 films were released per day, and the mood of new Bolly-
wood was unrepentantly celebratory. The hero drives a BMW
and wears Nikes. His family lives in a mansion—this period is
also marked for Bollywood's narrative turn to Non-Resident
Indians (NRIs), whose money and economic agility had bought

* "Data from the Multidimensional Poverty Index indicates that twenty years
ago, India had the second-best social indicators among the six South Asian
countries (India, Pakistan, Bangladesh, Sri Lanka, Nepal, and Bhutan), but
now it has the second worst position, ahead only of Pakistan. Bangladesh has
less than half of India's per-capita GDP but has infant and child mortality
rates lower than that of India." [Colin Todhunter, "What Has Neo-liberal
Capitalism Ever Done for India?" *Counterpunch*, November 30, 2016.]

them homes in the English countryside and penthouse apart-
ments in New York.

Today, India has the world's largest migrant population,
some 17 million people. Unlike the second-place holder, Mexico,
a sizable portion of India's migrants are often economically and
politically powerful. However, before the late 1990s and the
advent of neo-liberal reforms, NRIs were seen as a "living testi-
mony of inappropriateness." Hindus were said to have lost their
upper-caste identities and polluted their characters by crossing
the black waters of exile. Traveling across the oceans was a
journey so violent to one's *varna*, or caste and social standing,
that it required years of purification rituals to undo. NRIs had
abandoned the motherland in its tryst with destiny, at the
moment of its independence and liberty, and as such were tradi-
tionally seen as culturally and morally degraded, uneducated in
traditional histories and knowledge. It was Bollywood, notably
the films of the director Karan Johar, that recast the NRI as the
epitome of sophisticated modernity, as the masters of global
capital and international *savoir faire*, and it did so at the inter-
section of two ominous forces: neo-liberalism and Hindutva.

The NRIs seen on-screen at this moment were of the hedge
fund variety; they were not bodega owners or nurses. And though
we are never let into the journey of the NRI's migration—there is
no clue what the hero has done in order to become the beneficiary
of such riches—the signaling is clear: It was no struggle; no vio-
lence was done to him in the making of his millions. What vio-
lence might have been done to others is better off unimagined.

If you have a BMW, neo-liberal Bollywood seemed to sug-
gest, you can do whatever you want. The films took their cues

40 from real life. In 1999, Sanjeev Nanda, a Wharton graduate whose father was a wealthy industrialist, ran over and killed six people in his BMW in New Delhi while returning home from a party. Even though three of his victims were police officers, Nanda was quickly acquitted, and released by the first court that tried him.*

There were discos—there are always discos in Bollywood—but now they came with VIP tables and, later, in the 2000s, with girls who paid for their own drinks. What vanished, for the most part, were the villages. No longer were stories set in rural India but in the nation's mega cities, or else in American and European capitals. When the village makes an appearance, it is over-stylized, and, even if fondly remembered, peripheral. The hero doesn't live there anymore. He now lives in the India of beauty queens and billionaires. Aishwarya Rai and Sushmita Sen, 1994's Miss World and Miss Universe winners, are the Swami Vivekanandas of their day: Indians who go West and are embraced. Global forces were fast to realize that India was now a market open for business. It didn't matter that only a small component of its citizens were wealthy enough to buy products sold by L'Oréal, McDonald's, Mercedes, or Nestlé—all of whom moved into the country.

Today, this ideological flexibility seems perfectly suited to Bollywood's *nouveau riche* aesthetic. The new yuppie hero no longer has posters of Nehru, Gandhi, and Patel on his bedroom wall, but pinups of Madonna and Mickey Mouse.† He may

* Nine years later, he was retried by the Delhi High Court and convicted.
† As in Prem's bedroom in 1989's *Maine Pyar Kiya* (*I Have Loved*). Prem also has a wall of black-and-white cutouts of his own face.

drive Ferraris and buy his clothes at the Gap, but he still bends
to touch his mother's feet every morning.

Bollywood's elder statesmen bemoaned the industry's modern degeneration. Notably, Dilip Kumar complained that "cultural concerns" had been replaced by "a lot of ingenious ways of smuggling narcotics and killing of people." Naushad Ali, who wrote the music for Bollywood classics like *Mughal-e-Azam* (*The Great Mughal*), mourned the loss of "poetry and refinement" in modern films. The songs of early Bollywood were written in beautiful, classic Urdu, not today's bastardized Hindi and English, or *Minglish*. Naushad may have been thinking about songs like "ABCDEFGHI I Love You" from 1999's *Hum Saath-Saath Hain* (*We Are Together*), sung from inside a bus as one of the main characters and his new wife take his entire family on honeymoon with them: "Hey, hey," it goes. "A B C D E F G H I J K L M N O P Q R S T U V W X Y Z. I love you! A B C D E F G H I J K L M N O P Q R S T U V W X Y Z. I love you! La la la la la la laaa." It is a mistake to discount these songs as absurd. Their lyrics are simple for a reason: They are aspirational. Only 10 percent of India's population speaks English.

"The films that we make today are Indian only in name," Naushad lamented regardless. "We do not find India in them. In them all the things are foreign to Indian culture . . . the music, the story, the dress, are all foreign. Indianness is totally absent . . . where we stand today is only a place of despair and sadness."

Chapter Two

India's neo-liberal shift coincided with the emergence of a right-wing Hindu extremist political movement. It is no coincidence that these two forces intersected the way they did. Neo-liberal reforms dislocated millions of youngsters from life in rural India and transplanted them to increasingly crowded urban centers where, often jobless and struggling to survive alone, without the comforts of the village and necessary support structures, they were ripe for the plucking by fundamentalist forces such as the hardline Bharatiya Janata Party (BJP).

The BJP was formed in 1980 as the political wing of the fascist-inspired, paramilitary Hindu nationalist Rashtriya Swayamsevak Sangh (RSS). The RSS organized in a similar fashion to the German Brown Shirts or Italian Black Shirts: as a secretive, male-only organization martialed to preserve racial purity and the hegemony of upper-caste Hindus. Many of the upper echelons of the RSS were naked admirers of the Third

Reich; M. S. Golwalkar, the second "supreme leader" of the RSS, called Hitler's extermination of the Jews "a good lesson for us in Hindustan to learn and profit by." It was a onetime member of one of these such groups, who were notoriously ambivalent about India's freedom struggle against British imperialism, who assassinated Mahatma Gandhi in 1948. The Sangh, as the organization is known, remained on the outskirts of national electoral politics even after the creation of the BJP. The Sangh's objective is to capture state power, and winning elections is but a means to that end. In 1984, the BJP won merely two Lok Sabha parliamentary seats out of 543. In the 1998 elections, the party bagged 198 seats.

By the mid 1990s, through an agitational campaign, the BJP was transformed from a fringe party to one that secured approximately 40 percent of India's "very high-class" voters. No other Indian party, according to election data for 1999, captured such a high percentage of that electorate. Additionally, these upper-class voters were the only economic segment that voted so enthusiastically for the BJP.

Right-wing nationalism found a natural base in the NRI community. No longer were they abandoners of the motherland, but enterprising, hardworking vanguards, uplifting Indianness through their individual success and accomplishments. NRIs were too distant to bear the consequences of living under BJP rule and so were perfect allies; in addition, they had no political responsibilities. India does not allow dual citizenship, and any NRI who becomes a passport holder of another country can no longer vote or participate in the political system. They could only give back to the state through remittances, donations, and

44 an insecurity over their own cultural loss, which made them receptive to the BJP's chauvinistic nationalism. Furthermore, in their adopted countries, NRIs rarely had power matching their material prosperity—a fact that enraged many enough to drive them back to their homelands where they attempted to wield power by proxy.

It is precisely at this moment of India's breakneck liberalization, when the country's secular foundations were seismically challenged, that three stars appeared on cinema screens: Aamir Khan in 1988's *Qayamat Se Qayamat Tak* (*From Eternity to Eternity*), Salman Khan in 1989's *Maine Pyar Kiya* (*I Have Loved*), and Shah Rukh Khan in 1992's *Deewana* (*Crazy*). The three Khans—none of whom are related—were all born in 1965. At the time of their Bollywood breakout they were all in their early twenties. Aamir and Salman had influential fathers in the movie business, Shah Rukh did not. They were all educated, English-speaking, from comfortable if not well-off backgrounds, clean-cut, and, interestingly, the three biggest actors in India all came from a minority community that made up less than 15 percent of the population: They were all Muslim.

The fact that the three Khans all rose in stardom at the same time is meaningful in the Indian and subcontinental context. In their earliest manifestations, the three Khans represented three prevailing spiritual and political ideas of India and the subcontinent. In this, Salman Khan's film persona was initially built on a defiant masculinity and a determined Muslim identity—though he may do love stories, you won't catch Salman being pushed around by a love interest. In Nizamuddin, the historic Muslim area of Delhi, it is

Salman's face on the T-shirts of young men, not Aamir's or
Shah Rukh's. Even as his politics, or lack of them, in real life
is increasingly marked by timidity, in his heyday Salman Khan
starred in films set on the Indian-Pakistani border where he
takes in a Pakistani orphan and most audaciously plays an
Indian RAW (Research and Analysis Wing, India's intelligence
agency) agent who falls in love with a Pakistani beauty who
happens to spy for the ISI (Inter-Service Intelligence, RAW's
Pakistani counterpart).

Aamir Khan is widely considered to be the intellectual
of the three Khans, and his films are lauded as probing and
artistic. They also happen to be massive blockbusters. His
2016 film *Dangal* (*Wrestling Pit*) is the fifth most successful
non-English film of all time and was a phenomenal hit from
China to France. Even Xi Jingping, China's president, is said
to have "loved" *Dangal*, which was retitled *Let's Wrestle, Dad*
in Mandarin. Today, the world of international pop culture
is evolving at breakneck speed, but two factors seem to be
beyond doubt. China, though a late player to the game, prom-
ises to be one of the most powerful and influential forces in
global culture in the coming years. And it is Aamir that the
Chinese—and indeed the world at large—appear to have
placed their bets on.

He has risen to massive stardom in China, where his
adoring fans call him "uncle Aamir." He is the most followed
Indian on the Chinese social media site Weibo and was given
the prestigious title of National Treasure of India during a
2017 trip to the country. Not only are Aamir's films widely
celebrated in China, but local television also bought and
dubbed *Satyamev Jayate* (*Truth Alone Triumphs*), a television

46 talk show that the Bollywood star hosted and produced. The show dealt with harder-hitting issues than his recent films have covered, including child labor, female feticide, and honor killings. *Satyamev Jayate* also won over audiences in Djibouti, Papua New Guinea, and Sierra Leone, among other territories.

It is not just Aamir's talent that propels him miles ahead of the other two Khans but the impressive range of his craft. Unlike Salman and Shah Rukh, Aamir has director, screenwriter, and producer credits to his name. In 2017, *Newsweek* breathlessly declared Aamir—not anyone from Hollywood— to be the biggest and most bankable movie star in the world. Aamir's fans are no lightweights. They include Tom Hanks and *Time*, who beat *Newsweek* by several years to call him one of the 100 most influential people in the world, alongside Michelle Obama. "Can an actor change a nation?" *Time* asked in an earlier profile of the star, concluding that if the actor was Aaamir, it just might be possible. So enthusiastic was *Time* of Aaamir's *Satyamev Jayate* that they pronounced its comparisons to Oprah Winfrey's globally beloved show unfair. Aaamir's show was more serious, the magazine huffed.

Though in his personal life Aamir has criticized India's rising intolerance (while at the same time engaging in numerous photo-ops with Prime Minister Modi), in his films he doesn't engage in that fight. Like many public figures, Aamir has had to tread a delicate balance in today's India. His films pointedly won't touch the politics of the time, but will focus on benign topics like dyslexia, general tolerance among mankind, or women in sports.

While Aamir and Salman played heartthrobs in their first starring roles, Shah Rukh starred as homicidal maniacs and

obsessive stalkers in three of his early movies, all blockbusters. In *Baazigar* (*Gambler*), he asks a girl to marry him, makes her write a suicide note as a test of her love, and then pushes her off a building. After she dies, he adopts a new name, promptly asks her sister out, and ends the film by murdering her father. In *Dee-wana* he plays an awkward anti-hero romancing a woman whom we think is a widow, but . . . and in *Darr* (*Fear*)—"A violent love story" is the film's tagline—Khan plays a deranged, stuttering stalker. In the film he terrifies his love interest by calling her on the phone constantly ("I love you, K-K-K-Kiran"), breaking into her house, and shooting *and* stabbing her husband. Surprisingly, Indian audiences rooted for Khan's psychopathic character, not his frightened victim, enthusiastically cheering him all the way. "Pop sociologists," Pankaj Mishra noted, attributed *Darr*'s success "to the growing 'anomie' in Indian society."

It is as though Khan's characters understood something other heroes didn't: This new world order accommodated, if not rewarded, violent confrontation. What mattered now was the hustle, how fast you rose, and how hard you fought your competitors. India had changed, and with it, the rules of the game in Bollywood. "He can die in the film and lose the girl," Khan later said of his creepy character trifecta. "He can kill people. We don't have to like him, just the story he is telling."

Of all his contemporaries, Shah Rukh Khan's early life and career had been built on the old Nehruvian idea of India—pluralism, brotherhood, and symbiosis between its two biggest religions, Hinduism and Islam. Khan is Muslim while his wife, Gauri, is Hindu. His family came from Peshawar, Pakistan,

48 but his father fought for India in 1947. His youngest son, born through surrogacy, is named AbRam, a combination of Abraham, a Muslim prophet, and Ram, a Hindu God.

Straddling both India's ways of being, today Khan is a lonely figure. In his films, he was the bridge between socialist India, as it moved toward its hyper-capitalistic future, and a guide to how one could be modern but still principled and traditional in neo-liberal India.

Chapter Three

Now in his fifties, Khan has appeared in nearly a hundred films, was awarded an honorary doctorate from Edinburgh University and a Yale Chubb Fellowship (whose previous recipients include Chinua Achebe and Maya Angelou), and won countless Film-fare Awards.* He has an international fan club with over ninety unpaid but adoring administrators in countries from Peru to Germany, and has received numerous international honors, including a title of Malaysian Knighthood.† At the $100 mil-lion wedding of India's richest man's daughter, Khan joined Hil-lary Clinton onstage as the former secretary of state did her best to wiggle along to "Abhi toh Party Shuru Hui Hai" ("The Par-ty's Just Begun") while another former secretary of state, John Kerry, boogied alongside them. More importantly, Khan is the

* Bollywood's Oscars; when there wasn't a category suited to Khan's latest oeuvre, Filmfare simply created one for him, such as the "Power Award" or the "Filmfare Special Award Swiss Consulate Trophy."

† According to local newspapers, Khan responded in thanks by declaring that Malaysian prime minister Mahathir Mohamad "is my favorite person in the world."

50 icon of a brash but troubled culture of neo-liberal capitalism in
 the Global South.

 By the time Khan moved to Mumbai to become a Bollywood
star, he had already appeared in a local television series and
played the small role of a gay college student in Booker Prize–
winning novelist Arundhati Roy's cult film, *In Which Annie
Gives It Those Ones,* which she called "lunatic fringe cinema."
No TV actor before or since has successfully transitioned to the
pinnacle of Bollywood stardom, but fate seems to have looked
upon Khan with exception from the start. Standing on the city's
famous Marine Drive, the young actor, who used Camlin Glue
and water to style his hair when he was too broke to buy hair gel,
swore that one day he would run Mumbai. "Shut up," one of his
friends is said to have replied. "Don't talk shit."

 Mani Kaul, who hired Khan for his second TV role in a 1991
adaptation of Dostoevsky's *The Idiot,* was initially unsure that
the "babyface" actor had what it took to play Rogozhin, but
eventually admitted that he was won over by Khan's voice—"an
unstated whimper"—and his "strange mix of someone beautiful
and slimy." Convincing directors to hire him was a tough sell,
and Khan initially found himself considered as a runner-up for
roles, never the first choice. One director didn't think he could
be a romantic hero because his face "wasn't chocolatey enough."
So Khan decided on an unconventional route into the business:
bad guy roles. That he was so rapturously accepted in his por-
trayal of murderous lunatics speaks to the dark tide approaching
India at the time.

 As poverty became an unpleasant memory, easily erased
from Bollywood's storyboards, stars began to play a revolving
rota of NRIs living in palatial mansions in New York, London,

and Paris. Khan went from stalker to softie without missing a beat, playing a slew of NRI characters kitted out in Gap sweat-shirts and Nike caps, reveling in the consumer paradises of European capitals in the late '90s and early 2000s. These char-acters were uniformly upper-class Hindus, named Rahul or Raj, whose spirits had not been polluted by migration. Rather, these NRI characters perfectly embodied the religious piety and con-servatism of their forefathers while enjoying lifestyles of the rich and famous.

"The problems are romantic with romantic solutions," Nasreen Munni Kabir, an author and filmmaker who directed a two-part documentary on Khan, told me. "They are not social problems with social solutions—Shah Rukh is not looking for a job in his movies. The setting is not realistic, it's a lot of fan-tasy." For Indians, Khan quickly became "the poster boy of a new kind of aspiration," explained Nandini Ramnath, the film editor of the English news website Scroll India. "He seemed at home in the version of India created by the movies, as well as a global cit-izen who could comfortably inhabit American and English cities without losing his bearings. The stereotypical Shah Rukh Khan gesture—the arms thrown wide open—typifies this aspect of his persona. He is inclusive as well as expansive."

Alongside the globalized economic outlook ushered in by India's neo-liberal restructuring was a conservative, inward-looking set of traditional values. In one of his most popular films, *Dilwale Dulhania Le Jayenge* (*The Big Hearted Takes the Bride*), Khan plays Raj, a rich flunky living in England with a fast car, a mansion, and disposable income, who falls in love with Simran, an NRI from a simpler background. She is engaged to someone else, and he follows her back home to Punjab in order

52 to win her over. When Simran suggests they elope, Raj refuses. "I might have been born in England," he declares. "But I am *Hindustani*. I've come to make you my bride. I'll take you only when your father gives me your hand in marriage." Khan's early rise to romantic idol was orchestrated without him kissing a single love interest. Bollywood films are generally kiss-free in order to avoid conflicts with the Indian censor board and the movies have historically relied on heavily suggestive, even vulgar, nuance, coupled with outwardly chaste conduct. Khan's first screen kiss did not come until 2012's *Jab Tak Hai Jaan* (*As Long as I Live*) in which he plays a bomb defuser who gets retrograde amnesia.

Khan was the navigator through which rising India negotiated the riches, tensions, and violence of globalization. Onscreen, he was proof that you could be a wealthy New York football player but still be spiritually and emotionally guided by traditional Indian values. Off-screen, he was stopped by American immigration at U.S. airports in 2009, 2012, and 2016. Such is Khan's celebrity that the U.S. Assistant Secretary of State apologized the last time he was detained, assuring the world it was random checks, not profiling. "Whenever I start feeling too arrogant about myself, I take a trip to America, the immigration guys kick the star out of stardom," Khan said of the experience. "But I have my small victories. They always ask how tall I am and I lie and get away with five feet ten inches. Next time I'm gonna be more adventurous. What color are you? I'm gonna say white."

Bollywood's flair, fantasy, and spectacle have always been situated within the boundaries of conservative, traditional values

and as such have long reached global audiences. In the 1950s, Raj Kapoor's film *Awara* (*Vagabond*) was such a success that he was known in the Soviet Union as "comrade Awara." Even Joseph Stalin was a fan. Throughout the Cold War, it was Bollywood that provided the Soviet Union with ideologically safe entertainment. In the 1970s, Kapoor directed his son Rishi in *Bobby*, which readers of the popular film magazine *Sovetskii Ekran* (*The Soviet Screen*) voted one of their top five films of 1975, as it "taught them how to love."

Bollywood films were imported into Nigeria by Lebanese businessmen in the 1950s. Young Hausa men and women have long been devoted fans of Bollywood because it allowed them to be entertained "without engaging with the heavy ideological load of 'becoming Western.'" Switzerland erected a statue of the director Yash Chopra in Interlaken in gratitude for his "opening up a legacy of South Asian tourists." Rajinikanth, a Tamil-language star who rarely makes appearances in Bollywood but is so popular in Tamil language films known as Tollywood that audiences threaten to set cinemas on fire if his character dies in a film, saw his 150th movie, *Muthu*, run for twenty-three weeks in one Tokyo cinema alone.* Italy advertised summer screenings of Bollywood films, dubbed into Italian with the songs cut, as *Amori con Turbanti*, or "love with turbans."

Hyperconnectivity, global branding, and migration, however, have placed Khan in another category altogether. *DDLJ*, as *The Big Hearted Takes the Bride* is known in shorthand, is the

* On New Year's Eve 2017, Rajinikanth announced he was joining politics, setting up a new political party and contesting all 234 seats in Tamil Nadu.

54 longest continually running Indian film of all time; Maratha
 Mandir Theatre in Mumbai has been screening it every single
 day since its release in 1995. Cineplexes in London sold out
 shows of *Dil Se*, in which Khan plays a radio journalist covering
 the insurgency in North India, five times a day, making it the first
 Bollywood film in the United Kingdom to be screened at regular
 hours, and the first ever to reach the top 10 of a British film list.
 Khan's dance on the roof of a moving train in *Dil Se*, involving
 eighty separate cuts, was so outlandish no other Bollywood star
 has ever dared top it. *Devdas*, another SRK classic, was the first
 Bollywood film accepted to the Cannes Film Festival in 2002.

 Khan is also India's most pervasive celebrity endorser.
 Within the first decade of his film career, he had already done
 281 print ads and another 200 commercials. Khan has been the
 face of Pepsi, Frooti mango juice, Dubai tourism, Hyundai, and
 Fair and Handsome (a male whitening cream, for which he was
 roundly criticized). In 2005, he was the first male model of LUX
 soap in India. In that year alone, Khan was the face of 34 different
 products. An Indian research firm's 2002 advertising survey
 found that Brand SRK was so ubiquitous that respondents even
 associated Khan with brands he had nothing to do with.

 He has also been adept in forging advertising tie-ins with
 his films. For 2010's *My Name Is Khan*, a film about a Muslim who
 walks across America to tell everyone in the country that he is
 not a terrorist, Reebok launched a special sneaker. For *Ra One*, a
 passion project of Khan's (a superhero action film whose title is a
 play on the Hindu god Ravan's name), the actor signed deals with
 25 different brands bringing in nearly 6 million euros toward the
 film's expensive budget. For *Don 2*, a crime caper, TAG Heuer, the
 Swiss watchmakers, released a limited-edition Don watch, and

the actors all wore different TAG Heuer watches during the film 55
itself.

In the spring of 2016, Brad Pitt traveled to India to pro-
mote his Netflix original film *War Machine* alongside Khan, who
wasn't in the movie. Pitt said he could never be in Bollywood
because he couldn't sing or dance, to which Khan joked, "Singing
and dancing has to stay so that we can keep Brad Pitt away from
Bollywood." But was it conceivable, a moderator asked, that Brad
could be in an Indian film and Shah Rukh in a Chinese film? "I
hate using this word," Khan responded, "but this globalization
would happen, most definitely."

Since India's neo-liberal reforms came into place, Khan
hasn't played destitute characters, starring instead in a solid
stack of global-professional roles made famous by his partner-
ship with Karan Johar, the director who solidified Khan's role
as ambassador-at-large of how to not survive, but thrive, in
"shining" India. "If the 1970s hero was anti-establishment, as a
yuppie, I promised a better world," Shah Rukh Khan said in 2001.
"The yuppie doesn't bash a truckful of *goondas* [goons]. He's
smarter. He doesn't have to kill in the battlefield, he can make
a killing in the stock market. The yuppie believes in capitalism,
not communism. Actually, he believes in a new 'ism' every day."

In 1998, *Kuch Kuch Hota Hai* (*Something Something Hap-
pens*), the first of the Khan-Johar NRI films—which, presum-
ably in homage to Johar himself, have an abundance of "K" words
in all their titles—became the number-one foreign language
film in the UK. *KKHH*, as the film is popularly known, begins
in an Indian school straight out of an American comic book—
all bright colors and bubblegum aesthetics. Tina, played by Rani
Mukherjee, is a repatriated NRI who Rahul, played by Khan,

56 taunts with an English accent and goads into singing a Hindi
 song as some sort of schoolyard initiation.* Tina accepts the
 challenge and sings a Hindu *bhajan,* causing Rahul's jaw to drop
 in respect. He is instantly smitten. "Just because I've grown up
 in London, I haven't forgotten my culture—don't forget that,"
 she scolds him before stomping off. *KKHH* was sold out in South
 African cinemas for six months straight; in Durban it ran longer
 than *Titanic* and was seen by more people. During the 1999
 South African elections, Ela Gandhi, a Member of Parliament
 for the African National Congress party, or the ANC, and grand-
 daughter of the Mahatma, recorded the title track of *KKHH* as
 her campaign song, calling it *Kuch Kuch ANC.* "The movie did so
 well," Gandhi explained. "People identify with it and it conveys
 important themes of sacrifice, love, and non-violence."

 In 2001's *Kabhi Khushi Kabhie Gham* (*Sometimes There's Hap-
 piness, Sometimes There's Sorrow*), or *K3G,* Johar doubled down on
 the notion of the NRI as a bastion of national integrity and honor
 who is duly rewarded by obscene capitalist success. While Khan's
 NRI family live in an English manor, his brother attends school
 in Blenheim Palace of all places—a UNESCO heritage site and
 the birthplace of Sir Winston Churchill—and their main mode
 of transportation is a helicopter.† His wife insists on speaking
 Hindi to her English neighbors. His brother, played by Hritik
 Roshan, dances *Bharat Natyam* in Leicester Square, wearing an

 * This was Khan's fifth Rahul.
 † His seventh Rahul. Raj Kapoor in his heyday played thirteen characters
 named Raj (five more characters had Raj variants as names, such as Raju).
 Amitabh Bachchan played at least eighteen roles named Vijay. Khan's career
 isn't as long as either Kapoor's or Bachchan's, yet he's still managed to rack
 up eight Rahuls.

outfit of all leather, while his backup dancers, all white women, are clad in *shalwar kameez*.* Khan's son sings "Jana Gana Mana," the Indian national anthem, at his private school concert, supported by a chorus of English children. As his entire family immediately rise to their feet, the concert's audience of British patricians are so moved that they, too, stand — some brought to tears while others place their hands across their hearts. Even a little girl in a wheelchair is so roused by the Hindi lyrics that she painfully raises the only body part she can, her arm. *K3G* was subtitled into more languages spoken outside the subcontinent than inside it, including, but not limited to, Arabic, Dutch, Spanish, and Hebrew. In Peru, where it's a cult classic, its title was changed to *La Familia Hindu* (*The Hindu Family*).

Khan was not the auteur of these films, but he participated in the strange marriage between the Indian neo-liberal fantasy of money, power, and—as it was beamed out across the nation's screens—a distinctly cultural assertiveness. The consequences of these heavily nationalistic films still reverberate today. In 2016, Indian cinemagoers were obliged to stand for the national anthem, which is played before all films. The Supreme Court ruling that required not only the anthem to be played but also audiences to stand in solemnity came as a direct result of *K3G*. Having gone to watch *K3G* in a darkened Bhopal cinema in 2002, a Mr. Shyam Chouksey was so stirred by the scene of Khan's son singing "Jana Gana Mana" at his English school concert that

* In *K3G*, Roshan has the worst line I've ever heard in a Bollywood film. "I'm going to Haridwar to meet my two *favorite* girlfriends!" he trills. "Who are your girlfriends in Haridwar?" asks his skeptical friend. "My two grandmothers!" Roshan laughs cheekily.

58 he stood up from his seat. His fellow audience members were not amused and complained that he was blocking their view. Chouksey was so insulted at his compatriots' lack of respect for the national anthem that he began a protest outside the Bhopal cinema. When that yielded no results, he filed a case in Madhya Pradesh's high court, banging on until his cause reached the highest bench in the land.

By the end of the first decade of the 2000s, Khan had moved away from playing the moneyed migrant. *My Name Is Khan* is notable in this period as one of Khan's rare political films, where he plays a Muslim man with Asperger syndrome who immigrates to America only to see his stepson killed by bullies after 9/11. *MNIK* was a belated, post-9/11 realization that, though NRIs may want to be a part of the American Dream, Americans didn't want much to do with them. Their son only died, Khan's wife in the film says, because "his name was Khan." Khan walks across America in a quest to tell the president, and everyone else in the process, that his name is Khan, and that he is not a terrorist. The film was an international success and was distributed to sixty-six countries, including nontraditional Bollywood markets like Syria, Puerto Rico, and Taiwan. Khan played several other serious roles around this time, including in *Chak De! India* (*Go for It! India*) where he was a Muslim hockey captain who is declared a traitor for losing a match to Pakistan, and *Veer-Zaara* where Khan plays an Indian Air Force pilot who pays the ultimate price for falling in love with a Pakistani and crossing the border to be with her—jail. *Veer-Zaara* was the highest-grossing film of the year.

In international markets, excluding India, out of the top twenty-five Bollywood grossers of all time, by 2015,

Khan featured in eleven. The previous year, Khan was second on *Forbes*'s list of the wealthiest actors in the world—after Jerry Seinfeld and before Tom Cruise—had countless endorsement contracts, production ventures, and in 2016 had licensed his catalogue of films to Netflix in the first deal of its kind.

Though in 2018 the Supreme Court modified its ruling, making the national anthem optional at cinemas and not compulsory, Bollywood, Pankaj Mishra told me, created the mood music for Narendra Modi. Recent films push a jingoistic, cultural nationalism in step with the governing political chorus. Today, films increasingly tout government propaganda. Akshay Kumar, for example, who has starred in six hyper-nationalistic films in the past three years, regularly screens his films for Modi, including *Toilet Ek Prem Katha* (*Toilet, A Love Story*), which was based on the PM's sanitation drive, Swachh Bharat ("Clean India"), which—besides its disquieting and ominous focus on purity— largely seems to involve inviting the media to watch Bollywood actors sweeping some dirt around with a broom. The film also made positive references to Modi's demonetization in 2016, a move that wiped 86 percent of Indian currency out of circulation, slashed India's GDP by 2 percent in the subsequent financial quarter, and reportedly caused a hundred deaths. Amartya Sen, the economist and Nobel Laureate, called demonetization a disaster, but the makers of *Toilet,* in their political wisdom, disagreed and included a scene of a chief minister praising the prime minister for his note ban. Kumar's latest film, *Kesari* (which means saffron, the very color of Hindu nationalists), depicts a battle between Sikh soldiers, fighting on behalf of the British Raj, and Pashtun tribesmen resisting colonial oppression and

60 occupation. Yet in the *Kesari* version of history, the Pashtuns are
the enemy, Muslims and ravenous barbarians who recite prayers
before beheading girls, while Kumar is a saffron-clad hero.

He is not the only actor to have made a career out of aligning
entertainment with the politics of the day, however. *Sui Dhaga*
(*Needle and Thread*) took another Modi initiative, *Make in India*,
and used it as its subtitle. *Commando 2*, an action film that
critics said "could well have been written by a low-level Finance
Ministry official looking for a pat on the head and a promotion,"
detailed the state's fictional fight against black money.

Modi himself reached out to Bollywood stars twice to dis-
cuss what role Bollywood could play in "nation building," the
first time in October 2018 when he met Aamir Khan, and again in
December when he took selfies and analyzed Indian soft power
with luminaries such as Karan Johar and Ranveer Singh.* Akshay
Kumar, however, blurs the lines of Bollywood's political project
more than most. In the middle of the 2019 polls he was granted a
one-hour interview with Modi, who is the only prime minister in
India's seventy-two-year-old history to have never held a press
conference during his first term. Kumar studiously avoided
any of the hard-hitting issues of the day, making zero mention
of corruption, communal violence, or India's swift economic

* It was Ranveer Singh's wife, Deepika Padukone, who had been threatened
with beheading for her role in *Padmaavat*. A BJP leader offered a $1.5 mil-
lion bounty for her head and promised to look after the families of anyone
willing to kill the actress. ["BJP politician puts bounty on Deepika Padu-
kone's head." *Al-Jazeera*, November 22, 2017.] Though Padukone was
not present for the Modi photo op, her husband, who also starred in the
film, was. "*Jaadoo ki Jhappi!* [Magic Hug!] Joy to meet the Honourable
Prime Minister of our great nation," Singh tweeted afterward. ["Bolly-
wood 'squad' meets Modi to discuss 'nation building.'" *Business Standard*,
January 10, 2019.]

downturn. On his Twitter, Kumar teased the interview by adver-
tising it as "COMPLETELY NON POLITICAL" and proudly lived
up to his promise. "Does our Prime Minister eat mangoes?" was
the first question Kumar asked Modi. *Is your sense of humor intact
after becoming Prime Minister? You sleep only three and a half hours
a night, the actor probed. Don't you get sleepy?*

The actor, who is a poster boy for the Modi government,
starring in films based on the prime minister's projects, meeting
RSS leaders, and peddling state propaganda on TV and social
media, also happens to be a Canadian citizen who cannot vote
in Indian elections. After his embarrassing interview with the
prime minister, Kumar landed in a puddle of trouble when he
was visibly absent on voting day. After being roundly criticized
and questioned, Kumar was forced to admit he could not vote in
the elections. "About the Canadian thing, I am an honorary cit-
izen," he waffled. "I've been given an honorary thing. I think it's
a thing that people should be proud about. I have an honorary
doctorate also but I am not a doctor. So this is what people have
to understand." However, Canada has only ever bestowed six
honorary citizenships: The recipients include Malala Yousafzai,
Aung San Suu Kyi, the Aga Khan, Nelson Mandela, the Dalai
Lama, and Raoul Wallenberg. Kumar, a good, old-fashioned nat-
uralized Canadian, is not on the list.

Regional allies may dither and disappoint, but Modi's gov-
ernment could reliably count on Bollywood for its rapturous
support. After a suicide bomber hit a convoy of paramilitary
forces in Pulwama in February 2019, and Jaish-e-Muhammad, a
militant group based in Pakistan, claimed credit for the attack,
India and Pakistan stood at the precipice of war. India flew
fighter planes across Pakistani territory, and the two countries'

62 air forces engaged in dogfights for the first time since 1971. As tensions between the two nuclear nations magnified, Bollywood cheered enthusiastically for war.

"Mess with the best, die like the rest," Ajay Devgn tweeted, salivating over news that India had struck Balakot, a forested region in Pakistan. Raveena Tandon—it bears noting that neither she nor Devgn have been big draws at any box office in recent years—was equally gleeful: "What an explosive morning!" Priyanka Chopra, a UN Goodwill ambassador, faced petitions to have her position withdrawn after she, too, cheered support for India's Balakot strike, and Kangana Ranaut, who in recent years has styled herself as judge, jury, and executioner when it comes to her colleagues' nationalist credentials, opined that barring Pakistani artists from Bollywood "is not the focus, Pakistan destruction is."

Heading into an election year, Bollywood's Modi mood music reached fever pitch. On January 11, 2019, two films were released on the same day in what can only be described as a propaganda overkill. The first, *The Accidental Prime Minister,* was a whiny smear job of Modi's predecessor, Dr. Manmohan Singh (the BJP tweeted its trailer from their official party account), and the second, *Uri: The Surgical Strike*, was an action thriller based on India's claimed retaliation against militants who killed eighteen of its soldiers on a military base in Uri. The two-minute trailer features shooting, rocket launching, torture, and a government official reportedly based on Modi's National Security Advisor, Ajit Doval, boasting, "*Ye naya Hindustan hai, ye ghar me ghusega bhi aur marega bhi.*" ("This is the new India, we will enter that house and kill them too.")

The *coup de grace* was undoubtedly a film based on Modi himself, which the Supreme Court stopped from being released the very week before 900 million Indians went to the polls. The trailer for *Modi: Story of a Billion People* has been described as "a hagiography for dummies" and depicts Modi leading soldiers through Kashmir, waving an enormous Indian flag in the middle of a gunfight, promising to cut Pakistan's hands off, and carrying a child away from a bloody riot. The film's trailer was launched by its lead actor, Vivek Oberoi, who turned up dressed as Modi: white hair, prosthetic nose, and all. "I am a balanced person," Oberoi announced to the press at the launch, not looking or sounding very balanced at all. His father, a BJP member for fifteen years, had produced the film. Omung Kumar, the director, was also present. "I am a very neutral person," he chipped in.

This is the face of Bollywood today. There are no epics devoted to the struggles of Dalits, the lowest, "untouchable" castes of India, who constitute nearly 20 percent of the population. If you include cameos, in his ninety-plus films, Shah Rukh Khan has played only six Muslim characters. Three of those have been since 2016, though Khan has pointed out that that's a matter of coincidence rather than targeted political posturing. Bollywood's cinematic citizen is one of a moneyed majority. And though Khan is an innocent, a man standing at the crossroads of myriad ideas, ideologies, and histories, as he grows as a global icon, interviewed by David Letterman as one of the selected few for his Netflix series and more, at home he is increasingly besieged by the same forces that once carried his career to its pinnacle. With his rivals snapping at his heels, today Khan

64 seems marginalized, or at least viewed with suspicion by India's increasingly muscular right wing.

Bollywood is a pleasant diversion in the subcontinent, but cricket—South Asia's only positive legacy from an otherwise humiliating and larcenous experience with British colonialism—is a matter of life and death. Khan is the co-owner of three Twenty20 cricket teams, most importantly the Kolkata Knight Riders, an Indian Premier League cricket team that has twice won the IPL cup. Though one would imagine an association with India's beloved game would only increase SRK's megawatt status, it has been a source of friction.

In 2010, the actor was pilloried by the Shiv Sena, a right-wing Marathi party, after he questioned why Pakistani players were included in IPL auctions if they were not allowed to play in the league. Pakistan, widely considered the world's best at T20 cricket,* a fast-paced form of the normally languid sport on which the IPL is based, is the only country not invited to play in the franchise. Even Bangladeshi players are traded in the league, though they are fairly recent entrants to the game.† The Shiv Sena demanded Khan apologize for his statements, and when he refused, bayed for his blood.

While Bollywood bends over backward to participate in the weird nexus between India's entertainment industry, TV news, and Hindu nationalists, in the past Khan has been quiet, if not elliptically critical. "I'm often asked nowadays—probably you are asked the same thing—*What is your opinion on terrorism?*"

* By other people, not just me.
† I.e., they're not very good. Sorry.

he said after the 11/26 terror attacks in Mumbai in 2008. "I find this a very strange question, because no one can have a difference of opinion on terrorism." More recently, after noting that "religious intolerance and not being secular . . . is [sic] the worst crimes that you can do as a patriot," Khan was publicly rebuked by a general secretary of the BJP. While he had enjoyed *Baazigar* and *DDLJ*, the BJP spokesperson said, selecting an interesting choice of films, Khan's soul seemed to have vacated to Pakistan.*

Aamir, hailed by his fans as a politically minded artiste, came out in support of Modi's disastrous demonetization policy, calling it "a good initiative," and asked his fellow Indians to support their prime minister's long-term vision. (In the final analysis, it cost India 3.5 million jobs and India hit a forty-five-year unemployment high.) Aamir confessed that the currency ban hadn't affected him personally, as "I make use of card, be it debit or credit card, when we buy something."

A few days before the seventy-first anniversary of India's independence, Salman Khan tweeted a sepia photo of himself, looking especially beefy, as part of the Indian Sports Ministry's #humfittohIndiafit ("if we're fit, then India is fit") campaign. "*Swachh bharat toh hum fit . . . hum fit toh India fit. . . .*" ("Clean India so we're fit . . . if we're fit then India is fit. . . ."); he captioned the photo of himself gazing dreamily into the distance into what one can only presume is a mirror, with a plug for not one but two of the BJP's government initiatives, adding: "then u can do whatever u want to do man . . . but don't trouble your motherland."

* The BJP will put the Pakistan Tourism Board out of business, at this rate.

Karan Johar, his frequent collaborator who directed Khan in *KKHH*, *K3G*, and several other K-titled blockbusters, released a video resembling a hostage statement to apologize for casting a popular Pakistani actor in his 2016 film *Ae Dil Hai Mushkil* (*This Heart Is Complicated*). In his Stockholm Syndrome video, Johar bizarrely referred to Pakistan as if it were the Voldemort of nations, mysteriously never mentioning its name, only calling it "the neighboring country," and promising "not to engage with talent from the neighboring country." Johar saluted and affirmed his respect for the Indian army, listed how many Indians had worked on the production of his film, condemned terrorism, and swore his love for his country.*

The month before India went to the polls in 2019, every two minutes for a full hour Modi tweeted to Bollywood celebrities asking stars to use their voices to call people out to vote. He tweeted to Khan, Amitabh Bachchan, and Johar in one tweet, amending the tagline from *K3G*: "Urging @SRBachchan, @iamSRK and @karanjohar to creatively ensure high voter awareness and participation in the coming elections. Because . . . its [sic] all about loving your democracy (and strengthening it). :)"†

The Press Information Bureau, an official government body, used screen grabs of *DDLJ* with new dialogue to push the vote out:

"Kya Kaha, Raj har baar vote deta hai!!" ("What did you say? Raj votes every time!!")

* I wrote to Karan Johar to interview him for this book, but he did not reply to my requests. Presumably because he didn't want to be forced to make another video.

† *K3G*'s tagline is, "It's all about loving your parents."

"*Han Bauji,*" Simran's character confirms to her father—in the film, Khan's character, Raj, has to be beaten nearly to death in the last twenty minutes of the film before Simran's father approves of him. But in the government's ads, all it takes is that he is a voter. "*Jaa Simran jaa,*" the father says, "he is a responsible citizen."

In his reply and retweet, Johar squeezed as much enthusiasm as humanly possibly into 280 characters, and Bachchan responded with his now trademark Twitter verbiage. The prime minister also tweeted Aamir and Salman together, both of whom responded happily, Salman so much so that he was forced to clarify the next day that he wasn't joining the BJP. Khan also responded to the prime minister's call and, curiously, with more gusto than all the other Bollywood stars. "PM Sir asked for creativity," Khan tweeted in Hindi. "I'm a little late because I was making a video." He then uploaded a minute-long music video—an extra effort no one else took the time to include— calling for Indians to vote. At the end of Khan's anodyne rap on the joys of voting, a disclaimer flashes on the screen: "This video has been issued in public interest to encourage people to vote. This video does not endorse any political candidate or political party, or any views or positions held by any type of political candidate or party." The prime minister's response was immediate. "Fantastic effort!" he praised Khan in a retweet of the rap video.

After Narendra Modi won the 2019 elections, securing a second term in power, Salman was the first to extend his Twitter congratulations, and Khan followed next. Though he had seemed less enthusiastic than his peers about India's descent into rabid right-wingism, he, too, offered Modi his unsolicited, rambling congratulations: "We—as proud Indians—have chosen an establishment with great clarity and now we need to get behind

68 it and work with it to have our hopes and dreams fulfilled. The Electoral Mandate and Democracy is a winner. Big congratulations to PM @narendramodi ji and @BJP4India and its leaders." Aamir said nothing.

Mahesh Bhatt, the Bollywood director, who believes that the only reason "Pakistan will never go to war with India is because Shah Rukh lives there," and who described himself to me as the "only person in Bollywood who has made two flop films with Shah Rukh Khan," is the father of two actresses who have both worked with Khan. "The world and reality are burning," the director fumed to me on the phone from Mumbai. "You need to insulate yourself with fairy tales. This is what Shah Rukh panders to. He wants to be that; he wants to keep the fairy-tale yarn going. He wants to keep you on that frequency of life. He doesn't want you to gravitate into the abyss of what is called the truth. What is so marvelous about the truth?"

Chapter Four

The opulent promise of globalization and hierarchy is everywhere in Dubai. Emirates Airlines luxury cars announce what tier their passengers have flown on the driver's door—First or Business. Even the subways are divided into classes. On the highways, huge billboards with foreign names rise out of the sky. American Bed advertises the "world's best mattresses," German Home promotes bathrooms and kitchens, and Gaultier French Luxury, nondescript furniture. All their billboards are enlarged for wealthy commuters like stations of the cross.

Dubai is a mecca of money and consumerism but even as the city offers the glitter of globalization—islands shaped like palm trees; the world's largest indoor ski slope where, even as the sun burns at a steady 98 degrees Fahrenheit, you can snowboard to your heart's delight; a modern-day Babel Tower where you hardly ever hear Arabic, only a smattering of different tongues—it manifests all its alienation and sorrows.

70 You see it in Dubai Mall, where daylight never intrudes, inducing a climate ideal for twenty-four-hour shopping; in the small, uniformed Tamil men, invisible amid all the suntanned shoppers; in the cleaner who pushes a mop along the glistening floor with one hand and holds in the other a blue cloth to wipe pillars with as he passes them. No time must be wasted, no man must be less than a machine. The majority of Dubai's residents are not bronzed bankers. They are an invisible population of multinational migrant laborers on slave contracts: Filipinos, Indians, Bangladeshis, and Pakistanis trucked in to shovel fake snow and trucked out again before the sight of them makes anyone uncomfortable. Across from the sparkling pillars in the mall, a Filipino boy with spikey hair leans on the railing looking down at Chanel, Dior, and Gucci. His gaze is focused not on the shops, but on the mobile phone in front of him. I can only really see his back. "Can I help you?" it reads in white block letters.

It is just after 9:00 p.m. and dark-skinned boys are piled on motorbikes. None of them wear helmets. All along the roads, construction cranes work through the night, their beams lit up with spotlights. I try counting them, but there are too many. I give up at fifty-five. You don't see stars in the Dubai night sky, only the glow of skyscrapers. Illuminated billboards are the Emirate's most visible constellation. Kareena Kapoor advertises diamonds over six-lane highways, Katrina Kaif and Salman Khan a clothing store, Sushmita Sen an apartment complex ("Live your Life Resort Style"). It looks like the air is clouded with smog, but it's just the haze from all the bright, blinding

lights. The only non-Indians on billboards I've seen so far: the
Sheikh of Dubai and his son, hugging a racehorse.

Siyasudeen, the young Uber driver in a neatly pressed blue
shirt, is from Kerala. He sees me looking at the billboards. "You
like Bollywood?" he asks me.

"Yes," I say. "Do you?"

Siyasudeen nods. Shah Rukh Khan is his favorite. "It's not
because of glamour, it's because of good acting." His fingers are
spread out like a fan over the steering wheel; SRK is the most pop-
ular here in Dubai, he claims. "Ladies," Siyasudeen declares sagely,
"old men too. Ladies in Shah Rukh Khan's *fillums* are wearing their
dress properly. They are wearing good clothing. And old mens is
liking that too. It's moral. He struggles for his film line."

I ask Siyasudeen if he likes living in Dubai and he is quiet
for a moment. He sighs. "Yes," he eventually answers. "Yes. Yes,
it's okay."

At the entrance of the Palazzo Versace, a Nigerian concierge
stretches his arms out to welcome a rotund couple in *dishdashas*.
"You're home now!" he greets them warmly. There are orchids
all over the designer hotel lobby, a golden, life-size Arabic cof-
feepot centerpiece between two lobby sofas, two grand pianos
facing back to back, Versace's Medusa insignia cobbled out of
gold tiles on the floor, and fashion sketches of models with
no body fat on all the walls. "It is very nice," the man in the
dishdasha appraises the hotel in his thick, Gulf accent. "It is,
it is," the concierge agrees. Nearby, a Malaysian man twirls in
a circle, his arm outstretched before him, clicking an endless
stream of selfies.

————————

The 1,200-square-meter Imperial suite at the Palazzo Versace seemed to conform to the unrestrained aesthetic of Arabian Gulf autocracies. All available surfaces—lamps, tables, plates—were emblazoned with Versace's gilt Medusa heads, baroque urns, and flowery motifs. It is more than just a hotel room: It has its own ecosystem. There is a grand staircase leading to the second floor, three chandeliers in the sitting room alone, a private butler on call, a long dining table set for ten, and the Indian Premier League playing on a huge flat-screen TV. I'm trying to see which team is playing when he walks in.*

"*As salam alaikum*," Shah Rukh Khan greets me as he settles into a Versace chair. He's wearing a black hoodie, camouflage trousers, and scuffed Converse sneakers. Khan radiates a sunny boyishness rather than matinee idol hunkiness. He is not as imposingly tall as Bollywood's previous superstar, Amitabh Bachchan, and has bulked up in recent years—obliged by Bollywood's new ideals of masculinity to take his shirt off for work, Khan now sports a tight, sinewy musculature. His impressively black hair flops, when not slicked back into his standard quiff, over his forehead and across his dark brown eyes. He smiles often but shyly, checking first to see if you're smiling too. If you are, the hero's full lips widen and dimples appear in his cheeks. Tonight, he appears tired and sunburned.

* I may have mentioned that Pakistani players are not invited to play for the IPL, which is basically like organizing a basketball league and asking Kobe Bryant, Shaquille O'Neal, and Michael Jordan to stay at home.

We were scheduled to meet tomorrow when I will accompany Shah Rukh to a shoot for an Egyptian television show, but even though he's just stepped off a sixteen-hour flight from California, I got a call asking me to come tonight. We have some time to talk before he heads back to work at 11:00 p.m., when Alia Bhatt, Shah Rukh's co-star from *Dear Zindagi* (*Dear Life*), will arrive for a script narration.

"I'm watching all your films," I tell him.

"I'm sorry," he laughs, sheepishly.

"I've seen seven in the week before traveling."

"Twenty hours of your life," Khan estimates.

"One part says that I came into the film industry when India was opening up, the Indians in the diaspora—including Pakistan and Bangladesh, I mean the whole South Asia has the same status—were all proud suddenly having Indian movies to be watched, and second-generation and third-generation people were being made to watch these by the first generation to teach them culture, to show them this is *hamara* [our] land," Khan reflects. "Somehow, I led the movement because the kind of films I did were a mix of being cool, which I think people abroad wanted themselves to be felt like. So I was cool enough and we were traditional enough." Others felt that it was because he stood for the youth in India, or because he stands for self-made success, having entered the business with no backing. "Why I'm saying all this is because I think none of it is true." There's something more to it, Khan says of his superstar status, and something less.

He speaks animatedly, no matter the time and no matter how tired—or in fact, how long he has been speaking—with

bouncing emphases and stresses, flip-flopping between Hindi/ Urdu and his British-inflected, subcontinental English. "Is that how you pronounce it?" he often asks—checking or warning that he might mutilate "Cannes" or "asphalt" or "*Y Tu Mama Tambien*."

Abhinav, a white-gloved Indian butler, brings a small espresso cup and places it down on the side table next to Khan. He rips open a sachet of sugar and pours it into the coffee, stirring it gently, before crumpling the sachet into the ashtray, which he discreetly replaces with a fresh one. The whole while, neither looking exactly at Khan nor very far away from him, the gloved butler wears a mask of serene adoration.

"I've never been a straitjacketed, proper hero in my films," Khan continues. In *Baazigar*, "I take a girl up a terrace and throw her off and you're okay with that. I don't know why. I don't watch my films but I remember when that film released most of the kids were loving it. And it's so gruesome!"

"There's a certain sense of goodness I bring to badness. People trust me with badness. You know, normally people trust you if you're good. I think there's an inherent quality that you trust me with the badness. You say, it's okay, if he's going to be bad, he's not going to be *really* bad." Even though he's dressed like Justin Bieber, there is something avuncular about Khan.

"Why can't the Bollywood hero win?" I ask. "Why can't he ever catch a break?" There's no defying family, no getting the girl he loves, nothing—whereas in Hollywood, if the hero's aims are noble, he can defeat any obstacle.

"Sacrifice is a big part of our culture," Khan replies. "We're taught to sacrifice from childhood, in our religion—in all the

religions of South Asia—you'll only be told stories as you grow up of how heroes gave up things to achieve things for themselves but mostly for others."

In Hollywood, obstacles can be personal and therefore overcome, Khan continues, but in India your sacrifices are for others. "So if I did not marry in a film . . . the girl I love, it would be because I want her to marry the elder brother in the family because he's the one who's of the right age. Now if you were to see this in the context of the West, there's nothing like age, stage, or even brotherhood of that level."

Abhinav appears like a shadow and sweeps away another coffee cup.

"The most successful directors in the country right now, they only look for roles where I'm going to rise above human nature." Khan shakes his head. "They always make me do roles like that, even if I'm just a dance trainer."

Presumably that's why Khan never swears in his films. Tomorrow, during shooting, I will hear some classic swearing, but for now, at least until I ask the question, there hasn't even been a single dip in the language.

Khan offers me green tea, which seems more appealing than coffee two hours from midnight. I ask if he'd ever do a Hollywood film and he claims he's never been offered one. "And I have a secret dream, which is not a secret: I want to make that Indian film—participate in that Indian film—which is watched by the world." He's considered stories from the Hindu religious texts, The Mahabharata or The Ramayana, but feels that for such a film to go global it would have to have cutting-edge FX, fewer songs, no interval, and be standard movie length, only an hour and a half long.

"Good luck getting The Mahabharata into an hour and a half," I say.

Like a savvy producer, SRK waves his hand in the air. "There'll be sequels and prequels."

"A movie seen by everyone on earth doesn't seem that far off?" I suppose out loud.

"*Inshallah*," Khan replies solemnly, sipping his coffee.

Khan has fans all over the world, including a coterie of eight to ten elderly German ladies who have followed him everywhere he goes for the last twenty years, watching him lovingly from the sidelines. "It's fulfilling for me," he insists, interacting with these fans. "A lot of it has become about selfies now but I can feel there's a little more to them. I fulfill some incompleteness about their lives which I don't know about. It could be a young girl who dreamed of marrying a guy like Raj and she did not and now she's settled, she's got two kids, but the dream still lives on so when you meet her it's like 'I met my Raj!' and I don't have the heart to tell them I'm not Raj."* Abhinav is back with a second espresso, which he sets down. "I don't know, maybe your husband is a *billion* times better than that life you would have had with Raj . . . yeah, it's a very strange kind of . . . when you go for a live show people are screaming and shouting and all that happens but in quieter places people will just come and say, 'Can we touch you?'"

He whispers the last line.

It's nearly 11:00 p.m. and time for his narration. "We leave for shooting tomorrow at noon sharp," Pooja, Khan's PA, a small,

* SRK's character from *DDLJ*.

stout woman in her early thirties, says. "It's a tight schedule." I promise to be on time.

"*Khuda hafiz*," Khan says in Urdu as I'm leaving the Imperial suite.

"*Khuda hafiz*," I reply. May God protect you.

Mithun "not Chakraborty"—the twenty-nine-year-old chauffeur from Kerala who will be on duty during Shah Rukh's time in Dubai, wants to know everything as soon as I get into the car, which Khan insists will drop me back to my hotel given the late hour: What was Khan like? What did he say? What am I writing? Do I always write about Khan? Did I know him from before? Have I seen his movies? Mithun told me that he had driven everyone—including Kim Qadir-shee-an, a model who was being filmed the entire time she was in his car; in fact he never saw her face, and they were followed by police escort "all for this one girl"—but no one was as truly wonderful as Khan. "He started from *jero*. He had nothing. When I am born, that time also he was an actor. He looks the same," Mithun rhapsodized. "No changing, no different . . ."

"All love stories and we like his body language too," Mithun sighs as the lights of Dubai's skyscrapers and construction cranes glitter in the dark. "He's a genius, eh?"

Khan has overslept.

Apart from the animated cricket commentary on the flat-screen TV and the whirr of the Nespresso machine, at noon the next day there is no sound of life in the ostentatious suite. We were supposed to leave at twelve but when Pooja materialized at 1:00 p.m. she told me that they had all slept very, very

late. "We were partying till 8:00 a.m.," she announced, her ombré, highlighted hair perfectly styled, before flopping onto a long beige sofa, upholstered like everything else in the suite, in gaudy Versace fabric and complemented by baby blue and tangerine cushions in exaggerated rococo patterns. When Abhinav, wearing a Bluetooth device hooked to his ear, places a tray of ketchup, mustard, and mayonnaise on the dining table at 2:10 p.m., I realized that we weren't going anywhere anytime soon.

Khan appeared shortly after his breakfast has been laid out, fried eggs and toast. He moved slowly, tentatively, as though weighed down, and wore a denim jacket with a pale blue hoodie attached over a white cotton shirt and black jeans. A thick plaster of cakey foundation was airbrushed over Khan's face and pink blush swept across his cheeks. Putting his designer aviator sunglasses down, he settled into his chair at the head of a long dining table and gestured to me.

"Have some eggs, Fatima." Khan offered me his plate. There was nothing else on the table, and though I tried to decline, Khan cut me off. "Have some, have some," he insisted in his singsong voice. "You must eat."

I took the plate from Khan and cut myself a bit of egg white, knowing he would not eat until I had taken something.

He watched me carefully as I did this, then looking up from the plate I handed back, he flashed a dimpled smile. "Fatima," Khan said in Urdu, "what kind of way is this of cutting an egg?"

Noura, a lanky Egyptian executive from the Middle East Broadcast Company (MBC), one of the Arab world's first satellite channels and home to *Ramez Taht El Ard* (*Ramez Underground*), the show that Khan is shooting for today, is ushered into the dining room by Karuna, a member of SRK's curiously small team,

to run Khan through the script for the show on her laptop, frame
by frame. Abhinav, the butler, shuttles between the Nespresso
machine and Khan, setting down golden Versace espresso cup
after espresso cup, smiling beatifically and with great pride at
this task no one seems to notice.

Ramez Underground has been on MBC for eight years and it's
hugely popular during Ramadan. The premise sounds like a mix
between *Da Ali G Show* and *Jackass,* heavy on the *Jackass.* A star
is "lured" into doing a fake interview, Ramez plays a prank on
them, all is revealed, and Ramez does a gotcha interview after-
ward. "This is Fatima. She's a writer, here to observe Shah Rukh
for the day," Pooja introduces me to Noura, who nods at me with
blank disinterest.

"Have you seen our show?" Noura turns to Khan.

"Well . . ." He smiles charitably, physically unable to say no.
Until we reach the set later in the afternoon, no one on Team
SRK even knows the correct name of this show they have come
to Dubai to shoot for.

"We are the most popular in the Middle East."

"Oh great." He brings out the dimples. Khan artfully side-
steps all of Noura's questions, well trained in South Asian poli-
tesse where "no" is never uttered when one can be excruciatingly
vague instead.

Noura shows Khan a still of an Egyptian actor who did a
previous episode of Ramez's show. "Do you know any Egyptian
actors?"

Khan has moved chairs to sit next to Noura at the dining
table. His eyes narrow as he stares at a clearly unfamiliar face.
Noura watches Khan expectantly.

"I met a woman once . . . not sure if she was a singer or an
actor . . ." He struggles to look encouraging, squinting at the

80 photo and darting his eyes around as though searching his memory.

"We had Paris Hilton as a guest once; she's a social media star," Noura clarifies.

"Ah, yes?" SRK looks up from the laptop to smile cheekily at his team who are more a small clique of pals than a set of handlers. The ladies stifle a giggle while Noura carries on. They've had Hollywood actors before—Antonio Banderas and Steven Seagal—but this is their first Bollywood actor. "We're so excited."

"Oh, me too . . ."

Khan is shown a photograph of a lizard next. "The same people who designed the lizard did the horses for *The Revenant*."

"Fantastic . . ." he mumbles.

The next picture is of quicksand. Noura doesn't reveal who designed that.

"You will save the girl," Noura squeals. "And she will scream a lot! You will be angry! Very angry!" Noura pitches the choreography of what's to come. "If you want to hit Ramez, hit him! Ha ha." She even suggests throwing him into a pool.

Khan's eyebrows furrow with concern.

Karuna is listening carefully. "Is this safe?" she asks.

"Oh, I will save him!" Noura promises gleefully, clapping her hands together. "Shah Rookh, would you like to sit on a camel when we arrive?"

There is a silent pause and then Khan looks up at Karuna and Pooja. Everyone in Team SRK exchanges a quick, worried glance. "Let's see about that later," Karuna intercedes authoritatively before Khan can reply. It's getting late and we should leave.

Khan finishes his coffee—an invisible hand has already placed a piping hot Starbucks Venti Americano in the car

outside—and stands up to exit the sitting room. As we leave the
Imperial Suite, he leans toward me and says, sotto voce, like a sub-
continental uncle: "Fatima, I don't mean to be personal, but it's a
long drive. Do you want to go to the restroom before we leave?"

The drive from Dubai to Abu Dhabi will take us over an hour.
Mithun's eyes are focused on the road ahead, but every now
and then, for a quick second, they flicker toward the rearview
mirror. Khan sits in the back. The air conditioner is on full blast
and the windows are closed. We talk about his favorite Holly-
wood actors—Michael J. Fox and Peter Sellers—and directors.
Khan says he loves them all but especially Robert Zemeckis who
directed the *Back to the Future* franchise. "He just changed his
whole style of filmmaking doing that film with Denzel Wash-
ington. Where he's a pilot? He's on cocaine? And then he saves—
was it called *Flight*? Pooja, was it called *Flight*?"

Pooja, sitting in the front seat like an oracle, her fingers con-
tinually pecking at her phone, replies without turning around.
"*Crash*."

"*Flight* or *Crash*?"

"*Crash*. The one where he drinks and flies, na?"

"Yeah."

"I think it was called *Crash*."

"I think *Flight thee voh. Crash tho aik bohut achee* picture
thee, isme accident *hota hai*. (It was *Flight. Crash* was a very good
picture; an accident happens in it.) Anyway, it was a true story."

The first time Khan traveled abroad, to London, was just
after *Baazigar*. He was twenty-six or twenty-seven years old
and didn't even know airplanes were divided into classes of com-
fort. "I always thought that whichever seat you sat on, that's the
plane." He was fast asleep in his fancy hotel room in St. James

82 Court when, in the middle of the night, Yash Johar, the famous director and father of Karan, called him. "'*Berather*'—he used to say *brother* like Pathans do—'*berather*' he says to me, '*bohut bari hit hogaye tumari picture. Mubarak ho, mubarak ho.*'" ("Brother," your film is a big hit. Congrats, congrats.") Soon after, in Mumbai's famous Mehboob Studios, Salman Khan's father approached SRK and said, "'You know, I think you've become a big star.' So I said, why? He said because at the hair cutting salon they ask people whether they want a Shah Rukh haircut. That is stardom."*

I ask why it always rains in Bollywood films.

"It's an expression of good blessings showered from heaven."

How come the hero in the 1970s sometimes played a cop, a role that has largely vanished for heroes?

"Back then we had just become independent and it was a point of pride for Indians who couldn't be in those roles during the Raj."

How many cups of coffee does he drink?

"At one point, twenty, thirty Nespressos a day."

Before Dubai, Khan was at the San Francisco film festival. "So like, I'm sure some of the boys and girls who were there, if they were going out for a night out in Frisco after watching, say, *My Name Is Khan*, normally they would go out for a drink or something—they won't tell their parents back home in India. So 'where are you going, Ravi?' and Ravi'd say, 'I'm just going out with my friends to watch a movie, Mom.' But I'm sure Ravi made

* The two other Khans, Aamir and Salman, were both offered the lead role of *Baazigar*'s Ajay before Shah Rukh. Aaamir turned it down and Salman's father, a famous scriptwriter, rejected it on the grounds that the role was too negative for his son to take on so early in his career. [Anupama Chopra, *King of Bollywood*, p. 115.]

that call to his mom in India: 'Mom, I'm going out to see Shah
Rukh Khan, *haan.*' '*Oh acha, voh vahan pe? Oh acha,* very good!
Beta millay to mera bhi hello *kaydiyo.*'" ("Oh, he's there? Son, if you
meet him say hello from me too.") The mom would be happy, he
stresses, not because Shah Rukh Khan is Shah Rukh Khan, spe-
cial genius, but because he represents an attachment to India.

It is true that people, not just Indians, view Khan as emblem-
atic of success, hope, and pride. All the people I asked about his
films in Dubai—the Nepali girl working at the nail salon, the
Bangladeshi cleaner at the mall, the Pakistani taxi driver—were
unanimous about this. They were promised the riches of global-
ization. With migration would come wealth, security, and end-
less, stratospheric possibilities. They were assured that they
would be captains of the new global economy, only to find that, at
best, they are human minesweepers. Dislocated from home, dis-
placed and dispossessed as they toil invisibly toward maintaining
wealth that will never be their own, relegated to the periphery of
the city, they are lifted from some of the strain of their lives for
the three hours that they watch Khan dance and sing.

Around us, Abu Dhabi starts to form out of the sunlit desert.
First it looks more industrial than Dubai (imagine), and then, as
we near the Emirate, it grows greener, lush, like a real city.

"And seriously, I'm not trying to give myself importance,
but I said in an interview myself that I'm a feeling that can't be
denied. And not because I'm so good, I'm so famous, or I'm so
bloody fantastic. I know it more than anybody else how normal,
and, uh, if not mediocre, just about okay I am. And I'm not being
modest either. I know. Somehow because of the way the country
has moved, the people have moved, all the reasons we discussed
yesterday, I have become that feeling, that desire, that hope,

that pride, even that patriotic feeling, whatever, all of them combined."

There is an impatience in Khan's voice as he speaks, a weariness at having to defend oneself against self-importance while actually being very important. "I don't think about trying to manage this," Khan says of his global persona. "Because it hasn't been done by me—it's not created by me. I'd be a fool to think I did all this. I did acting. I wear makeup in the morning and I still know how to do that. The rest of it, I don't know how to do. So I better, very clearly, just go and do what I know. It ain't broke yet, so I'm not fixing it."

There is a flurry of activity around the waiting Falcon AW 189 helicopter and the cameras are already rolling. Noura wants Khan to look nervous getting off and on the heli, Pooja relays. Also, has he decided about the camel?

Arun, the legacy makeup artist whose father used to do Khan's makeup, and Raj, the hairstylist, are putting their final touches on the star. As Khan walks to the helicopter, two air traffic controllers in fluorescent vests hold their mobile phones up in the air, snapping pictures of SRK instead of controlling the air traffic or whatever they are supposed to do. We are all piled into the back of the twenty-seater, so that on film it will look like Khan is alone in the helicopter. Noura, still full of beans, tells me she "loves" Khan's films "because the cultures are so similar, you know?"

We sit under the shudder of the helicopter blades. Orange foam earplugs are passed around and finally, we lift off, hovering over sea-green water. All the inlets of land in the sea seem to have been shaped by men's hands, like everything in

these Emirates. The movement of the helicopter's rotor blades makes it seem as if the sunlight is flickering, like a light bulb dying. Even with the earplugs, the sound of a helicopter is awful, like someone karate chopping your ears again and again and again.

Khan gazes out of the window thoughtfully. If he's acting, I can't tell. Everyone is on their phones, snapping pictures of the scenery for their Instagrams, and through the gap in the seats, I can see the co-pilot gesticulating wildly with both his hands. He waves them and flattens his fist against his palm and then squeezes them together as though he's shaping kibbeh. After what feels like forever, the pilot announces that we will shortly be landing at the resort of Qasr Al Sarab. A sponge with M.A.C. powder and a mirror floats up to Khan. Looking out of the window as we descend, I see a red carpet in the middle of the empty desert lined, curiously, with palm trees. Khan is gazing with great concentration out the window. Below, three camels are waiting in the ochre sand.

Wearing his aviators, Khan glides down the red carpet and into a white dome resembling something out of *Star Wars*. Inside the dome, camelgate having been successfully resolved, he sits down for the setup interview with an earnest Arab gentleman who throws one softball after another at Khan.

Q: "Are you a coffee drinker?"

"I drink a lot of coffee actually, yeah."

Q: "Amee-tab Bah-chan. When we say this name, do you compare yourself to him quite often? Do you say, no, Shah Rookh Khan is better?"

"Haha. No."

86 When the show airs during Ramadan, #shahrukhkhan is a global Twitter trend. One of the producers of *Ramez Underground* tells me that their show is the biggest production in the Middle East, with the most notoriety and the most reach. "Go to any coffee shop any time after the fasting," he says, "and you'll find Ramez on all the TVs in all the shops." They chose Khan, the producer insists, because "for us Shah Rukh Khan is not an Indian star. Shah Rukh Khan is an international star."

While Khan does the dummy interview with the earnest host, Ramez, a weasely little character, will be shown on a cutaway screen in another room. He is wearing a studded leather vest over a black T-shirt, studded leather gloves, and is cracking Egyptian jokes and shrieking. Compared to Ramez, the dummy host seems like Tom Brokaw.

After the shooting in the dome, we are packed off in a jeep and sent flying over billowing desert dunes. As the vehicle careens and slides through the burnt orange sand, our tire marks are instantly erased as the wind and millions of grains of sand sweep over them like waves. The shoot is shrouded in too much secrecy, Arun, SRK's makeup artist, worries half-jokingly. "I only hope it's not a kidnapping attempt on Mr. Khan."

But what is happening to Khan is much, much worse than that.

As he leaves the fake interview, Khan is put into a separate jeep under the guise of doing a promo for the fake interview in a different location. There is a driver and another passenger in the front seat and a pretty, heavily made-up Arab girl with black tattooed eyebrows and pouty, cosmetically enhanced lips in the back with Khan. Ramez, meanwhile, is lying down on the floor in some secret location while his team zips him into his lizard costume.

In his jeep, bumping along on the sand dunes, Khan teaches
the girl some Hindi. Cut to Ramez, his head sticking out of the
green lizard outfit. "*Kaifa ta taalam al hindiya fi talath daqa'ik!*" he
squawks. ("How is she going to learn Hindi in three minutes!")

Girl: "Do you know any Arabic words?"

SRK (dimples, smiling): "*Shukran.*" ("Thank you.")

Cut to Ramez: "*Afwan ya sidi afwan!*" ("Sorry, sir, sorry!")

At this point, the viewer is asking himself: Does Ramez
have to interject every five seconds? Does he ever shut up? Yes,
he does. And no, he does not.

As their jeep jumps over the dunes, the girl screams and
grabs onto Khan's muscular arm. He flexes his bicep so she
can hold on better but doesn't touch her. "Ooh, my gosh!" she
screams. "Ooooh, my goooosh!"

In the split screen of the episode, Ramez in his lizard suit
narrates all this as though we don't have eyes.

After turbocharging down an especially steep dune, the
car stops and proceeds to sink, nose first, into quicksand. The
driver and passenger are quick to beat it, climbing out through
the sunroof.

"What are you guys doing?" Khan gamely asks before
climbing out himself and pulling the girl out.

"I don't know what's happening!!" she screams and hops up
and down on top of the sinking car.

One of the men flops into the quicksand—which looks like
coffee-colored mulch—and the girl (still screaming) falls in and
is submerged up to her neck.

Very quickly it gets worse: As if the quicksand were not bad
enough, they now have to deal with Ramez.

The host pulls on his lizard head—after an aide hands him a
bottle of water to sip through a straw—and crawls out of a cave.

88 As the enormous, rather believable looking lizard lurches closer to her, the girl points to it and screams, "Aaaaaaah . . . *Rabi rabi rabi!*" (God, god, god!)

Khan is issuing safety instructions—"hold on to me!"—but it's hard to hear his cool advice over her screams and Ramez's lizard growls. Khan's reflective aviators haven't slid a millimeter down his nose, and just as you, the viewer, are asking yourself: *Do lizards actually growl?* Ha Ha! Surprise! It's not a lizard, it's Ramez.

"*Ahylan, ustadh* Shah Rukh Khan!" ("Hello, Mr. Shah Rukh Khan!")

I recall Noura's words from earlier and hope that Khan does hit him.

Suddenly the quicksand stops pulling and the car stops sinking and mercifully the girl finally stops screaming. Khan lets go of the passenger he was attempting to save alongside the girl and drops him into the mulch.

"Wait, wait, wait!" Ramez yelps. "*Main tumse pyar such karta hoon!*" ("I really love you!")

Khan furiously flings some quicksand at him. "Don't tell me *pyar pyar ke* shit man!" (I guess you'd translate this as "love love shit.") "This is nonsense! You've got me here all the way from India to do this shit?"

"I'm so sorry," Ramez whines.

Khan really does sound angry, and when the episode airs, channels all over the world will show this clip as though someone were truly stupid enough to almost drown SRK, global legend, in quicksand. The star flings more mulch at Ramez.

"This is a *brank* show called *Ramez Underground*!"

"I don't want to know what the bloody show is called!"

Ramez is now out of his lizard costume, holding his hand to his heart. "We love you, I swear to god. You're my hero! You're my dream!"

"The less you speak, the better for you," the hero hisses, voicing what must be on millions of viewers' minds. He throws Ramez to the ground and drags him by one foot across the desert floor.

"You're a gentle!" Ramez screams when Khan invites him to bury himself in the sand. "You're an example for *beoble*! You have to forgive me. I said I love you!"

There is a brief détente when Ramez sings "Marjaani Marjaani," a song from one of the hero's films, and Khan stomps off.

"SRK! *Main tumse pyar karta hoon!*" Ramez howls behind him. ("SRK! I love you!")

"*Main jaan laylunga teri,*" Khan shouts back. ("I will kill you.")

In an ornate drawing room at the Qasr Al Sarab Desert Resort, after the mulch and the mud and the quicksand have been cleaned off, Khan sits down—freshly attired—for the final segment of the show, an interview with Ramez.

"This is my dream," Ramez swears, putting his hands together in a namaste.

"To drown me in your swamp?" Khan retorts. His famous eyebrows, which have been stationary so far, spring into life. One pulls up as the other pulls down. Here he is: Khan, the superstar.

"Why can Indian actors sing and dance and do everything?" Ramez has changed into an even stupider outfit for this segment, marked notably by red spiderweb sneakers. For some reason, he has also brought a cake to the interview.

"We can do everything," Khan deadpans. "It's in the water."

90 "Were you helping the girl cos you flirting her?" Ramez asks, using *flirting* as a verb. "I feel like you love me," he purrs. "Your face is smiling. Do you have a message for the hundred million Egyptians watching?"

"Thank you for loving me so much," Khan says, heartfelt, straight to the camera.

Ramez, who behaves as if he's consumed a liter of petrol, seems briefly subdued, yet the moment the interview is over, chaos erupts. All the film crew—Lebanese, Egyptian, and Moroccan men, who five minutes ago had been holding mikes and adjusting lights—go berserk. As we leave to make our way to the helicopter, there is a mini stampede as they all try to get to Khan, to touch him, to shake his hand, to take a selfie.

We jump into the helicopter, which is waiting for us in the dark, and the doors close. The electricity, that sparkle of his, is gone, its currents have flickered off. Shah Rukh sits alone in a row of empty seats. Momentarily it seems as though he is about to recline, but he remains sitting upright, waving half-heartedly at the window. It's late at night and it's been a long day. For a moment, I watch Khan waving to nobody and wonder how tired he must be to be waving out at the darkness at nothing.

But then as we lift into the sky, the red lights of the helicopter flashing in the dark, I see them—people gathered around the helipad, countless men, resort employees, and the camera crew, watching Khan, their arms raised, bidding him farewell as he disappears into the night.

Chapter Five

Erika Varez, late to class, bounds up the stairs barefoot, having already left her shoes on the landing. Her long, straight black hair is loose around her shoulders; she wears a block-printed blue kameez and loose black churidar leggings. Her students have already started practicing without her; "Maar Dala" is playing loudly on the speakers. In the 2002 film *Devdas*, the iconic Madhuri Dixit dances to the song. Here, at the Centro Cultural India in Lima, it is being performed by twelve Peruvian girls.

Erika drops her bag at the entrance and pauses for a moment, touching a poster of Saraswati, Hindu goddess of the arts, the paper yellow with time, that hangs near the door. Erika bows her head down to touch the floor of the dance studio in submission, the way a Hindu would enter a temple, before she springs up and runs into class. Her students, ranging from a teenager in a football jersey to an elderly woman in a knee brace, are relieved that their teacher has finally arrived. Erika stops the music and like a classical *Bharat Natyam* teacher, sings the beats out loud, snapping her fingers—*dum dum ta ra ra dum*—as the girls flop about.

"No!" Erika shouts as her students fall to the ground, crawling on the floor and smiling as they imitate Madhuri, the courtesan broken by longing for the man she cannot have, Shah Rukh Khan's alcoholic Devdas. "No!" Erika shouts at their happy faces. "*Suffre! Suffre!*"

Jhonn Freddy Bellido, Erika's manager and best friend, and I are watching the class from outside. Jhonn, wearing thick black-and-white glasses, is the founder of Bollywood Peru. He is a connoisseur of Malayalam, Bengali, Marathi, Telugu, Tamil, Kannada, and even Pakistani films. His family are originally from the highlands of Peru, the city of Ayacucho, but he was born here in Lima. Though his day job, carpentry, was handed down by his father, Jhonn is an entrepreneur. Besides running his Indian cinema appreciation group, he manages a troupe of twelve Bollywood dancers and works for the Indian embassy's cultural center as an ambassador of sorts. Over the weekend he organized a screening of *Jab Harry Met Sejal* (*When Harry Met Sejal*), which stars SRK as a grumbly, bad-boy tour guide who gets roped into traveling the continent of Europe by Anushka Sharma in order to find her engagement ring, which she has lost somewhere between Lisbon, Budapest, Amsterdam, Prague, Vienna, and Frankfurt. Two hundred people attended the screening, Jhonn tells me. "But Shah Rukh Khan is not my favorite," he confesses. "Rajinikanth is."

Erika teaches Bollywood dance at the center twice a week, but tonight Jhonn has also organized a performance of his dancers at Mantra, one of Lima's few Indian restaurants. Besides his small black shoulder bag, Jhonn pulls a carry-on bag behind him as we leave. Three of his troupe will be performing tonight and Jhonn chooses and designs all the costumes. He goes to

Gamarra, Lima's garment district, where there's nothing but tailors for ten blocks. There, you can order a *lehenga* or *sari* for $20, but Jhonn is a perfectionist. He spends about $100 an outfit. It's the fabric, he says. Good cotton is expensive. The girls dance at weddings, cultural fairs, and Diwali and Indian Independence Day parties, making about $30 to $50 per dancer for a show. Once a month they dance at Mantra, and Jay Patel, the restaurant's Gujarati owner, advertises the evening on his Facebook page.

In the Uber to Mantra, Erika and Raisa, another of the dancers wearing blue eye shadow and her hair pulled into a tight bun, sit in the back with Jhonn. Erika sings a *bhangra* song, stopping to check if she's pronouncing the Punjabi correctly by Googling the lyrics. "Mi Gente" by J. Balvin is on the radio, but Erika sings the *bhangra* in a low tone, as if she doesn't hear the reggaeton at all.

In the restaurant, decorated with Indian miniature paintings and a small rack selling brightly colored spices and tea, tables are filling up—aside from the owner, Jay Patel, who moved to Lima from Ahmedabad ten years ago, there are no Indians. Limenos on dates, families, even the director of Peru's tourism promotion board, sit at the tables facing a large TV and order their dinner.

Erika is the first to come out, dressed with jasmine in her hair, a red *bindi* on her forehead, and henna painted delicately over her fingertips. Again, she touches her hand to the floor and then to her head in submission before she begins to dance. Raisa and Victoria follow: All three are unbelievably natural. They move gracefully, singing the lyrics of classic Bollywood songs as though they have grown up speaking Hindi, their eyes

94 and their hands moving perfectly, seamlessly, as the audience claps and cheers.

Jay Patel sits at a table next to mine, his spectacles on a string around his neck. "God knows why the hell"—Patelji shakes his head, his Indian accent thick and untouched by Spanish—"this Shah Rukh Khan is so much popular here. There are fans and fanatic fans of Shah Rukh Khan; not even in India I have seen so much." He estimates that the rest of Bollywood accounts for just 10 percent of Peru's feverish adulation and it's "cultural" movies that they love, the kind "where they wear saris and family things" happen.

Patelji scrunches his face and shakes his head again. "My personal guess is he looks like Peruvian or something." He turns to Jhonn—who, as much as he likes food, is studiously avoiding the cup of rich milky chai in front of him—and says in a mix of Spanish and Hindi, "*Parece cholo, hain na*, Shah Rukh?" ("He looks like a *cholo*, doesn't he, Shah Rukh?")

Peru began its tryst with Indian cinema, or *cines Hindu* as it's known, in the early 1950s. Unlike other markets where Bollywood is popular, Egypt or Nigeria for example, Peru has neither historic ties with India nor a sizable NRI population. Until 1963, the two countries didn't even have diplomatic relations. Fifty-six years later, there hasn't been any significant bilateral business or political cooperation between India and Peru. Though the Indian steel conglomerate Tata set up shop in 2010 and trade is set to grow, the momentum is still relatively slow. According to the Indian embassy, no more than four hundred Indians live in the entire country.

Two films, 1954's *Mendigar o Morir* (*Boot Polish*) and the 1957 classic *Madre India* (*Mother India*), kicked off Lima's love affair with Bollywood. At the time, there were two cinema halls that showed Indian films regularly, City Hall and Metropolitan. A third, Colosseo, had screenings, too, and along with Metropolitan was in a poorer neighborhood than the more centrally located City Hall. Not only were the Bollywood classics instant blockbusters, but *Madre India* was screened especially on Mother's Day as well as during Holy Week. "You can understand Mother's Day," Professor Ricardo Bedoya, Peru's most eminent film critic, told me as we sat in his apartment overlooking the Malecon, "but what's interesting is that during *Semana Santa*, people here feel you don't go to the movies to have a good time but to suffer, to feel empathy with the suffering of Christ."

It was mainly poorer Limenos who flocked to those three cinema halls, migrant laborers and women who had left their homes in the Andean highlands to come and work in the capital. The films are easy to understand, they don't condescend to their audience, and they are built around the nobility of suffering and the valor of the poor and dispossessed. *Boot Polish* was produced by Raj Kapoor, but it was the arrival of *El Joker* (*Mera Naam Joker*) in the 1970s, a Kapoor starrer, that truly cemented Peru's affinity with *cines Hindu*.

Even though Peru has a sizable population of Japanese and Chinese who migrated to the country in the late 1800s, East Asian cinema—except for the kung fu movies of the 1970s—never really made a dent here. Bollywood's themes, on the other hand, "have a connection with the imagination of Andean people," Professor Bedoya explained, "family relations, themes

96 of family disintegration, the city and migration, the moral
of sacrifice as personal redemption." It is the Andean belt—
Peru, Ecuador, Bolivia, and Colombia—that makes up the
Bollywood-watching base of South America, and not the *payeses
blancos*. The more European Argentina, Chile, and Uruguay are
neither as amenable to Indian cinema's themes nor do they see
themselves reflected in the films visually. Peru's indigenous
population, with their dark brown skin and mestizo features,
look Indian. A lot of young men in Lima, with their straight
black hair cut in flat-brush style, appear as though they asked
their barber for a Shah Rukh.

"We are a post-colonial society, so we have racism incor-
porated," Felix Lossio, the young director of cultural industries
at Peru's Ministry of Culture—and author of a book on Bolly-
wood's popularity in Peru—told me. *Cholo* is a pejorative term
but still widely used to describe Andean men. The notion that
someone from the Andes could wear their traditional dress
proudly in the city was a strange one, Lossio continued, and
though society isn't segregated, young Andean men were still
routinely discriminated against. In Peru's boutique cinema
industry, the characters were largely urban and white. You might
get a creole character every now and then, but that was it.

At the time I was in Lima, *La Paisana Jacinta*, a crude and
racist comedy where Jorge Benavides, a white actor, dresses
up in brown-face drag to portray a backwards Andean *campe-
sina*, was in the cinemas, infuriating many. The non-European,
Andean population associate Hollywood with sex and violence,
Lossio explained, whereas many of the indigenous Peruvians he
interviewed for his book felt that "Bollywood movies showed
them that they could hang a picture of a rural scenario or a llama

on their walls, because basically they were migrants from those rural areas, without any shame. Indians are wearing *saris*, for example. They could be cosmopolitan and urban and successful but wear a *sari* and have a traditional way and even dance to traditional music." That, Lossio declared, was impossible to see in films coming out of Lima.

Peru's "guilty machismo," as Bedoya called it, stemming from its strict Catholic culture, was another reason for the country's attraction to Bollywood. All around Lima were black and red billboards: "Peruvians against machismo," they read in big block letters. The country has some of the highest femicide numbers in South America. Since 2013, Peru has ranked third in the world in the number of complaints regarding gender violence according to the World Health Organization, behind only Ethiopia and Bangladesh.

"In Hollywood, a woman who has been cheated on by her husband—Barbara Stanwyck or Joan Crawford—what would they do?" Bedoya asks. "They would get revenge. She will be a millionaire, and when she's at the top, she will destroy him." The professor, a tall man, bald on the crown of his head, slices the air with his hand dramatically and then pauses. He leans forward in his chair. "But that doesn't occur in Latin American cinema. In Latin American movies, the woman is born to sacrifice herself for sadness. Dolores del Río is an icon, a Mexican actress. There's a movie called *The Abandoned* by Emilio Fernández, and this is the archetypal movie about women, which remains till today: A woman who is about to be happy is betrayed and then begins her fall, which includes extreme poverty, prostitution, suffering, and sacrifice—because of a man who is her son. She loses her life, but she saves her son."

"There are no happy sides to these movies," the professor laments, "only melodrama and suffering."

"Neither in Bollywood," I say.

He shrugs. "At least you have singing and dancing."

Bollywood fan clubs in Peru operate a little like the gangs in *West Side Story* (minus the knives). Each club has its own codes, insignia, and rules and they maintain a fierce rivalry between each other. There are subcultures of dance groups, film appreciation societies, and unlimited fan clubs. Dhanush, the Tamil actor and singer, has one, Kajol (they pronounce her name Ka-yol) too; even lesser stars like Preity Zinta, who hasn't had a hit film in years, can rally a cluster of admirers in Peru.

Of all the local SRK clubs, however, only two are run as conglomerates: Shah Rukh Khan Fan Club, known as FC, and the Khan-blessed SRK Universe. FC is older and affiliated with a group run out of Chennai while SRKU runs in coordination with Muhammad Ashraf, its young founder in the Maldives and his "CEO" in Michigan. When you ask the groups in Lima about each other, they reply politely, but through clenched teeth. FC is more middle class, filled with mostly young female professionals who work in NGOs, hospitals, and hotels. A few FC members have traveled to Mumbai for Khan's birthday—the trip costs between three to four thousand dollars, a prohibitively expensive amount for SRK Universe members, who live farther away, on the outskirts of Lima, venturing less into Miraflores and the posh districts of the city. The single female members of FC might comfortably attend events at the Indian embassy in San Isidro, whereas SRK Universe doesn't have the same level of contact or comfort with Lima's diplomatic circles.

Instead, their members are families, mothers and daughters,
nuclear cells of parents and grandparents, who attend meetings
together. All the fans that I meet are indigenous Peruvians: Not
one person is white.

Bollywood in Peru is not an elite interest. It belongs to the
struggling and the aspirational who see their battles mirrored
in the brutal, unforgiving landscape of India's classic cinema,
from the 1950s onward to the 1980s, where dreams are broken
by destiny, wealth is no protection from the whims of gods, and
even the powerful are at the mercy of the stars. Since the advent
of neo-liberalism in the 1990s, however, Bollywood's exces-
sive materialism mimics Hollywood's. No longer is the hero an
honest villager fighting a corrupt system; now he is a multina-
tional brand consultant with a Rolex whose parents celebrate
their wedding anniversary by taking a hundred of their closest
friends on a Mediterranean cruise. But even these pornographic
displays of wealth and luxury don't put off Lima's working-class
audiences. There is something acceptable, even exhilarating,
about a brown man who makes it big.

The odds are still crushingly stacked against him, and unlike
Hollywood, his fall can still be bloody. There is often no happy
ending; the system—no matter your riches—will not vindi-
cate you. You might still die a pauper. You do not have the pur-
suit of happiness enshrined in the constitution of your life. But,
imagine: one of your own beating fate, overpowering destiny,
and transcending life, even briefly. How beautiful would that be?

Outside Zentro in Avenida Bolivia, hawkers sell lottery tickets
and a dispirited Venezuelan bouncer in a tight black T-shirt
frisks men entering the cavernous bar hall. It is here that SRK

100 Universe holds its annual birthday celebrations for Khan in lieu of traveling ten thousand miles to Mannat, the actor's Mumbai home. Shots with names like Miami Vice (piña colada and daiquiri fresa) and Cucaracha (tequila and liquor de café) are advertised on backlit blackboards. Two men sit in a corner, sharing a liter bottle of beer. Except for them, and our table of SRK Universe members, Zentro is empty.

Misael Wadros Avalos, who goes by the Bollywood name Pyare (beloved) Khan, is a heavyset thirty-five-year-old who arrives carrying a bag of rolled-up SRK posters and calendars. For fifteen years he has run an online Indian cinema portal—a yearly subscription of eight dollars affords you access to pirated Bollywood films subtitled in Spanish—which came to the attention of Farhan, SRKU's CEO, in Michigan. Farhan got in touch with Misael three years ago and asked if he would be interested in opening an SRKU chapter in Peru and thus the fan club was born. Today they have two hundred members.

"Shah Rukh Khan prolonged my existence for five years," Violeta, a seventy-two-year-old grandmother of fourteen, declares dramatically as she sits down. Violeta, with short graying hair and deep-set eyes, has been a cancer patient for the last eighteen years. In 2013, she was placed on radiotherapy but it didn't take. Violeta vomited through the nights, lost her hair, and was finally told she needed surgery on her thyroid to extract the malevolent tumor. "One month before I was due to have the operation, my husband, the love of my life, my companion for forty-seven years—forty-seven years of marriage—died." Violeta's voice chokes and tears gather in her eyes. "I did not want to live."

Her daughter, Gabriella, an actress, sits beside her. She nods her head in tragic confirmation. "Every day she wanna die."

"Without him, with my illness, I had nothing in life. But then one of my granddaughters brought me a film of Shah Rukh Khan, *Mi Nombre es Khan"—My Name Is Khan*. Violeta watched the film that night, followed by another movie, and another, staying up until 3:00 a.m. She had always loved movies, calling herself a "fanatic," and had appreciated Mexican, Argentinian, Spanish, even Hollywood films. But nothing she had ever seen before rivaled the perfection of *cines Hindu*. "I can't pass one day without Shah Rukh," Violeta swears. "Not one day of my life. I said to my granddaughter, if you bring me more films of this actor, I will keep on living and stay with you for more time."

Misael orders a round of snacks for the table, and Violeta, warming to her theme, insists that, in another life, she must have been Khan's mother. There are twelve of us sitting in Zentro's echoing hall. Jhonz, the youngest member of SRK Universe, is four years old and Violeta is the eldest. Jhonz is wearing a leather jacket and a black fedora. His mother, Katherine—or Maya as she's known in the group—wanted to call him Shah Rukh but she was hospitalized when he was born and her husband went off and named him without her. When Jhonz was in utero, the doctors couldn't hear his heartbeat. They advised Katherine to eat chocolate, to go walking, to do all sorts of things, but nothing worked. She was afraid he would be stillborn. It was only listening to "Love Mera Hit Hit" ("Love is My Hit Hit")—at this the whole table interrupts Katherine's story to sing the song—that got her baby to show any signs of life.

But Jhonz was born with a heart problem. That's why he identifies with Khan, Katherine says, because in *Kal Ho Naa Ho*, Khan also has a heart defect. Jhonz, who has been listening to all this quietly, speaks for the first time. "He dies," he informs

me. Now that we are friends, Jhonz shows me a photo of a pistol on his mother's WhatsApp. "It's Shah Rukh's." He smiles innocently.

Before we met, Misael assured me that SRK Universe was not just attracted to the celebrity of Shah Rukh Khan. It meant something to them that he breaks the stereotypes of Hollywood, namely that the handsome protagonist has to be a gringo with white skin, green eyes, and blond hair. They were moved by the way he imparts a "love for the family" in his films. He touches our souls, Misael told me, and it was their love for the Bollywood star that had cured many of their members of "vices" and helped them overcome tragedy. He was not exaggerating. Marlid, a petite forty-four-year-old housewife with sleepy eyes, was an alcoholic for twenty years. When her mother died, Marlid, a devoted only child, began drinking heavily. In 2007, she got badly drunk at a neighborhood fiesta and ended up in the hospital. When she returned home, a friend brought her some DVDs to distract her, and though she had never seen *cines Hindu* before, it inspired her to stop drinking and change her life. Bollywood helped her appreciate nature, Marlid says, to see flowers, to focus on her family and on love. And that she did: She married a wonderful man and had a baby three years ago, whom she named Aryan Valentino, in honor of Khan's own son. In her *barrio* everyone calls her Shahru, after her idol. "I don't see Shah Rukh as a man I want to be with, you know?" Marlid professes, her small round face lit up with joy. "I see him as a man full of values, someone to admire."

All the members' stories follow this pattern of deep despair lifted only by immersion into Khan's films. Angie, a dimpled eighteen-year-old, who works as a teacher in a language institute and has been drafted as the translator for this gathering,

interrupts her translations every now and then to promise me
that she, too, has a very personal and very sad story. Angie has
been calling me since I reached Lima, usually at 7:30 a.m., to dis-
cuss my plans for the day. She bombards me with continual,
breathless texts to ask what it's like to be a writer, which she'd
like to be, too, one day. She wants to write about values, a van-
ishing concept in her country. The texts come five at a time:
What am I doing in Lima in my spare time? Have I been to this
place or that? Have I eaten this dish or that? She would like to
recommend I go here and see the following ten sights, here is
some information about each of them, and on and on. She won't
say exactly what her sad story is but teases parts of it through
the evening. She was thirteen and heartbroken, she reveals at
one point, leaving me to imagine the rest.

But for all the stories of illness and trauma, SRK Universe
is a pretty upbeat bunch. They cry and laugh in equal measure,
are obsessive but heartfelt, their tragic confessions broken by
spontaneous dancing and Hindi singing.

Do they like any of the other Khans? Aamir? Salman? "We
love Aishwarya," Angie sniffs, alluding to Bollywood gossip of
Aishwarya Rai's tumultuous love affair with Salman. "She's such
a good person and the news is that he hit her. He was, like, kind
of violent. We know everything."* Wady and Misael try to offer
an answer, something to the tune of differentiating between the

* Salman Khan has always denied the rumors and allegations that he was vio-
lent. "No, I have never beaten her," he said of Aishwarya. "Anyone can beat
me up. Any fighter here on the sets can thrash me. That is why people are not
scared of me. I do get emotional. Then I hurt myself. I have banged my head
against the wall; I have hurt myself all over. I cannot hurt anyone else." [From
an interview with *Mid Day* on September 18, 2002, quoted in Jasim Khan,
Being Salman (Penguin Books India, 2015).]

value of art over the artist, but Angie is adamant. "We're feminists here," she says, speaking for everyone.

They ask if I know Khan and I say that I've only met him recently. "Could you feel his fatherly love?" Angie asks.

Though they all profess to admire Khan for his values, culture, and traditions, it is Wady whose allegiance to the Bollywood star is the most profound.

"I am hard," Wady emotes in his deep actor's timbre. "Because the men in Peru are macho. The men don't cry." But watching *DDLJ* for the first time, Wady found himself awash in tears. It was that film that made him want to be an actor when he was seventeen years old, lost, and on the cusp of suicide. "I wanted to study acting to be like Shah Rukh," Wady says ("You can be like his shoes!" Violeta calls out across the table), "to have even one percent of his grace."

The whole evening at Zentro, Wady has been goofing around, speaking in Spanish-inflected Hindi, grabbing the women's hands to twirl them in a dance, dropping to his knees to sing and shimmy his shoulders. But suddenly he grows somber. "*Yo soy un chico de pueblo.*" Wady puts his hand on his heart. ("I am a man of the village.") "*Yo no soy un Chopra, yo no soy este Kapoor. Un chico.*" ("I am not a Chopra, I am not a Kapoor.") Wady has been in eight films, but it hasn't been easy. "Here we have no opportunities being Inca," Wady says, his shoulders hunching. "Here, there are only opportunities for Brad Pitt. Here, if there's anyone of our color in films, they only have a story where they come from the highlands or they're stealing money or doing something bad. If Shah Rukh Khan was born in Peru, he would have been a *poor* man. He would never have been the King of Romance in films. Never."

By the 1980s, the run of Bollywood films in Lima's cinema halls was largely over. With the arrival of VHS and Betamax, people could watch movies in the comfort of their homes, depriving the neighborhood *cines de barrio* of income to pay their high rents. They either closed down or were bought out by evangelical churches and shopping malls. Cinemas migrated to the commercial centers of Lima where, in order to fill seats, only local movies or big Hollywood exports were screened. The decade of the 1990s saw cinemas replaced by multiplexes and with them, the suffocating hegemony of Hollywood.

Even in the countryside, a combination of high inflation and the state's fight against *Sendero Luminoso*, the Shining Path guerrilla movement, resulted in the shutting down of cinemas. In the twilight of cinema halls, piracy spread like fire through the Andean highlands, first with videotapes and later with DVDs. At the same time, a curious phenomenon began in the Andes. Until 1996, according to Professor Bedoya, all of Peru's films were produced in Lima. There might have been exceptions in any given year, but for the most part, cosmopolitan Lima dominated the industry. After 1996, movie production started to spring up in Ayacucho, Huancayo, Puno—the central and southern Andes. And the Peruanos behind this burgeoning Andean movement were young directors from agricultural backgrounds whose cinematic sensibilities had been heavily influenced by Bollywood.

Due to the saturation of pirated films—the current rate is about $1.50 for two DVDs—this generation of Andean directors' cinematic culture was gleaned from Bollywood films watched at home. These young directors hadn't ever seen movies on the

106 big screen and the cinematic path they charted for themselves wasn't especially sophisticated in terms of cinematography or production value. Their films were self-financed and, in order not to lose their money to Peru's rampant piracy, they traveled alongside their work, visiting villages and renting out churches or municipal salons to screen their wares. To guard against their own films being pirated, the directors ensured no screening could be held without them being physically present, so the movies were difficult to access.

This genre of Andean films, born at exactly the moment that Peru was undergoing its own neo-liberal adjustments, were largely horror films. The dramas were anchored in the family, ravaged by alcoholism and incest, classic parables of corruption and degradation, eroding what was innocent and pure in the battle of modernity against tradition. Since the adoption of a neo-liberal economic model, Peru's political discourse had been centered around the capitalist mantra of bootstrap you-can-doism. "You have to be successful, you have to be an entrepreneur: The narrative of success is really present in Peru for the last twenty-something years," Felix Lossio recounted. And furthermore, coming as it did at the height of the Shining Path violence, resistance to the neo-liberal invasion of the 1990s was relatively weak. Structural adjustments barreled into place and Peruvians hedged their worries about inequality against the promise of stability and success.

"Neo-liberalism disarticulated many things in Peru," Professor Bedoya told me sadly. "For example, the feeling of belonging to the land and the loss of ethical borders." In many places along Peru's southern boundary with Bolivia, young

people who once tilled the lands turned to smuggling, moving to
the jungle and becoming *narcotraficantes*. The ruptures caused
in families, broken by addiction, smuggling, and crime were at
the heart of Andean horror melodramas.

In Andean films about incest, the man who commits the
incest is usually an authority figure in the local community,
like the mayor or head of police. *Jarjacha: El Demonio del Incesto*,
named for a mythological half-human, half-llama monster, is a
prime example. The incestuous couple, in which the victim is
always female, turn into a *Jarjacha* (so named because it mimics
the sound of a llama chewing its food). The local community is
so enraged by the crime of incest that they capture the creature
and wait for sunrise so its identity can be revealed. Corruption
and a profound sense of disillusionment with the authority's
lack of moral and ethical credibility was a central accompani-
ment of Peru's neo-liberal experiment.

"The *Pishtako* is another character in several films," Bedoya
continued. Born out of oral legends, this monster is a human
gringo who comes to the Andes to steal the fat of the locals,
which he uses as fuel for his industrial machines. "But still—"
Professor Bedoya raises his eyebrows—"today people in Lima
don't know what is a *Jarjacha* or a *Pishtako*." They only know
the Limeno films with happy endings, the success stories, *Jerry
Maguire* you-can-do-it fables.

"But why," I ask the film critic, "when there is this legacy
of horror films built on top of potent political commentary
coming out of the Andes, would indigenous people turn towards
modern Bollywood, whose agenda seems distinctly apolitical,
or more specifically, de-politicizing? The central message of

cines Hindu today is repeated *ad nauseum,* no matter the actor: Don't fight. Don't upend the system. Don't tangle with power."

"Ah," Bedoya says as he sits back in his armchair, "but it's different here. The message here is not don't fight, but it's hard and you will be punished if you do."

Part Two

Forsake alcohol—eat grapes instead!

—Recep Tayyip Erdoğan

Chapter Six

In 1977, Pakistan was placed under martial law. Seemingly overnight, the socialist, progressive direction the young country had been charting since the tumultuous start of that decade was blocked. General Zia-ul-Haq, the CIA-backed, fundamentalist dictator, imposed his writ on all levels of Pakistani society. All political activity was banned, activists were publicly flogged, and barbarous edicts calling for the stoning of adulterous women were signed into law. Pakistan's new military ruler attempted to subjugate all facets of the Pakistani imagination to his total control, brutalizing society with a combination of violence and blanket repression. Newspapers were forced to submit to twice daily censorship checks while women were banned from reading the news on Pakistan Television (PTV) if they did not cover their hair. The same general who called for thieves to have their hands amputated was so offended by women dancing that, at one point, he even outlawed public performances of classical dance. Yet it was exactly under this martial law's suffocating oppression that the arts in Pakistan were at their most vibrant.

The artist Ijaz ul Hassan painted his famous *New Year Bouquet*, a noose of barbed wire in an empty vase, after he had been arrested by the junta, tortured, and then subjected to a mock execution. The journalist and playwright Imran Aslam wrote *Khaleej*, a television serial about labor unions, the excesses of elite rule, and socialism. The poet Faiz Ahmed Faiz penned his most searing verse against the army from exile in Beirut. PTV broadcast *Aangan Terha* in the late 1980s, twelve episodes of biting satire. In one famous episode, an effeminate servant is trying to learn English. What's the interrogative of "I am coming?" he asks his boss. Is it, "Are me going?" By the time the military's censors got the joke, it was too late—everyone else already had.

Between the 1970s and '80s, playwrights scripted television dramas and satires that traveled not only to the United Kingdom and Canada but were also runaway successes across the border in India. Pakistan had always been an enthusiastic audience for Bollywood, but when it came to television, there was no doubt that the Pakistanis bested their neighbors.

Pakistani dramas like *Tanhaiyaan* (*Loneliness*) and *Khuda ki Basti* (*God's Own Land*) were watched on bootleg cassettes in India and had devoted followings. The dramas were written in poetic, classical Urdu, tackled social and political issues with subtlety and narrative refinement, and were staged in realistic settings that affirmed middle-class respectability. For Indians, who had little access to their neighbors, the dramas were stunning. They depicted a culture very much like India's own, with familiar family structures and dilemmas. In 1987, Doordarshan, India's state television, started to broadcast *Ramayan*, seventy-eight episodes based on the Hindu mythological epic

112 of the god Ram's exile and return to his kingdom. It was a huge
sensation, aired just as the Hindu nationalist agitation against a
Mughal mosque gained traction—a movement that would cul-
minate in the destruction of the Babri Masjid in 1992 and even-
tually bring Hindu nationalists to power in the late 1990s.

Ramayan signaled the start of a nativist turn in India's oth-
erwise secular entertainment industry and was enormously
popular among middle-class audiences who were so swayed by
the show that they sometimes offered *puja* to their television
sets before the broadcast. Other religious dramas, such as the
ninety-four episode *Mahabharat*, followed.

As the commercialization of television began in the late
1990s and early 2000s, private channels proliferated in both
countries. In 2003–2004, under yet another Pakistani dictator,
General Pervez Musharraf, TV licenses became easy to obtain
and private channels began to spring up. Though initially it felt
as though Pakistani audiences were subjected to a never-ending
cycle of political chat shows—crossfire sessions of uncles
shouting at each other—soon there were cooking channels,
Sindhi news channels, and entertainment channels. Pakistani
dramas came back in a big way, and across the border too.

In 2006, Musharraf's government formally allowed Indian
channels to air in Pakistan. Indian serials were shown in Pakistan
around this time, admired for their *saas bahu*, or mother-in-law/
daughter-in-law, extravaganzas. Unlike the over-the-top melo-
drama of Indian television serials, however, the Pakistani shows
were more widely relatable. Their characters didn't live in man-
sions but in ordinary middle-class homes. The heroine didn't
wear diamond necklaces to breakfast and didn't wake up with a
face full of makeup. Most importantly, they were short—ending

after one season of between ten and twenty tightly crafted episodes. Indian serials, on the other hand, ran over years and often veered into ridiculous territory. On the soap opera *Kumkum Bhagya* (internationally titled *Twist of Fate*), a character's pregnancy was stretched out over a good thirteen months and didn't even end there. Another long-winded *saas bahu* drama ran to a painful 1,833 episodes before it whimpered to a finish. Subcontinental audiences turned to Pakistani dramas in the 2000s for the same reason they had many decades earlier: because they were realistic and socially conscious dramas built around the tensions of middle-class life. Just as Pakistan's artistic star was rising, however, it got hit by an unexpected phenomenon: Turkish soap operas.

Turkey, like India, had once been a closed and heavily protected economy. Between the 1960s and 1980s, the Turkish army, with popular support, acting as it was as a bulwark against any deviation from Kemalism, the political principle of secularism established by the father of modern Turkey, Mustafa Kemal, overthrew multiple elected governments. As a result, for many decades, Turkey remained steadfastly inward-looking. Until the 1980s possession of foreign goods, even cigarettes, was illegal; local companies produced purely for domestic consumption; a passport was procured with notorious difficulty; and only one television channel, TRT—owned and run by the state—served the people's entertainment needs. It was after the 1980 *coup d'état* that Turkey, literally at gunpoint, opened up. "After the tanks come the banks," a foreign correspondent noted as Turkey put in place IMF-style economic reforms that ushered in the liberalization of foreign trade through import and export regulations, the reduction of workers' fees, the

114 privatization of the public sector, and the convertibility of the
old Turkish lira.

Today, Turkey is the second largest NATO army, after the
United States, and remains an enormously strategic geography:
where East and West collide, where Europe connects to Asia,
and where the Black Sea links to the Mediterranean. After its
neo-liberal turn, Turkey found itself standing at the doors of
Europe, in very different conditions than the last time it had
been there, laying siege to Vienna. This time around, it was beg-
ging to be let in. To call the European Union's response luke-
warm would be an understatement. There were others, closer to
home, however, who welcomed Turkey with open arms.

In 2012, *Ishq-e-Mamnoon*, the Urdu-dubbed telecast of
the Turkish TV show *Aşk-ı Memnu* (*Forbidden Love*), unexpect-
edly topped Pakistan's TV Rating Points (TRP). Turkish dramas
sneaked into the market initially due to economics: They were
cheaper to buy than original Pakistani programming. By the
time Pakistan bought a series, Turkey had already sold it to sev-
eral territories and could offer an episode for between $2,500
and $4,000—a steal compared to a local show, which cost
upward of $10,000 an episode to make.

Aşk-ı Memnu, adopted from a classic Turkish novel, was
the story of a fraught love triangle. Bihter, whose father has
died leaving her family in debt, marries Adnan, a much older,
widowed businessman with two children. Firdevs, Bihter's
scheming mother, assumes Adnan will propose to her but is
shocked when he asks for her daughter's hand instead. Does
Bihter marry Adnan to spite her mother? Or to help her family?
Or out of love, as she claims? Once she moves into Adnan's
beautiful Istanbul mansion, she discovers Adnan's petulant

daughter, Nihal, is in love with her handsome, blond cousin, Behlül, who lives in the family house. Behlul, a brooding rebellious type who has a tattoo on his bicep that reads "Only Allah Can Judge Me," is in love with Bihter—who secretly loves him too. The children's governess, Mademoiselle, is in love with Adnan. It was fifteen episodes in before I could tell exactly whose *ask* (love) was *memnu* (forbidden) because of all the *ask* floating around. By episode nine it occurred to me that Behlul and Bihter might never actually get together because everyone was so profoundly honorable and duty-bound to do the right thing. Rather than this realization putting me off, it kept me watching.

Even though I was cut off by YouTube geo-blocking before the forbidden love in the title could be expressed by more than just longing glances (and I was twenty-odd episodes deep into the serial by then), the standing committee of Pakistan's upper house of Parliament condemned the show for its "vulgar content," which, they insisted, had deeply offended the nation. According to a Pakistan ratings network, however, more than 55 million sufficiently unoffended people watched the show's finale. It was the first time in Pakistan's history that a foreign show drew such high numbers. By the next year, the Turks had fully invaded. There were seven soap operas being telecast across Pakistan and channels, desperate not to miss the wave, halted local dramas mid-season and booted them off the air in order to replace them with Turkish content. The Turks infiltrated India next. *Aşk-ı Memnu* was so popular there, India's Star Plus channel bought the rights to make an Indian adaptation. And that was only the beginning.

Muhtesem Yüzyil (*Magnificent Century*) trounced all who came before, Turkish or local. The drama begins in 1520 when

116 the wise, azure-eyed Prince Suleiman Selim Khan has become the tenth Ottoman Sultan. He is twenty-six years old. The Vatican—a coterie of malevolent old white men—receives this news happily: "The Lion of Islam is dead. Gone is the lion, here comes the lamb," they cheer. The show journeys from the start of Suleiman's reign right till its end. Though its early fight scenes are produced with the same aesthetics of a 1980s video game, we see Suleiman expand the Ottoman Empire throughout the world. "Hapsburgs, Tudors, how do the Ottomans dare to try to become part of this family? How can we have a Muslim dynasty!" Hungarian king Louis froths before beheading an Ottoman emissary. It is refreshing to see a European doing the beheading, for once. When he is not expanding his multicultural, artistic, and tolerant empire, Suleiman, for his part, spends most of his downtime writing poems and crafting jewelry.

The Turks had done something neither the Americans, the Indians, or our own shows did: They had achieved the perfect balance between secular modernity and middle-class conservatism. Unlike the deviants of *Santa Barbara* and *The Bold and the Beautiful*, most of whom were heirs and heiresses named after flora and fauna, historical epics aside, the Turks were ordinary folk, chemical engineers or mechanics, simple men battling to live good, fair lives. The protagonist was not the *begum*, reclining on a sofa and shouting at her deprived, migrant maid, but the maid herself. In contrast to Pakistani or Indian serials, in Turkish shows the maid was not invisible, relegated to the periphery of the story, her poverty used only as a prop to elevate the master's house. Here she was the architect of her own destiny, an innocent who comes to the city to provide for her family

and change her fortune, and she does so without any spiritual or material corruption, no matter the obstacles placed in her way. Turkish historical dramas were not about wars in Muslim lands like *Homeland* or fiery sagas warning against unwashed, villainous Muslim invaders: Here the Muslims were kings. They ruled over dominions unbroken by oceans and were noble, tolerant, and just.

Turkish television shows blazed through the subcontinent and far beyond because their heroes were modern, but not Westernized, moving through the fractures and fissures of the world defeating violence and victimization, propelled purely by the righteous power of values.

Chapter Seven

"The first agreement we should do is don't call them soap operas," Dr. Arzu Ozturkmen, who teaches oral history at Bogaziçi University in Istanbul, scolds me. "We are very much against this."

Soap operas, *telenovelas*, and dramas are all different genres. What Turkey produces for television ("we don't call it Turkish television either") are *dizi*. They are a "genre in progress" declares Dr. Ozturkmen—who is a published author on the subject—with unique narratives, use of space, and musical scores. While most statistics show that Americans watch the most TV in the world at 4.5 hours a day, Turkey's Radio and Television Supreme Council (RTUK) claims that the honor goes to the Turks, who watch an average of a full hour more.* More surprising, however, is that, due to its volume of international sales and global viewership, today Turkey is second only to America in worldwide TV distribution.

* *Dizi* run an average of two hours per episode, so this is hardly surprising.

The first Turkish *dizi* to leave home was *Çalikusu*, which
Russia bought in the 1980s and retitled *Lovebird*. It was such a
big hit that Tims Productions, one of Turkey's biggest *dizi* pro-
ducers, remade it in 2013 and once again it was snapped up by
Russian audiences. Ay Yapim—alongside Tims, these two pro-
duction houses are the Alpha and Omega of Turkish *dizi*—first
began investigating international markets as early as 1994,
though they didn't find many takers then. In 2007, foreign sales
of *dizi* only brought Turkey a grand total of $1 million. Ten years
later, the value of *dizi* exports exceeded $350 million.

At the 2012 MIPCOM, the commercial TV festival at
Cannes, Turkish production companies did business with tra-
ditionally closed markets like China, Korea, and even NBC Uni-
versal, which bought the rights to distribute *Aşk-ı Memnu* to
Latin America. Latin America was once the mother ship of soap
operas, exporting *telenovelas* to the world. But today Chile is the
largest consumer of *dizi* in terms of number of shows sold, while
Mexico, followed by Argentina, pay the most to buy them.

Dizi are often adapted from Turkish literary classics and are
sweeping epics that run over two hours long. Advertising sec-
onds are cheap in Turkey, and RTUK mandates that every twenty
minutes of content be broken up by seven minutes of commer-
cials. Every *dizi* has its own original soundtrack and can have up
to fifty major characters, as *Magnificent Century* did. They are
filmed on location in the heart of historical Istanbul, at exqui-
site *yali* or Ottoman-era wooden homes along the Bosporus, or
the stunning Izmir coast, using studios only when they must. In
the 134 hours (and counting) that I've spent watching *dizi,* the
best show yet has been *Çukur* (*The Pit*), a faithful Turkish rendi-
tion of *The Godfather* set in an Istanbul ghetto.

Çukur films on location in Balat, a run-down but vibrant Greek Orthodox and Jewish neighborhood dating back to Ottoman times. The day I visited the set, a stringer for China's Xinhua News was filming a segment on the show while a bearded *simit*-seller screamed out his wares, oblivious to the cameras shooting nearby as well as the irritated taxi drivers honking madly at the congestion in the narrow streets. *Çukur*'s art directors and production managers rented and renovated ten shops that have become central locations for the story of the Koçovali family, the *dizi*'s version of the Corleones, and have agreements with some of the locals who get walk-on roles. "Think of *Narcos*," Tolga Kutluay, the show's director of photography, tells me. "They also use real locations."

In the spring of 2018, *Çukur* was number one in the TV ratings.* As we sat underneath a laundry line of children's undershirts, flapping in the breeze like flags, while Kubilay Aka, one of the actors, checked his reflection in a camera lens, Kutluay, who wears two silver earrings, majestically waved his hand across the scene. "You can't find this in the studio."

Dizi story lines, which have covered gang rape to scheming Ottoman queens, are "Dickens and the Bronte sisters," Eset, a young Istanbul screenwriter and filmmaker, tells me. "We tell at least two versions of the Cinderella story per year on Turkish TV. Sometimes Cinderella is a thirty-five-year-old single woman with a child, sometimes she's a twenty-two-year-old starving actress." Eset, who worked on *Magnificent Century* and *Kösem* as a treatment writer, counts off the narrative themes that *dizi* are eternally loyal to:

* In Istanbul, everyone is number one in the ratings.

- You can't put a gun in your hero's hand.*
- The center of any drama is the family.
- An outsider will always journey into a socioeconomic setting that is the polar opposite of their own—i.e., moving from a village to the city.
- The heartthrob has had his heart broken and is tragically closed to love.
- Nothing beats a love triangle.

Dizi are built, Eset insists, on the altar of "communal yearning," both for the audience and the characters. "We want to see the good guy with the good girl, but, dammit, life is bad and there are bad characters around."

The upward course of dizi imperialism can be traced to three hit shows from the early 2000s: Aşk-ı Memnu, Fatmagül'ün Suçu Ne?, and Magnificent Century. Izzet Pinto, the founder of Istanbul-based Global Agency, which bills itself as the "world's leading independent TV content distributor for global markets," told me it all began with 2006's Binbir Gece (1001 Nights). At the time, Gümüs (Silver) had already entered the Middle East, where it was retitled Noor and was enormously successful. Noor starred the blond ex-model/basketball player Kivanç Tatlıtuğ, frequently described as "the halal Brad Pitt," and was more popular in the Arab world than at home. Tatlıtuğ, the dream husband originally called Mehmet, was renamed Muhannad in the dubbed Arabic broadcast. Though voice talents tend to dub the

* Çukur is a good example of this: Even though it is a mafia/crime dizi and guns abound, at least up until the middle of the first season, the hero, Yamaç Koçovali, never touches one.

same actors across all their shows for continuity's sake, Tatlıtuğ was so beloved in the Middle East that all his future *dizi* characters would also be named Muhannad.*

Newspapers, even as late as 2018, were still carrying stories on the collective Arab swooning over Tatlıtuğ. "Arab wives wish husbands were more like Turkish actor Kıvanç Tatlıtuğ?" screamed one Turkish daily, citing an American professor in Doha who portentously announced that "Turkish" is now "synonymous with the word 'romantic' in the region." The *Khaleej Times*, a Gulf newspaper, went so far as to note that "the Tatlıtuğ effect" was resulting in divorces from Saudi Arabia to Jordan. Even the Grand Mufti of Saudi Arabia moaned that too many people were rushing off to watch *dizi* during Ramadan, and he may not have been wrong. *Noor's* 2008 finale was watched by 85 million people in the Middle East.

1001 Nights starred yet another blue-eyed Turkish dreamboat, Halit Ergenç, but unlike *Gümüs*, which was limited to the Middle East, wherever *1001 Nights* was sold—close to eighty countries—it broke through the ratings.† Ergenç would go on to star in *Magnificent Century*, the Holy Grail of *dizi*. When it first aired in Turkey in 2011, *Magnificent Century* claimed one-third of the country's TV audience. The foreign press called it an "Ottoman-era *Sex and the City*" and compared it to a real-life *Game of Thrones*. Every episode had up to three historical

* Tatlıtuğ also was Behlul in *Aşk-ı Memnu* (or Muhannad in *Ishq al Mamnou*, if you're keeping up).

† The Middle East and North African region, or MENA, is considered as one sale, though it includes, depending on the distributor, between twenty-three and twenty-five separate countries.

consultants, a production team of 130, and 25 people delegated
to costumes alone.

Based on the life of the tenth Ottoman Sultan, Suleiman the Magnificent, *Magnificent Century* told the story of the sultan's love affair with a concubine from his harem. Except for the first Ottoman sultan, Osman, no others married the mothers of their successors. Sultans traditionally slept with a concubine until a son was born, at which point mother and child retired to a distant province where the young prince would be groomed to rule. The logic was that, once a concubine had a son, her loyalty to the sultan was divided. Hurrem, who the sultan broke with tradition to marry, is a largely unknown historical figure. She is believed to have been an Orthodox Christian from modern-day Ukraine—from the fifteenth century onward, sultans fathered all their offspring with Christian women from their realm who converted before they became mothers—and she was the first concubine to ever marry a sultan. Many believed Hurrem used black magic to entrap the sultan, and though many philanthropic and architectural works across Istanbul are attributed to her, she remains a divisive figure due to key historical events she is rumored to have influenced.

Hareem al Sultan (*The Sultan's Harem*), as *Magnificent Century* was renamed in the Middle East, was such an enormous success that Arab tourism to Istanbul skyrocketed. Turkey's Minister of Culture and Tourism even stopped charging certain Arab countries broadcasting fees. Global Agency estimates that without its most recent buyers in Latin America, the show has been seen by over 500 million people worldwide. Most recently, it became the first *dizi* ever bought by Japan. Since 2002, more

124 than 150 Turkish *dizi* have been sold to over 100 countries including Algeria, Morocco, and Bulgaria. It was *Magnificent Century* that blazed the way for others to follow.

Halit Ergenç, who played Sultan Suleiman in *Magnificent Century*, feels that *dizi*'s runaway success is partly due to the fact that American TV is entertaining but not moving. "They don't touch the feelings that make us human," he told me, nursing a cold cup of coffee as we spoke in Istanbul. The sentiment in Turkey was one of weariness when it came to America's losing cultural appeal. Whereas once Turkey's gaze was keenly tuned to the West, studying its films and television shows for clues and codes of how to behave in a modern, fast-paced world, today the shows offer little guidance. Ergenç's wife—a fellow actress—watches *This Is Us,* he says, "and what I see is that people who are watching *This Is Us*, I see that they are thirsty for these feelings."

"I was thinking of one of the American TV series—let's not say its name. The philosophy of the TV series was being lonely. Being, um—" he searches for the polite word—"multi-partner at the same time and searching for happiness. And all the people who were watching those series were very excited about it." I can only guess he's referring to *Sex and the City*, but Ergenç, who pauses and leans forward, doesn't say. "That's a tiring thing for living, isn't it? Being alone, changing partners in a quick way, and searching for happiness, and each time you search for it, it's a failure. But it was in a very fancy world so people were very interested. They're spending and spending—spending their time, spending their love, spending everything."

The *dizi* that became global behemoths, drawing hundreds of millions of fans wherever they went, were powered by

narratives that put values and principles in battle against the
emotional and spiritual corruption of the modern world. *Fat-
magül'ün Suçu Ne?* (*What's Fatmagül's Fault?*) swept territories
around the globe. Centered around the gang rape of Fatmagül,
a young girl, and her ensuing battle for justice, the show rallied
women from Argentina to Spain where it was recently broadcast
on prime time to high ratings, drawing close to a million viewers
an episode. *Fatmagül* surpassed its Spanish distributor's expec-
tations, not only edging out its closest competitor by over a
hundred thousand viewers, but it was even the most watched
show on its channel, scoring higher than *Modern Family* or *The
Big Bang Theory*. Telenovela audiences had grown so weary of
increasingly sexually charged content and violent *"narcotele-
novelas"* that they turned to Fatmagül in huge numbers, giving
its channel, Nova, the best ratings it had seen since 2015. The
dizi is so popular, seven more *dizi* have followed on the back of
its success, with at least six more slated to follow. *Fatmagül* is
soon to get the full Telenovela treatment in Spain and is being
adapted to a daily, half-an-hour, afternoon format.

 Fatmagül, written by Eçe Yörenç who also wrote *Aşk-ı
Memnu*, is the story of a simple, hardworking orphan who is
engaged to Mustafa, a fisherman often at sea. At the same
time as viewers are introduced to Fatmagül, they meet Selim,
a rich playboy who arrives in Izmir by seaplane to celebrate his
engagement. He had to fly, he moans, because cars make his thin
model fiancée nauseous. He and his frat-boy friends descend
upon the coast and are shepherded around by Kerim, their local
friend, who is a poor but happy blacksmith. After a night of hard
drugs and drinking, Selim and his friends gang rape Fatmagül,

whom they attack as she tries to reach the port to see Mustafa before he sets sail. Kerim was there but has no memory of taking part in the rape. Fatmagül survives, just barely, but is cruelly dropped by Mustafa who will no longer marry her now that her honor has been sullied. Selim and his friends, fearing a noose closing around them, force Kerim to take sole responsibility for the crime. They all have futures to protect—university places in America, factories they are soon to inherit, family businesses to run. Kerim has no future and this, they agree, is the best solution for everyone. Under an old-fashioned concept that marrying your rapist is a form of justice, Fatmagül and Kerim are wed.

The *dizi* addressed a woman's place in society while burdening her with every conceivable problem she might face in this part of the world—bearing the weight of shame, enduring a forced marriage, tense familial relations, struggling against the suffocating power of the rich—all while setting her on a lonely quest for justice. But Fatmagül perseveres. She educates herself and defeats every hardship in her way as she fights for, and receives, manifold justice: civil justice through the nation's courts, divine justice through the punishment of her violators—and, of course, the justice of true love.

In February 2018, Turkey suffered one of its worst months in terms of femicide. Forty-seven women were murdered, twelve of whom were killed by their husbands or boyfriends. Like every part of the world, Turkey grapples with violence toward women, but the issue, particularly when depicted as crimes relating to "honor," receives a great amount of press. One out of every two women killed in Turkey since 2010 was killed by her partner. A 2015 UN Women report calculated that 40 percent of Turkish

women suffer domestic abuse, though the Turkish government's estimate is even higher at 86 percent.[*]

"We have an idiom in Turkey," Pinar Celikel, an Istanbul fashion editor told me: *Ya benim olursun, ya kara topragin*. "You'll be mine or you'll be the blackest earth. It's the meanest thing you can say in Turkish." She shuddered. Though Turkey gave women the right to vote ahead of European countries like France, this undercurrent of hostile possession, jealousy, and violence is felt from village to city. Though *dizi* have dealt with abuse, rape, and honor killings, it's fair to say that, by and large, on-screen, Turkish men are portrayed as more romantic than Romeo. "They show people what they want to see"—Celikel waves her hand in the air—"It's not real."[†]

"In a truly capitalist society, Turkish series are not capitalist enough—neither with their narrative nor with their story lines," Eset declares. "This is another aspect of globalization: the need to tell advertisement-friendly stories. This industry is based on ad revenues. How many brands can you find who are going to be truly behind those causes?" That said, he points to *Fatmagül* as groundbreaking in terms of women's issues. Prior

[*] According to a 2017 UN Women report, 35 percent of women worldwide have experienced abuse at the hands of a partner.

[†] Ece Yörenç told me that when *Fatmagül* was adapted in India, the local producers declined to make the central character a strong, empowered woman at the end of her ordeal. She tried to tell them that was the whole point of the story, but with her own busy schedule of writing *dizi* for Turkey, couldn't follow up with India every week. She also noted that the Indian version of *Aşk-ı Memnu* had a problem with Mademoiselle being in love with Adnan, her employer, because it didn't sit well with their caste sensibilities. They asked Yörenç if they could make Mademoiselle the aunt instead of the governess. She refused (inter-family romance didn't sit well with her sensibilities). So, they settled on making her the dead mother's old friend.

128 to *Fatmagül*, agents of change and the heroes of the stories were always men, but "*Fatmagül* didn't accept women's place as being subjugated, almost invisible. Pretty much the subaltern of this society is women."

Fatmagül was such a powerful soft-power vehicle that in 2012 Eset was approached by a "Republican American think tank" who hired him to write a *dizi* telling the "good American story" of an American woman in the Middle East out to enact positive change, "a woman who softens America's image type of thing." Eset declines to say which think tank was the commissioning agent except to hint that a former Bush administration undersecretary was involved at the institute.* "I wrote it." Eset shrugs as he rolls a cigarette. "But they weren't able to sell it."

* This is a frighteningly longer list than one would like.

Chapter Eight

It is drizzling. I am standing in a bleak parking lot on the Asian side of Istanbul in front of a white van. Ferhat hands me a Glock 19 pistol. It's the same model Turkish soldiers use, he says, as he swings open the van's doors. Inside, there is an RPG-7 lying on the floor and about sixty other weapons hang on racks. Ferhat, who is ex-military, pulls out a "bad guy rifle" (an AK-47) and another favorite, an SR-25 sniper rifle. All around us, men in military uniform prowl across the parking lot. Ferhat, wearing an army camo sweatshirt and wraparound sunglasses, hands me the SR-25 to touch. "Good, yes? Feels heavy, yes?" I assure Ferhat that, yes, it's very good/heavy. No one bats an eye at this show-and-tell. All around us there are street signs in Arabic and extras in cheap suits.

We are on the set of *Söz* (*The Oath*), a new Tims *dizi*, watching the filming of episode 38. A demolition expert saunters by, chatting to a man in a balaclava while an actor rehearses a scene, holding a rifle in each hand, shaking his head to mimic the blowback effect of the weapons. I notice that Shah Rukh

Khan alone wore more makeup in Dubai than this entire cast seems to have on. As I walk past the men's room, I see a suited and booted extra standing in front of the darkened mirror above the sinks. He rests his hands on the porcelain and breathes deeply, watching himself. He says something to his reflection in the mirror, whispering it at himself like a mantra as he prepares for an upcoming scene. A walk-on part in a Turkish *dizi* pays about $22 a day (a day is sixteen hours long), nearly double if there's dialogue.

There are seventy different shows being filmed all across the city at any given moment though hardly ten will be left standing by the end of the season. Even fewer will get renewed for a second run. *Söz* is a military *dizi,* a new genre sweeping the nation. Though it's too early to have a sense of its global effect, *Söz* has already received remake offers from faraway markets like Mexico. Tims has always had an international outlook, I was told. They even tried to cast major Hollywood stars for *Magnificent Century* and were "so close" to signing Demi Moore to play a European princess until her divorce from Ashton Kutcher got in the way.

You might describe *Söz* as a Turkish *24,* if a day were the equivalent of 472 hours long. Of the five major channels in Turkey, each one has one of these "soldier glorifying" shows, Eset the screenwriter tells me later, and all the shows are "zeitgeist relevant." The baddies are either "internal enemies"— popular and believable after the 2016 coup attempt—or foreign villains.

Söz takes place in a Turkey on edge, beset by violence and existential threats. Soldiers are everywhere, blazing through the wreckage of suicide bombings at shopping malls and hunting

terrorists who are hard at work kidnapping pregnant women. In the first episode, after an attack on a mall, a soldier promises that they will not rest until "we drain this swamp," an eerily familiar refrain. In the hundred plus hours I've spent watching *dizi*, *Söz* was the first show where I saw a woman wearing a hijab. Mustafa Kemal, later renamed Atatürk, the father of modern Turkey, famously declared that he wished "all religions [were] at the bottom of the sea." He removed Islam as the state religion from the constitution and banned the fez, which he described as emblematic of "hatred of progress and civilization," even though it was just a hat. He went so far as to execute those who disobeyed his 1925 law requiring Turks to wear brimmed hats. The veil—which Atatürk lambasted as a "spectacle that makes the nation an object of ridicule"—did not fare much better. By the 1980s, women in all public institutions, including universities, were banned from covering their heads.

One senses a unique discomfort here in Turkey, the fractures felt by a people overwhelmed by the loss of their empire and once glorious status in the world. But that shadow of glory hovers forever on the horizon, promising to return. All manner of life here accommodates this hope. Everyone in the *dizi* business spoke to me of how beloved the shows were in "Turkic countries" and former Ottoman territories, speaking affectionately of bonds that, broken nearly a century ago, were hardly voluntary to begin with. Five minutes on the streets of Istanbul presents multiple encounters with women in headscarves, yet at the same time they are nowhere to be seen on-screen. *Dizi* portray only the most modern tableaus of Turkey. But as they guide audiences at home and in the world through the maze of modern identity politics, they make concessions where necessary.

"They tried that," Eset said, speaking of *dizi* attempts—even if paltry—to include veiled women on-screen, "but even the conservative folks don't like to see conservative women on TV. You can't get them to kiss, to stand up to their fathers, to run away, to do very much at all that would be considered drama." Women in hijabs are almost never shown in television ads, the award-winning journalist and novelist Ece Temelkuran told me. "Even in AKP party advertisements, you only see one hijabi woman." Yet this uncertain balance between Turkey's national pride and global insecurity, as well the tensions between their secular and conservative fidelities, speaks to many in the Global South today. Audiences see no conflict between a distinctly Eastern morality deprived of traditional imagery set instead against a backdrop of Western cityscapes, lush with consumerist symbols of plenty. Temelkuran's diagnosis was clear: "This country is torn between these two pieces of cloth—flag and headscarf."

As we move upstairs to a cold office building to watch a man pick up a phone for an hour while the demolition guys shoot up glass windows in the corridor, I tell Selin Arat, the director of International Operations at Tims and my guide for the day, that I'd seen an episode of *Söz* the previous night. And every time I looked down at my notebook, by the time I looked up again everyone in the scene seemed to have been murdered. Who are the terrorists supposed to be? Arat, a delicate strawberry-blonde woman in a business suit, laughed. "It would be life-threatening if we knew who they were."

I thought maybe it had something to do with the current geopolitical situation since the cars in the parking lot all had Syrian license plates? "Well . . . it's a universal theme; it's happening

everywhere." Arat shrugged. "I'm not sure if this is a good thing. I
don't know if we're getting prepared for a world war . . ." Her voice
trailed off as the show's main director—there are two parallel
crews working simultaneously, the only way possible to shoot
a two-hour episode in six days—called *cut* on the phone scene.

Yagiz Alp Akaydin directed *Magnificent Century* and previ-
ously worked in Los Angeles as an assistant director on *Tinker
Tailor Soldier Spy*. Where is this supposed to be? I tried him.
"We're right now either in Iraq or Syria," he replied genially. Arat
leaned across her chair. "We don't point fingers," she reminded us.
At any rate, whoever The Terrorists are, *Söz* is a hit. Their second
episode has 10 million YouTube views. "It's the first Turkish
show that has surpassed one million subscribers on YouTube,"
Arat noted proudly. They even sent Tims a silver plaque.

All along the ivy-covered Dolmabahçe Road are black-and-white
portraits of Atatürk: swimming through a crest of waves, ral-
lying a regiment of soldiers, in coat and tails looking like a mus-
cular Gary Cooper as he inspects a white blossom in his lapel.
Above the romantic portraits of Turkey's founding father, a
canopy of red and white flags flutters over the maddening traffic.

This spring, LED billboards advertise the launch of
Mehmed, a new *dizi*. At twenty-one years of age, Ottoman Sultan
Mehmed conquered Istanbul, taking Constantinople from the
Byzantines and ending their empire forever. Kenan Imirzalioglu
smolders as Mehmed on the red posters that cover every mall,
tram station, and bus stop. *Bir Cihangir Fatih*, the tagline on the
poster reads, "The conqueror of the world."

Timur Savçi sits at his desk in Levant as five TVs, all tuned
to different channels, illuminate his spacious office. In 2009,

134 Savçi, the founder of Tims, and his frequent collaborator, Meral Okay, started thinking about an epic on Sultan Suleiman the Magnificent. Okay, who died in 2012, sent Savçi three testimonials: one written in the voice of the Ottoman sultan and two others from Hurrem and Ibrahim, captured Christian slaves who would rise to the top of the sultan's court. Savçi read the testimonials at 2:00 a.m. and greenlit the project right away.

The Ottoman Empire, founded toward the end of the thirteenth century, was a truly globalized structure. In quick succession, the Ottomans—who built their reputations as *ghazi* or Turkic border warriors—captured Athens, Tabriz, Damascus, Cairo, Belgrade, and beyond. Their empire swept from Eastern Europe to the frontiers of Africa and onward to the Middle East, which they ruled for six hundred years. By the mid-1300s, they held more land in Europe than they did in Asia. In 1529, at the pinnacle of Ottoman power, Sultan Suleiman and his soldiers beat down the doors of Vienna. Though they didn't capture what would have been their entryway into Western Europe, the Ottomans laid siege to the city two more times.

Though the Ottoman Empire was more tolerant than any European kingdom or empire—they gave refuge to Jews fleeing Catholic Spain's Inquisition and protected the numerous ethnicities under their realm, including Armenians—they were still Muslims. Regardless of the fact that they were a multicultural, pluralistic power, anti-Ottoman sentiment blazed across Europe: Lord Byron famously died fighting the Ottomans in Greece and Voltaire whined about how he would "always hate the Turks." They welcomed outsiders, allowed them religious freedom (for a tax), imposed no singular language, and did not flood conquered territories with settlers. The Ottomans had no

word for "minority" in Turkish because they, as Muslims, were
the minority of their own empire. Only with the dissolution of
Ottoman power in the aftermath of World War I was Europe
transformed from a "regional backwater" to its twentieth cen-
tury superpower status.

Modern Turkey, as envisioned by Atatürk, turned its back
on its Ottoman history, humiliated by its debasement and parti-
tioning at the hands of European powers. Atatürk vowed to build
a new nation, one modeled largely on the form of its vanquishers.
Under his party's slogan, "for the people, in spite of the people,"
Atatürk set about constructing an aggressively modern, sec-
ular nation. The Caliphate was abolished, severing Turkey from
its leadership role in the Muslim world. Turkish was purged of
Arabic and Persian words, its Arabic script changed to Cyrillic.
The Georgian calendar replaced the Islamic, and the Swiss civil
code was adopted in place of Shariah (which had only applied to
Muslims anyway). From an empire built upon pluralism, Atatürk
drove modern Turkey toward a strident monoculture.

Yet it was that bygone Ottoman pluralism, that moment of
grandiose and gracious Muslim power, that *Magnificent Century*
chronicled. The head of one of the most influential production
studios in the country and the force behind *Magnificent Century*,
Savçi, an outlandishly tall man with a fresh, unlined face, smiled
widely when I told him that I had just come from Lebanon, a
formerly bitter and rebellious Ottoman colony that had fallen
prey to an unexpected wave of Ottomania thanks to his show. It
seemed as though the whole nation had been seduced by a power
they once fought to the death to expel, all thanks to his TV show.
"Yeah." Savçi nodded proudly. "But you're no longer Ottoman," I
reminded him. "Yes!" he boomed. "But we're Muslim!"

Surprisingly, this nostalgic Muslim sentimentality did not ingratiate the makers of *Magnificent Century* to the state, themselves enthusiastic proponents of Ottomanism, but had rather the opposite effect. In 2003, Turkey elected Recep Tayyip Erdoğan to lead the nation. Erdoğan's AK Parti, which he cofounded, stood from the outset for the twin pillars of justice and development but drew its heartbeat from neo-Ottomanism as well as Islamic brotherhood and identity. Before rising to power, Erdoğan sold *simit*, was a semi-professional football player, and served as the mayor of Istanbul. Though he initially assured his citizens that he was committed to secularism and EU membership, after winning nearly a dozen elections in a row and stopping a 2016 coup attempt by calling loyal supporters—whom he called the Guardians of Democracy—out on to the streets, Erdoğan's political vision for Turkey no longer follows any serious obeisance to Atatürk's ideals. On the contrary, Erdoğan has made no secret of his ambition to push the Turkish state away from its Kemalist foundations and back toward its glorious Ottoman past.

Erdoğan accused Atatürk's "language revolution" of "destroying the Turkish language" and has revived the teaching of Ottoman Turkish in schools. The ban on the veil has been relaxed—Erdoğan's own wife and daughters cover their heads and Erdoğan himself is a proudly observant Muslim who often speaks in religious tones. His government has gone further than any other in, if not apologizing for the 1915 Armenian genocide, at least acknowledging both the tragedy and the suffering of the Armenian people.*

* It's fair to say this is probably born out of a deep-seated hatred of all things Kemalist rather than a wellspring of affection for Armenians.

The self-explanatory "zero problems with neighbors" foreign policy initiative pushed by Erdoğan's government in the early 2000s has fallen by the wayside as he openly charts an Ottoman revival with himself as sultan. Turkey has played a destabilizing role in Syria where it has simultaneously funded and associated Al Qaeda–linked Syrian rebels in their fight against the Syrian state and attacked Kurdish groups at the forefront of battling Daesh. In 2018, Turkish troops entered Afrin, Syria, to cleanse the town of Kurdish fighters and promised to push on to Sinjar in Iraq, if necessary. Turkey is spending generously in order to establish itself as a worldwide power; for instance, Turkey's humanitarian aid to Sudan exceeds that given by the United Nations. After Saudi Arabia diplomatically shunned Qatar, Turkey sent military aid to the pariah nation, where it operates a military base.

Any Turk worth their salt knows what Erdoğan's foreign minister, Ahmet Davutoğlu, was alluding to when he beseeched his compatriots to reclaim their "ancient values" and "again tie Sarajevo to Damascus, Benghazi to Erzurum and to Batumi." Neither is Erdoğan himself shy of hinting that there's a new sultan in town. When he met French president Nicolas Sarkozy—a staunch opponent of Turkey's membership into the EU—in 2011, Erdoğan gifted him a letter written by Sultan Suleiman promising to help King Francis I who, in 1526, had just been imprisoned by the Holy Roman Emperor:

"I am Sultan Suleiman," the letter begins. "Sultan of Sultans, Ruler of Rulers, Earthly Shadow of Him who Crowns Sovereigns. Ruler of the Mediterranean Sea, Black Sea, Rumelia, Anatolia, Karaman, Greece, Dulkadir, Diyarbakir, Kurdistan, Azerbaijan, Damascus, Aleppo, Egypt, Mecca, Medina, Jerusalem, all the

138 Arab realms, Yemen and many other lands. You are Francis, King of France."*

Under Erdoğan's ambitious vision for a neo-Ottoman sultanate, Turkey must not only reimagine itself at home but also project its power upon the world. *Dizi,* especially one about the most beloved Ottoman sultan in history, would seem a natural accompaniment to Erdoğan's political project. Cultural pundits scrambled to position Turkish culture, in the form of *dizi,* as the firepower behind "the digital renaissance of the Ottoman empire."

But not everyone was so taken by *Magnificent Century*'s sultan and his bride, least of all Erdoğan himself. While opening a local airport, the then prime minister Recep Tayyip Erdoğan fumed that their ancestors had spent "thirty years on a horse," not larking around the harem with scantily clad birds. RTUK claimed to have received over 70,000 complaints after the show first aired. The government withdrew permission to the producers to film in historical sites such as Topkapi Palace, and Turkish Airlines pulled it from their in-flight entertainment systems in order to avoid government ire. A deputy from Erdoğan's AKP went so far as to submit a parliamentary petition to legally ban the *dizi.* But though *Magnificent Century* was never utilized by the state to project Turkish soft power out to the world, other *dizi* were.

Two more recent productions airing on TRT, Turkish state television, have the government's wholehearted endorsement, if not their guidance. The first, *Dirilis Ertuğrul,* or *Resurrection: Ertuğrul,* begins right at the start of Ottoman glory, with Ertugrul Ghazi, the father of Sultan Osman, the founder of the

* "He seemed not to have read it," Erdoğan sniffed later.

empire. The *dizi*'s tagline is "A nation's awakening," and for five
seasons and counting, viewers have watched Ertuğrul battle
crusaders, Mongols, Christian Byzantines, and more. It has the
honor of being the most popular show to air on state TV and
the only *dizi* to receive a set visit by Venezuelan president Nich-
olas Maduro, presumably a fan, who wore a Turkic hat for the
occasion. He was not the only head of state who was impressed.
"Until the lions start writing their own stories," Erdoğan said of
Ertuğrul, "their hunters will always be the heroes."

The second *dizi*, *Payitaht Abdulhamid* or *The Last Emperor*,
bookends the Ottoman obsession, based as it is on the last
powerful Ottoman sultan, Abdul Hamid II. The *dizi* aired in
2017, drawing in big numbers—every Friday one in ten tele-
vision watchers tuned in as the sultan staved off rebellions by
the Young Turks (who would eventually unseat him), scheming
European powers, separatist rebellions, and even the machina-
tions of Theodor Herzl, the father of Zionism. Both supporters
and detractors of the *dizi* pointed out that the sultan was mod-
eled incredibly closely on Erdoğan; the followers of the Turkish
president saw symbiosis between the two proud leaders who
were unafraid to confront the West and who dreamed of posi-
tioning Turkey as central to pan-Muslim unity. Critics delighted
in pointing out the two men's paranoid reliance on intelligence
services and strict, if not oppressive, grip on power.

Ece Temelkuran told me these state efforts at show business
were lacking, noting that a film about Fethullah Gulën, Erdoğan's
arch-nemesis and a shadowy spiritual leader blamed by Erdoğan
for fomenting the failed 2016 coup, was a dud, even though it was
screened for free in Turkey. "They still cannot produce culture,
which is amazing," she said, relieved. "The main reference point

140 of this political movement is obedience, so how can you be both obedient and create something culturally or artistically valid?" Regardless of which voice was being used to blend nostalgic Turkish history with entertainment, the goal has been accomplished: Neo-Ottomania is a worldwide phenomenon.

Today, Timur Savçi, who sets the tone for the *dizi* industry at large, is preparing an English adaptation of *Magnificent Century*. He isn't the least bit interested in taking American shows and adapting them to Turkish. "We are making just originals. It's better!" he says with a big laugh. The English-speaking world is the one region his *dizi*—or any *dizi*—never penetrated. It could be because America and England don't like to watch subtitled shows, Savçi muses, sitting at his spotless desk, "or it could be the fact that this is about an Islamic state at the end of the day." I ask if that's something Tims would tone down in the English version of *Magnificent Century*? Savçi, a jaunty, jovial man, shakes his head. "It's important to remember that, at the time, the Ottoman Empire was the superpower of the world. What the U.S. is now to the world is what the Ottoman was. If they look at it in this perspective, they would understand it more, but if they don't know this, they would feel threatened."

In addition, *Magnificent Century* is about a woman's journey from slavery to becoming the queen of an empire. "In no other culture in the world can you find that," Savçi says. True, but presumably making *Söz* an international success is a tougher sell? "We do want this show to be global," the mogul replies. "But right now, we're looking at format rights because not many countries are really too interested in watching Turkish soldiers be glorified." He pauses and smiles. "The U.S. always

makes shows and at the end they say 'god bless America.' Well,
god bless Turkey!"

At night, on the steep cobblestones of Galata, young men hold
informal photo shoots. A man in tight, faded jeans leans against
a wall as his professional camera-toting friend snaps away like a
private paparazzo. All around this nighttime modeling, fat stray
dogs, their ears tagged by the municipality, snooze under the
warm glow of the streetlights.

Unlike India, Turkey has no aspirations to speak the language
of global commerce and trade. Few people, even in the metrop-
olis, speak English, and recent attempts to include the language
in advertising leads to confusing, often ominous-sounding
results. At Atatürk airport, just after immigration, a big sign wel-
coming foreign real estate investment reads, somewhat menac-
ingly, "Whoever consults will never regret." On the set of *Söz*, the
fake office motto was as incomprehensibly threatening: "Your
time is under our insurance."

Though Latin *telenovelas* were a big hit in the 1990s—
Argentinian and Brazilian shows were screened for hours on
Sundays especially—high quality American television has been
watched in Turkey since the 1970s. Turkish actors, such as Mert
Firat, told me they learned all their codes from American televi-
sion shows like *Dallas* and *Dynasty*. It was where they learned to
emote and to perform the melodrama that *dizi* require. But there
was something lacking, something fundamental missing from
those early guides to how to be rich and powerful in the modern
world: values.

Kivanç Tatlıtuğ doesn't feel it's necessarily a question of
values or conservatism, but empathy. In an email interview, he

spoke to why audiences around the world are turning to *dizi* over Western productions. "Most of these audiences feel that their everyday stories are 'underexplored' by Hollywood and Europe," Tatlıtuğ wrote. "This is ultimately a matter of diversity in storytelling. I understand the appeal of a story like *Breaking Bad* or *Game of Thrones*, these are both amazing TV shows. However, some people may also feel disenfranchised from these Hollywood themes and may want to watch a story which they can empathize with."

"Disappearing family values are not concerns for the West," Eset says. We are at Kaktus, a coffee shop in Cihangir, and our hip waiter, complete with a millennial/Daesh long beard, saunters over to tell us all the coffee machines in the coffee shop are broken. "For the past four years or so, forty percent of the most watched Turkish shows have been remakes of Korean dramas," Eset says, pointing out that the Koreans have been swifter than the Turks at penetrating the Latin American market. "Korea is also a country which gives great importance to family, but in the West the romantic notion of those good old family values is gone." What percent are remakes of U.S. dramas? I ask. "None," Eset replies.

At the time we met, Eset was working with a joint Turkish-American production house, Karga 7, which has expressly global ambitions for their shows. "When I talk to people about Turkish TV series," he tells me, "mainly they are taken by this romantic notion of family where everyone is trying to cherish one another, the dangers are external, and socioeconomic classes play a great role in the love story of the poor boy loving a rich girl or vice versa. Normally a story like this in the West would be treated through an individual's journey where there is more sex, there

is more violent, there are drugs." Turkey has none of that.
He points out that the couple in *Fatmagül* don't kiss until the
fifty-eighth episode or thereabouts.

Dizi have no expiration date, Eset declared, and will easily
outrun the Brazilian *telenovelas* of the 1990s. "Because of cen-
sorship and what you can show and what you cannot, a new
language has been formed, which is a romantic language.... Bra-
zilian telenovelas didn't soften or harshen their stories. With
Turkish series, you can make them as harsh as you want. We are
telling the softest, most romantic version of the story anyway."

Chapter Nine

One can traverse the Lilliputian country of Lebanon in an afternoon, driving from the southern Hezbollah stronghold—where the country's most beautiful beaches are found, free and open to the public, some shacks selling beer with fried fish, others only nonalcoholic drinks—past Beirut with its mishmash of rundown neighborhoods and hip enclaves, all the way to the north. You can get to the Syrian refugee camps in Akkar, nearly two hundred kilometers away from the capital, in two hours if you are driving like a Lebanese. (If you're driving like a normal human being, maybe three and a half hours.)

Since the Syrian civil war erupted in 2011, an estimated 1.5 million Syrians fled to neighboring Lebanon, nearly half of them settling in the northern hamlet of Akkar, close to the Syrian border. Today, this small Mediterranean country has the largest per capita refugee population in the world. In Akkar, blue road signs point toward Syria, reading as a warning rather than a direction. Dollar stores—one whose unfortunate banner reads 1$1$—and cheap hardware shops are brief respites from

stretches of no-man's-land and crumbling Crusader-era cas-
tles nestled in north Lebanon's green valleys. If you drive slowly,
every so often the spaces between the garages and hardware
shops part and you catch a glimpse of the turquoise-blue sea.

Sheikh Abdo, Al Ihsan's community leader, fled his home
in Homs six years ago. He and another thirty-seven fami
lies arrived in Lebanon with nothing—no money, no phones,
nothing—and built the camp themselves. The Al Ihsan refugee
camp in Akkar was originally a garbage dump. They asked the
municipality if they could have the land; they cleaned it, dug
for water, poured cement on the ground, and put up electricity
lines. Just before the camp was fully constructed, in late 2011,
Asma Abu Izzedine Rasamny was visiting Akkar with donations
for the newly arrived refugees. Rasamny, who is half-Syrian
and half-Lebanese, had no background in social work or edu-
cation. She studied psychology in university but had spent her
childhood in Damascus. She was a young mother to small chil-
dren, and after hearing about the flood of refugees arriving in
the north, felt compelled to do something, anything, to help.
Rasamny called up friends, other Syrians who had moved to
Beirut, and together they pooled enough money to pack a van
with milk and diapers. When she arrived in the camp, it was
Sheikh Abdo who helped Rasamny distribute the goods. They
had never met before but Sheikh Abdo knew the refugees, he
knew which families were in dire need, and which mothers had
hungry babies. He moved Rasamny through the camp, making
sure she made all the right stops in the community. Afterward,
he invited her to his home for a cup of tea.

All the families in Al Ihsan were living in plastic tents then,
surrounded by open sewage. The children were ill; they had

146 visible skin infections and rashes, as well as stomach ailments.
The scale of poverty Rasamny saw was unlike anything she
had seen before. But in the middle of all that despair and des-
titution was one standing structure with a roof and four walls:
a classroom. It had been constructed and kept with a meticu-
lous, almost reverential, care absent in the rest of the camp. A
donation of $400 had built it, Sheikh Abdo told Rasamny. "But
isn't it more important to clear the sewage?" she remembers
asking him. "Isn't it more important to make sure there's clean,
running water?" But Sheikh Abdo shook his head. No, he told
Rasamny. "As long as we have a classroom in every camp," he told
her, "we have hope."

"The kids had no toys, so they'd pick up sticks and make
guns," Sheikh Abdo tells me as we sit barefoot on the floor of his
home, constructed from plywood and concrete. "All the games
were about war, about fighting, with bad language. We needed
the school for this reason. We were trying to teach them not
to speak in a violent way, not to fight." The Malaak Academic
Center in Akkar, set up by Rasamny right next to the Al Ihsan
camp, holds classes teaching math and science, arts and crafts,
Arabic, French, and English from preschool to the eighth grade.
All the rooms are built from plywood and provide a safe space
for up to 350 students. There is a kitchen garden, a music room,
and a computer zone. Malaak, which means "angel" in Arabic,
survives on donations. It has a staff of ten local teachers assisted
by a group of German and Portuguese volunteers.

The day I visit, a Syrian family from America has come
to give gifts of dolls and candy to the children. Their bronzed,
sculpted physiques are in sad contrast to their hosts, who pos-
sess the small bodies of children, thin arms and tiny wrists, but

the haggard, hollow faces of adults. The eyes of the refugee children are heavy and burdened. The children see you wanting to feel better about their suffering but know, as you do, that they will have no actual relief from your visit. It only serves to make you, the visitor, feel better. They gather quietly at first, standing in front of Malaak's brightly painted walls and heart-shaped graffiti but as they receive their gifts a certain anxiety builds, both in the suntanned family who are struck by the poverty in front of them and in the children who cannot believe this is all they are entitled to after their young lifetimes of suffering.

In the Malaak kitchen, twenty-three-year-old Fatima and Muna, who is double her age, prepare a lunch of macaroni and yogurt. Fatima has pale white skin she takes care to shield from the sun, and she covers her hair with an elegant patterned hijab. She misses everything about Syria, she tells me, especially her home. She survives on memories of her family, gathering at night in front of the television. "I watch Noor and Muhannad here too," she says, using the Arabic names for two Turkish *dizi* actors, Songül Öden and Kivanç Tatlıtuğ, "and it brings me back home." When I meet them, the women are watching *Kösem*, a historical drama based on a powerful concubine who ruled the Ottoman Empire as regent.

Fatima rests against the steel table in her green dress, white socks, and petite black heels as she cooks. "I like that they're long, they never end. Our Syrian shows end in one month, but the Turkish ones go on and on." She smiles shyly. "I feel like I live with them." She is especially fond of the way they handle matters of class. "That a girl from high class society falls in love with a man from a poor background and loves him anyway because she is humble." She blushes and lowers her eyes.

Muna likes the Turkish *masalsalat,* or shows, as much as the next person, but she attempts to lodge a brief vote of support for Syria's dramas, which had once been the most sophisticated in the Arab world. "Before the war we had shows that used to talk about love," Fatima concedes, becoming animated. "But afterward, it was only shows about cheating, about a girl who takes her friend's lover." She straightens up and smooths down her dress. "After the war, the couples would have conflict and they'd never find solutions. I didn't like it." Fatima turns back to the macaroni, little yellow commas floating in yogurt. "It was upsetting to watch."

Before the war, Syria produced quality television dramas, but ever since the 1950s Egypt had been the undisputed cultural mecca of the Arabic-speaking world. However, television only started to gain influence later, in the 1970s. Until then, it was radio that most easily carried mass culture across the region. And the power of the medium was concentrated on the rise and fall of one woman's voice: Umm Kulthum. She sang passionate Arabic ballads, standing on a stage for hours, her eyes closed and her voice quivering, a handkerchief held tightly in hand. People said the cloth was doused in opium, which Umm Kulthum sniffed as she sang long beyond what a mortal voice could endure. The songstress wore her thick black hair piled in a voluminous bun on the crown of her head: They called her the Star of the Orient.

Every Thursday night, the start of the weekend in the Middle East, Umm Kulthum was broadcast over the airwaves and entire families would gather around the radio to listen. Umm Kulthum was vital in spreading Arab nationalism as the Egyptian president Gamal Abdel Nasser, who seized power in

the early 1950s, timed his radio addresses right after her weekly concerts. She sang to the mood of the nation, before the 1967 war with Israel, and after its crushing defeat. Her rousing songs were twice made national anthems. With her on the radio, Egypt was the unchallenged cultural power of the Arab world.

No more. Egypt, economically crippled and culturally denuded by despotism, has lost its footing. TV has replaced radio and the Egyptian songbird has been unseated by a cast of hunky Turkish actors and doe-eyed heroines.

In Akkar, two floor fans have been switched on, blowing a gentle breeze of warm air across Sheikh Abdo's makeshift home. "For the young and the old, these shows are a link to our past," he explains, drawing an Elegance Super Slim cigarette out of its pack and lighting it. They are a reminder of what the refugees once had the good fortune to experience before fate brought them here, to this converted garbage dump cum camp: family, love, bonds of brotherhood, and friendship.

Khadija, a mother of seven, clad in a long, regal purple caftan, has been in Al Ihsan five years. She and her family had left the only home she ever knew, Homs, and were shuttled across four cities by the Red Cross before being settled in Akkar. Her husband worked in construction in Syria but was unemployed here, even though there was so much building that needed to be done. Her five sons lived in constant fear of being picked up by the Lebanese army. They don't have the right papers and are illegals in Lebanon. When they try to work, they get caught and arrested. The Lebanese army and police eventually let them go, Khadija said, but it scares the women so much. The men get sick in jail—it's so filthy there, so unhygienic. And the women, they

150 get sick after, from mental illness. While we spoke, out on the
 dirt road, a bus with a white decal of Jesus in profile on its back
 window, wearing a crown of thorns and a tear in his eye, drove
 by. As it ground past the narrow space between the camp and the
 world, a cloud of dust lifted up from the earth. "Jesus save u," the
 decal said to no one in particular.

 "I watch all the shows," Khadija told me emphatically,
 pressing her hands on my knees as we sat together on thinly
 stuffed, misshapen cushions. "I watch them for the stories—
 love, defending love, defending each other. That's what I like."
 Her long hair was tied back into a bun and her face glowed as she
 spoke about the *dizi*. "It takes me away from here. I'm living in
 war. I want to watch romance."

 Sheikh Abdo must be in his early forties. He is too young
 to be called sheikh but was given the honorific in appreciation
 of everything he's done for the displaced in the Al Ihsan camp.
 He inhales deeply from his slender cigarette, running a hand
 across his white stubble as he does so. "All of them watch the
 shows here too. There's nothing to do at night except to watch
 TV." This small community of Syrian refugees has been in Leb-
 anon since the start of the Syrian war, Sheikh Abdo says sadly,
 and they'll stay until there's a solution.

 The roof over our head is made of thin, silvery sheeting
 and the home is bare except for one luxury item: a fridge in
 the corner, which hums audibly as we speak. Sheikh Abdo is
 not exactly a fan of Turkish television programs—he wants to
 make this clear to me. All that tension? It's too much, Shekih
 Abdo says dismissively, too much gossip and intrigue and sus-
 pense. Who can tolerate two hours of that every night? He was
 a teacher and social worker before the war and it is purely in

this anthropological regard that he might join his fellow exiles in watching an episode or two.

In the early days of the war, people were obsessed with the news in the camps. At 4:00 a.m., sometimes Sheikh Abdo would walk outside his brick and silver sheet home and see young men, teenagers, kids even, outside on the dirt roads, pacing up and down in the dark, scouring their mobiles for news of home. "They'd tell me so and so killed so and so, this guy blew himself up. They're ten years old but they knew what was happening in Halab [Homs]. They knew who was a *shaheed* and who was alive, still fighting."

"It's less intense now." He shrugs, exhaling a thin plume of smoke. "Some of those youngsters have figured out that the news is nothing but lies." Seven years of war have taught the refugees that there's no hope to be found in breaking news. "Put on the shows," those same boys say now, Sheikh Abdo recounts. "Let's remember home. Let's remember Syria." But he doesn't join them, he reminds me. "I don't want to watch the shows," he says. "It's not home, it's Turkey."

"But it's better than the news?" I venture. Sheikh Abdo's phone lights up with a WhatsApp call: It's been buzzing since we sat down. He glances at the screen for a moment, his brow furrowing before he looks back at me. "Of course," he replies. "But it's still stress."

It is evening and the azan from a nearby mosque is being sung. From my Beirut hotel I can see a neon yellow sign of the cross in the gloaming, as though hanging from the sky. Below, a heavyset man with a coffee cup sits on the back steps of Monastere St. Antoine le Grand. From the balcony I can see only that his head

152 is bent. As he lifts a hand, there is a spark of fire and he lights a cigarette, pulling from it. I can see the cherry glow. Just as the azan fades to a close, church bells are rung.

Fadi Ismail is the general manager of Middle East Broadcasting Center's subsidiary, O3 Productions, and the person responsible for bringing Turkish television to the Middle East. "To brag a bit," Ismail corrects me with a laugh, "I'm the one who opened Turkish culture through TV to the whole world." MBC is the Middle East's biggest broadcaster and first satellite free-to-air channel to run a twenty-four-hour drama network for the Arab world. They operate throughout the MENA region, home to almost 400 million people. MBC has a news channel, a children's channel, a women's channel, a Bollywood channel, and a twenty-four-hour drama channel where they broadcast Egyptian soaps, Latin American *telenovelas*—when I speak to Ismail, they have just started importing Korean dramas to the Arab world—and *dizi*.

In 2007, Ismail went to a buyer's cinema festival in Turkey and chanced upon a tiny kiosk showing a local television series. "I stopped and watched it, not understanding anything going on," he remembers. "But immediately I could visualize it as Arabic content. I replaced it in my mind with Arabic audio and everything else looked culturally, socially, even the taste of the food, the taste of the clothes, everything for me looked like *us* and I thought, ah eureka!" *Dizi* had never left home turf before nor, Ismail says, did the producers expect it to. The TV producers hadn't even printed a leaflet for buyers.

Ismail bought a Turkish series for his channel. It was a beautiful story set around a Turkish political development in the 1960s, and while it didn't launch as a runaway success in the

Arab world, it whetted the appetite of a region. Ismail doesn't remember the name of that first show because they had already hit on the formula of giving everything—the title, the characters—new Arabic names. "At the end of the day, every one of these titles had the word 'love' in it, so I stopped differentiating. They're all love, love, love. Love Something, Blue Love, Long Love, Short Love, Killing Love." It was their next show, *Noor*, starring the infamous Muhannad, that broke the Middle East. That show, Ismail says, captured a gap in the drama market that no one since has managed to wrest away.

Though the Egyptians had traditionally been known for their cinema, they also dominated television sets across MENA until Syria took over in the 1990s. Syrian actors were renowned for their dramatic and comedic skills. Their directors were artistes. Talented scriptwriters produced shows of quality with substantial state help. The government poured money into the television industry, providing auteurs with cameras, equipment, state subsidies, and permission to film in Syria's historic sites. But then the war broke out and the country's bright promise flickered. It was at this moment, Ismail says, that the Turks were ready to move in.

But it was because Syrian dramas had already become a "pan-Arab phenomenon" that MBC decided to dub all the Turkish dramas they bought into the Syrian Arabic dialect. "That is one of the reasons of their huge success," Ismail concludes. "We dubbed the Turkish dramas with the most prevalent and established drama accent: Syrian." Before Turkish dramas flooded Middle Eastern screens, people in Lebanon watched Mexican and Brazilian *telenovelas*. Though they were popular, they eventually ran out of steam for two reasons. The

154 first was language. *Telenovelas* were dubbed into Modern Standard Arabic, or *fusha*, a standardized literary Arabic understood from Iraq to Sudan and used in newspapers, magazines, and newscasts. Free from local accents and slang particular to each country, *fusha* is a formal, classical Arabic.

Second was a question of values. "The Mexicans really did not resemble us, not at all," says Imane Mezher, the Format Distribution and Licensing Coordinator of iMagic. iMagic operates the Middle East's franchise of format television hits like *X Factor*, and experiments with new formats like the World Belly Dance Championship and an Islamically approved *Extreme Makeover* where contestants don't alter God's design out of vanity but have reconstructive surgery on life-threatening issues. Mezher shakes her head at the memory of the *telenovelas*. "You have a daughter and you don't know who her father is, you don't know who the mother is. The stories were moral-free. . . . At the end of the day, like it or not, we like things to be a little more conservative. The Turks are amazing at that. They are the real mix between European freedom that everyone longs for, and at the same time the problems are conservative, the same we face. The people have the same names as us, the same stories as us, and people love that."

Elias el Haddad is drinking 961, an artisanal pale ale brewed with Lebanese herbs and spices and named after the country's area code. He emits socially conscious/international millennial style from the offset—rimmed eyeglasses, a shock of unruly hair, and tailored jeans—and sits at a long communal table at Urbanista in Gemmayze, his sleek Apple laptop open in front of him. After studying business and design in Europe for ten years, thirty-five-year-old Haddad returned home to Beirut. When he

came back to Lebanon, Elias tells me, he was shocked by how
completely overwhelmed by the West his compatriots were.

"The Americans have been conquering us with Mickey
Mouse for one century and a half." He complains, speaking in
a French-Arabic-English patois. "They sell Mickey Mouse on
mugs, on T-shirts, everywhere, on TV, in films. It's not even a
myth or something, it's just something one person drew."

Lebanon may be a small country with a population pushing
6 million, 1.5 million of whom are Syrian refugees, but it has
long cherished its reputation as the intellectual hub of the
Middle East. The first printing press in the Arab world was here.
More newspapers and periodicals were printed in Beirut than
any other Middle Eastern city in the nineteenth century (even
as late as the 1970s this was still true) and as such it was fer-
tile ground for the development of Arab nationalism. As early as
1909, a Beirut women's magazine compared "the despotism of
the husband to the despotism of the Sultan." But a wave of wars
and occupations have dented the city's once esteemed reputa-
tion as the Paris of the Middle East (alternatively, the Switzer-
land of the Arab world), and among the strange consequences
of this dethronement is that a class of people—such as Elias, a
cosmopolitan Western-educated, French-speaking elite—that
would never have watched non-Western films and television
have taken not just solace, but refuge in *dizi*.

Haddad launched Boshies, a "neo-oriental," unisex brand
conceptualized specifically to go global. Boshies comes from
tarboosh, the Arabic word for the Ottoman Fez, and Haddad
chose it because he believes it's the only positive common
denominator between all Arabs and "Orientals." A great deal of
the excitement about Turkish *dizi*, the mania over the costumes

in *Magnificent Century* and Hurrem's jewelry knockoffs, which are sold in boutiques across the Middle East, is not so much an adoration of Turkish *dizi* but a defense of culture. "We are the best storytellers, no?" Haddad exclaims. "The *1001 Nights* comes from this region . . . modernity is not a European value, not a Western value. We can all be modern. We buy products from the West because they're the most powerful economically, but it doesn't mean we can't act in a modern way, be Lebanese, and keep our traditions. You can do both. You can be young in 2017 and stay Lebanese, stay Arab."

At 1:00 a.m., Saudi Arabian time on March 2, 2018, MBC took *dizi* off the air. Six *dizi* were pulled, costing MBC $25 million in losses. "There is a decision to remove all Turkish drama off several TV outlets in the region," the channel's spokesman said. "I can't confirm who took the decision."

MBC was founded in 1991 by Waleed Bin Ibrahim al Ibrahim, a Saudi businessman whose sister was married to a former king. Both he and his partner, Saleh Kamel, were among those locked up in the Riyadh Ritz-Carlton by the kingdom's crown prince, Mohammad Bin Salman, during his so-called "anti-corruption" shakedown. The thirty-four-year-old crown prince—whose pet projects include, but are not limited to, obliterating Yemen, the poorest country in the region, eroding Iranian influence in the Muslim world, and murderously silencing his critics—had been in negotiations to buy MBC since 2015 but found Waleed's $3 billion asking price too high.

In November 2017, MBS, as he is known, arrested most of MBC's board and shareholders in what was billed as a corruption sweep, or as the *New York Times* put it, "the sellers had been

detained by the buyer."* After an eighty-three-day stay in luxury
jail, Waleed was released and his company had a secret new
majority owner, whose first order of business was to cancel all of
MBC's *dizi* programming. Before the crown prince's caprice, the
MENA region accounted for the largest international consump-
tion of *dizis*. *Magnificent Century* was advertised alongside *Game
of Thrones* and *Oprah* in Dubai, Ece Yörenç—*Fatmagül's* script-
writer—was asked by Saudi Arabia to write TV series for their
local channels, and rumors circulated of princes and politicians
inquiring after show spoilers during state visits to Turkey.

Unfortunately, Turkish soft power wasn't the only thing
to have irked the young prince. MBS was infuriated by Tur-
key's brazen flouting of his 2017 blockade of Qatar. The Saudis
"say we will return to moderate Islam, but they still don't give
women the right to drive," Erdoğan taunted the crown prince in
a speech.† "Islam cannot be 'moderate' or 'not moderate.' Islam
can only be one thing . . . perhaps the person voicing this con-
cept thinks it belongs to him. No, it does not belong to you." In
retaliation best described as in the "NO YOU ARE" vein, MBS
accused Erdoğan of trying to build a new "Ottoman Caliphate,"
included Turkey in what he bizarrely called a "triangle of evil,"
and swiftly erased *dizis* from Middle Eastern TV.††

* Lebanese prime minister Saad Hariri was also, in the weirdest incident in
 twenty-first century geopolitics, forced to resign on television and held
 incommunicado in Saudi Arabia for two weeks around the same time.
† Saudi Arabia allowed women to drive for the first time in June 2018. They
 were denied the right to vote till 2015 and continue to live under an oppres-
 sive guardianship law whereby they cannot eat alone at restaurants, divorce,
 or claim custody of their children. It should be noted that slavery was only
 formally banned in the kingdom in 1962.
†† Presumably more terrifying than a "square of terror" or "circle of bad things."

The Turkish government's goals of *dizi* world domination carry on regardless: By 2023, they hope to pull in $1 billion from exports. Sipping sparkling water with pomegranate seeds dancing amid the bubbles, in his Istanbul glass office, Izzet Pinto, the founder of *dizi* distributor Global Agency, told me that $500 million is a more realistic target given the loss of the Middle East market. Figures are confidential in Turkey and no one will disclose numbers but Pinto estimates the MBC decision will affect the business by only about 15 percent. "Of course it's a serious number," he sighs, flicking some invisible dust off his gray suit lapel, "but we can survive without it." Pinto foresees that selling remake rights, expansion in Latin America, and the opening of Western Europe, notably Italy and Spain, will balance everything out.

Ay Yapim, GHQ of beloved *dizi* like *Çukur, Gümüs, Ezel,* and others, wasn't thrilled by the Saudi decision either, but expects a digital future for the Middle East. Because they sell to MENA, they geo-block YouTube from uploading the episodes, but will likely relax on that front. And over at Tims, Selin Arat predicts that Turkish series have reached a level now where they will not go down—they may not go up much, either, but they've created their own appetite in the world. "Yes, it will be sad," Arat conceded of the Saudi blockade. "But it won't be the end of the Turkish *dizi* invasion."

But even before the cancellation of Turkish *dizi* in the Middle East, in the summer of 2017 it seemed as though the Turkish cultural tide, like all the others that came before, was in danger of receding.

Mohannad Mahmoud is standing in a kitchen, making sweet Turkish coffee on a small stove. "Dubbing happens mainly in Lebanon, Syria, and Jordan because the accent is neutral and you have a lot of university graduates in acting and theatre studies." Mahmoud stirs the coffee before it boils. He is of an indeterminate age, youthful in a yellow polo shirt and elegant salt and pepper hair. The Mahmoud family are Palestinian from the mixed Muslim-Christian town of Tarshiha, but Mohannad's father was born in a Lebanese refugee camp and he in Abu Dhabi. Racti, a family business, has kept the Mahmouds in dubbing and subtitling for the last fifteen years.

It's late in the morning, and while we sit down to have thimbles of thick, spiced coffee, the voice talents are already at work in the studios next door. A lot of the dubbing was done in Syria, Mahmoud says, and carried on during the early onset of the war. "But if they were doing twenty soap operas a month before, then they were doing only three. And I think at some point the government put some restrictions on soap operas—on everything Turkish because of Turkey's political stance." The closest place for Syrian voice talents to go was Beirut, and many of them decamped here to carry on with their work.

Racti used to dub Mexican *telenovelas* back during the Latin craze. The money was good—about $2,700 an episode—but the flood of *dizi* today means that a boutique studio like Racti would only get $800 an episode to do the same work. "For soap operas you need at least ten to fifteen voice-over talents," Mahmoud explains, "cuz it's not a documentary about stem cells where you can have one talent do six of the voice-overs." Add in the costs of translation, "preparing" the show—which is the voice

160 version of casting—recording, overlaying the soundtrack onto
the new Arabic voice track, and $800 looks pretty thin. And this
in a market where there's plenty of money to go around. In *dizi*'s
early days, Middle East broadcasters typically paid less than
$50,000 an episode, a number that hit half a million dollars at
the height of *Magnificent Century* hysteria.

The voice talent, dubbing episode 182 of *Supercars* next
door, steps out of the studio. He has a shaved head and the
tanned glow that seems to be Lebanese standard issue. He can
do a Syrian accent when required for *dizi* dubbing, which he
promptly demonstrates while noting that the Turkish wave is
over. The new big thing are Korean soap operas. That's true,
Mahmoud confirms; though Racti has done Arabic subtitling on
Turkish series for Netflix, they're doing a lot of Korean shows at
the moment.

Voice-over talents are a pool of approximately sixty free-
lancers in Lebanon, and Rania Mroueh happens to be one of the
best. She's acted in over twenty Lebanese series, has dubbed Ira-
nian, Spanish, Mexican, Russian, and Brazilian series and even
a hit Bollywood film where she played the voice of a young boy,
but not any *dizi*. "There's a part of it that's *moda*," she says some-
what dismissively, moving her thick, wavy hair away from her
face and setting down a heavy handbag, tucking away car keys
and phone as she sits down. "Dubbing is now a source of money."
Mroueh shrugs, adding that she has no interest in being part of
any *dizi dublage* and would only do it if it was something spe-
cial, something exceptional. But for Mroueh, Turkish cultural
imperialism has proved to be no different than the American
version. It conceals its aims with talk of values and morality, but
one only has to look out into the wider world to know that there

is nothing innocent about soft power. Resistance to *dizi* may be slow to gain momentum but the people will eventually gather and Mroueh will be there, standing at the front of the barricades.

The Turks, like their ancestors, are behemoths, bulldozing everything in their path, she explains. Everyone else has been hoodwinked into watching their series because they're dubbed so well into Arabic it lulls them into believing the shows are actually their own, but Rania Mroueh is not fooled. She sees them. She knows what they're doing. "There's a three-hundred-year gap and people say, 'Normally I hate Ottoman but this stuff now looks pretty!'" Mroueh huffs. "There's a lot of people who like the good looks; it doesn't matter who's inside. I don't like malls. I like to go to a regular shop where there's a man who's been working all his life." Outside, the streets are covered with posters of Gamal Abdel Nasser, and a man selling salted corn from a cart shouts his wares out to the street. "Modernism is eating up all the small people and making big companies profit more," Mroueh continues angrily. "All this good looking and modern, it's suspicious for me. I don't like it. It eats culture. It eats up history."

Fadi Ismail, the man who kicked it all off in the first place, would seem to agree. "Today I am trying to do what the Turks have done but through the Arab media . . . trying to go beyond the Arab border. I don't think we are less capable." Arab dramas, he insists, are "shaking" the Turks. And why not? Why isn't it possible to do what the *dizi* have done? "Today's culture isn't under the influence of one trend—the American trend—anymore," Ismail concludes. The American century is over. And what do the Turks have that's so special? Okay, in the next three, four years, not much will change, "but beyond that, everything changes."

Epilogue

"It's not our vision to make a single artist earn a huge amount of money or to achieve the Korean invasion but to make people in the world receive Korean culture without resistance."

—Shin Hyung-kwan, *CJ Entertainment*

The line between North and South Korea is one of the most militarized borders in the world, buffeted by armies at full battle readiness. Landmines, armed guard posts, and electrical fences surround the Demilitarized Zone (DMZ). North Korea has launched incursions, infiltrations, and raids, but South Korea has terrorized the North with a unique weapon of their own: K-pop.

Both Koreas maintain speakers across the 240-kilometer-long buffer, but South Korea's are more technologically advanced and can be heard as far away as 10 kilometers in the day and 24 kilometers at night. In 2015, after North Korea claimed to have tested a hydrogen bomb, the South turned their speakers up high. "We have selected a diverse range of the most recent pop hits to make it interesting," a defense ministry official announced, noting that the music—including Big Bang's "Bang Bang Bang" and Apink's "Let Us Just Love"—was not designed to annoy North Koreans, but to pique their interest in "Korean

cool." North Korea called it "an act of war" and threatened to
blow up all the speakers.

K-pop has the unique power of simultaneously threatening
apocalypse on the Asian peninsula and fostering peace initia-
tives between North and South, technically still at war since the
1950 conflict was ended with a cease-fire rather than a peace
treaty. At the opening ceremony of the Pyeongchang Winter
Olympics, North and South marched under one banner to
upbeat, bubbly K-pop. In April 2018, Kim Jong Un became the
first Northern leader to attend a K-pop concert and professed to
be "deeply moved" by the experience.

But before there was K-pop diplomacy, it was *Hallyu*, or
the Korean Wave, that swept past South Korea's borders with
expansive, military precision. In the past decade, the southern
peninsula has been pronounced the first non-Western country
to "meaningfully export almost all its cultural forms" across the
world. As early as 2008, the value of Korea's cultural exports
surpassed their cultural imports. Korean films competed at
Cannes, K-dramas were dubbed into indigenous languages like
Guarani and have captured 86 percent of television viewership
in Iran, and K-video games* are responsible for bringing Korea
1,200 percent more revenue than K-pop does (and global K-pop
sales pull in $5 billion a year).

Unlike Indian and Turkish pop culture, Korea's is a bait and
switch. In many ways, K-culture is little more than American
culture repurposed. To call Korea Americanized is putting it
lightly. The president's house is called The Blue House, the local

* When in doubt, just put a K in front of whatever product you are talking
about.

164 secret service the KCIA,* fried chicken and beer is the national
 fast food, basketball is played at election campaign rallies, and
 on the spotless streets of Itaewon in Seoul, buzz-cut marines
 can still be found stepping off base for a Frappuccino.

 For the uninitiated, K-pop sounds like something you've
 heard, and vaguely liked, before. Described as "post-disco"-
 EDM-bubble-gum-earworm pop, it's the kind of music you
 might play in an interrogation cell to induce talking except for
 the irritating fact that it's genuinely catchy and happy. That it's
 sung in a completely foreign tongue doesn't stop anyone from
 singing along, due to the fact that Korean, like English, is syllabic
 and doesn't have the heavy intonations and stresses of Man-
 darin or Japanese. Svengalis built the industry from the bottom
 up and with a distinct gaze toward the world and so made sure
 that, though Korean chord progressions are faster than English
 language pop (which is what makes it dancier), there is a stra-
 tegic smattering of English phrases to keep listeners satisfied.
 The billions of fans who galloped along to "Gangnam Style"
 might not have noticed that the song only has two English lines:
 "Hey sexy lady" and "Gangnam Style."

 Thanks to global connectivity, K-pop is hemmed in by no
 borders. In 2016, K-pop music videos, known for being slickly
 produced with industrially precise and cool dance choreog-
 raphy, were watched 24 billion times on YouTube, with 80
 percent of the views coming from outside South Korea. In You-
 Tube's top ten list of videos with the largest number of views
 in twenty-four hours, six belong to K-pop bands. YouTube was

 * See?

famously forced to upgrade its counter when 2012's "Gangnam Style" became the first video in history to hit over one billion views. Spotify and Apple Music have K-pop channels—more than a quarter of Spotify's 2017 K-pop streams come from North America—and sold out K-Cons, or K-pop conventions, have been held in Abu Dhabi, Mexico City, and Paris.

In May 2018, BTS—their name stands for Bangtan Boys (or "Bullet Proof Boy Scouts" in Korean though they've recently amended its English acronym to stand for "Beyond the Scene")— became the first K-pop group to top the *Billboard* 100 charts. Already the most tweeted-about celebrities of 2017 and Guinness World Record holders for most Twitter engagements in the world, the seven-member boy-band's *Love Yourself: Tear* became the first album sung in a non-English language to top American charts in twelve years. Consider also that BTS began 2018 as number one on iTunes in over sixty-five countries, just over a third of the world. They were also the first K-Pop band to address the United Nations and beat out Justin Bieber to win the *Billboard* Social Artists of the Year Award.

"We are preparing for the next biggest market in the world," declared Lee Soo Man, the founder of SM Entertainment and titan of the industry, nearly a decade ago. "And the goal is to produce the biggest stars in the world."

K-pop, more than Bollywood or *dizi*, is a perfect storm of colonial history, heavily Americanized culture, and neo-liberalism. In the mid-1960s, South Korea had a lower per capita GDP than Ghana and North Korea—it wasn't until the 1970s that they slowly crept past their Northern neighbors on any meaningful

166 indicators—and were among the four largest debtors in the
world.* Isolated and with no arable land or natural resources to
speak of, unless you count ginseng, South Korea's rise to cul-
tural imperialists was surprisingly swift and methodical.

Known as the Hermit Kingdom, the Korean Peninsula was
invaded more than four hundred times in its history and spent
hundreds of years under Chinese and Japanese influence. With
that knockout rate, they were understandably wary of outsiders
and adopted a severe isolationist policy. In 1832, they turned
away the mercenary East India Company who landed on their
shores on the grounds that foreign commerce violated Korean
law. When the Americans sent their own merchant ship thirty
years later, the Koreans burned it to a crisp and killed all its crew.

In 1910, Korea was annexed by Japan, the Korean language
was banned, and the peninsula was subsumed by Japanese cul-
ture and traditions. The Japanese went so far as to censor local
music, promoting choral songs in their place. Christian mis-
sionaries had already taught the locals, mainly women, to sing
in ensembles. Western music was so familiar that in the late
nineteenth century, the Korean national anthem was sung to the
melody of "Auld Lang Syne" and changed only after liberation
from Japan in 1948.

Overnight, Japanese imperialism was unseated and
replaced by American occupation. The Americans unilaterally
partitioned the peninsula and randomly chose the thirty-eighth
parallel as the border between North and South, though it had

* One might even say North Korea was ahead of the South in appreciating
the value of cultural soft power: In 1978, Kim Jong Il famously kidnapped a
highly regarded Southern film director, Shin Sang-ok, along with his actress
ex-wife, so that they could make propaganda films for his Juche revolution.

no local significance. From 1945—48, the Americans ran a "full
military government" and billions of dollars from the U.S. trea-
sury were poured into creating an anti-communist bulwark out
of the South.

Traditionally, the international language of pop music has
been English. While every nation has its own music industry,
exempting one-hit wonders, popular music of the last cen-
tury has been "national music." K-pop didn't trample bor-
ders because it was more musically sophisticated than anyone
else's music but due to its curious beginnings, born out of
neo-liberalism and the shock waves of the 1997 Asian financial
crisis.*

Before the 1997 economic meltdown, known as the IMF
Crisis in Korea, the entertainment industry made no effort to
export its cultural products. It was forced to shill its wares only
after 1997 as Korea's export-heavy economy scrambled to make
up for lost revenues. With no valuable resources or agricultural
land and unable to pursue aggressive military technology due
to their 1953 Mutual Defense Treaty with North America, the
Korean economic model was overly reliant on exports. Korea
industrialized its economy not by innovation but by large-scale
assemblage and shipping-it-out-age. Chaebols, or industrial

* Consider the following samples, which range from AKMU's "Dinosaur":
Dinosaur! oooh hooo ooh hoo/Dinosaur! Oooh hooo oooh hoo or G-Dragon's
"Crayon": *swag . . . black . . . crack/Get your crayon! Get your crayon! Get your
crayon!* To this odd BTS number called "War of Hormones," sung in Korean:
*My testosterone heavily shows up/After winning a war of hormones/I'll do some
research, your existence is against the rules . . . If the standard of beauty is in the
ocean, you're the Seriously Sea/A mini cultural asset that should be taken care of
on a national level.*

168 behemoths like Samsung and Hyundai, had been the prized white elephants of the Korean economy and they were badly battered by the crisis. Once again, the Americans were responsible—when they didn't use tanks, they used banks; throughout the 1980s, American neo-liberal reforms pried open domestic markets around the world, flooding cultural markets with Western products, companies, and competition. Korea was no exception.

The 1997 crisis kicked off in Thailand when high interest rates and weak financial institutions caused the baht to collapse. The currency catastrophe spread like a virus across East Asia, hitting Korea and causing the won's value to nosedive. Korea's IMF bailout was the largest ever given at that point, $57 billion, which included IMF classics like lifting the foreign investment ceiling and "creating flexibilities in the labor market"(translation: firing thousands of workers). The trauma of the IMF crisis made clear Korea's costly dependence on large corporations and triggered an overwhelming national shame.* For Korea to recover it would have to totally reimagine its economy and shift its national focus to something new. President Kim Dae-jung chose pop culture.

Pop culture required no organizational infrastructure— only talent, time, and training. Dae-jung was intrigued by the vast revenues North America drew from Hollywood and Britain from its stage musicals and so began to realign Korea's export obsession from heavy industry to information technology and

* The day the IMF loan was signed is officially known as the "Day of National Humility."

culture. Even with a relatively large population of around 46
million at the time, Korea's market size was too small for pop
culture to be profitable. In order for their wounded economy to
thrive, they would have to export their culture ruthlessly, just as
they had done with cars and electronics.

The government set up creative agencies within their min-
istries, funding them with millions, tied Hallyu to diplomacy,
issuing manuals on how to penetrate geographic regions (i.e.,
don't put dramas on Middle Eastern TV during prayer times),
built mega concert arenas, and wired the entire nation with
broadband internet as early as 1994, understanding that the
spread of culture on a global scale would require seamless con-
nectivity. By 2014, South Korea had laid down internet connec-
tions two hundred times faster than the average connection in
North America. As a result, phone etiquette in Seoul is nil. On
the drive to Incheon airport, my taxi driver alternated between
watching a live baseball game, mapping out speed radars in order
to break them one by one, and texting all his living relatives. The
pause we mere mortals are tortured with when opening files or
loading pages just doesn't exist in Korea.

Outwardly, they didn't seem that keen on their own pop
industry either. I imagined I would be greeted by throbbing
disco pop upon arrival, but the only place I heard K-pop in Seoul
was in my hotel room. The city was oddly quiet. On the subway,
locals held mini electronic fans in front of their faces like micro-
phones, but no one sang. The Third Infiltration Tunnel at the
DMZ pumped drippy elevator music through the underground
speakers and taxis uniformly favored sad Korean warbling that
was more Celine Dion than CL.

————————

Of the three big record labels, all launched by former musicians as the Korean economy was rebuilding itself post-crisis, SM is credited with building the K-pop Leviathan we know today.

Inspired by MTV, Lee Soo-man, also known as "Chairman Lee," founded SM in 1989 with a view to replicate American entertainment in Korea. A year later, he had his first hit: Hyun Jin-young, a hip-hop singer whose star fell as quickly as it rose when he was nabbed for drug use. Lee almost lost SM in the wake of the scandal but learned an important lesson: Finding and honing talent was not enough. Labels would have to be mercenary about controlling their stars.

SM set up a ruthless studio incubation system, accepting one trainee out of every thousand applicants, on whom they would spend an average of $300,000 over a five-year period training. Lee christened his precise and terrifying formula for success Cultural Technology. CT, as it's known, allowed SM to design and strictly monitor every aspect of their incubees' lives. It is the first thing SM executives study when they join the firm and is credited with building Korea's pop industry from scratch.

The manual is confidential and can't be taken out of SM offices. Its mythical status is owed to the fact that CT is constantly updated on how exactly to achieve K-success down to agonizing details such as "when to bring in foreign composers, producers, and choreographers; what chord progression to use in which country; the precise color of eye shadow a performer should wear in a particular country; the exact hand gestures he or she should make and the camera angles to be used in the videos," according to John Seabrook of *The New Yorker*.

"Nearly every aspect of K-pop is functional, intended to satisfy the market," notes John Lie, a professor of sociology,

adding that the "K" in K-pop "has more to do with *Das Kapital* than with Korean culture or tradition." For example, there is no lip synching because Korean audiences find it fake, and trends are scientifically tracked to see whether a potential boy band should debut as gangster tough "beast-dols" or feminine, lip-glossed "flower boys." In the early days, before "socials" changed the nature of fandom, record labels cultivated an almost sinister mystique around their debut stars—who were not allowed to own their own phones, speak in public, or use public toilets.*

Isak Kim sits in a Gango-sil café, surrounded by plastic surgery clinics and K-beauty shops. She wears a long, flowing summer dress and cartoonishly large eyeglasses, reminiscent of anime exaggeration. "I was one of the first halfies to come into SM," she tells me with a blush of pride. At the time Kim debuted in a K-pop duo there weren't many Korean-Americans in the business. She was auditioned by SM Entertainment's founder, Lee Soo-man himself, in 1999 when SM held their first international auditions in L.A.

Kim, like all K-pop aspirants, signed a suffocating ten-year contract and was moved from California into a Seoul condo where she lived with a label chaperone, studying and training from 10:00 a.m. to 10:00 p.m. She was put on a diet, given dance, singing, and language lessons, and invited to have a nose job, which she refused.

A manager told me, with the secrecy used to convey nuclear codes, that standard K-pop trainee contracts now include seven

* Side note from across the border: Kim Jong Il's official biography states that he has never made a bowel movement.

172 to twelve non-negotiable surgeries from double eyelid sur-
gery—which involves cutting the eyelid skin to create a crease—
to jaw shaving. Some boy-banders undergo leg breaking surgery
to add a few centimeters of height while others, bending to
the Korean aesthetic of skinniness as the height of attractive-
ness, inject poison into their necks in order to atrophy their
muscles. Sure, it's hard keeping your head upright with those
muscle-free, delicate swan-necks, the manager supposed, but a
bit of physiotherapy goes a long way.

In 2019, the Ministry for Gender Equality and Family
warned local broadcasters that K-beauty standards, by which all
stars "have similar appearance such as skinny body figure, light
skin color, similar hairstyle, body conscious clothes, and similar
makeup," may lead to unhealthy perceptions of beauty. The min-
istry had gone so far as to issue guidelines as to how to approach
what they called a "serious problem" but were forced to with-
draw them after an immediate outcry from fans screaming cen-
sorship and oppression. "In Korean they're not called 'artists,'"
Ashley Choi, a Korean-American music executive, told me in
Seoul. "They're called 'celebrities'; they're called 'entertainers'
because they don't create music. They call them 'idols' because
they want them to be gods; they want them to be untouchable."

Korea's two military dictators often banned Korean songs
for "thoughtlessly following foreign trends," but today it's pre-
cisely this thoughtlessness that can be credited with globalizing
the K-pop industry. The substance and style of K-pop is bla-
tant mimicry of the West, safeguarded by good old Asian values.
Though he's notably not thought of as K-pop, months after
"Gangnam Style" became a worldwide hit, the stock value of Psy's

father's company doubled. Such a successful son could only have
been raised by an equally impressive father, the logic went.

K-pop videos are nowhere near as sexually suggestive as Japanese J-pop or American music videos; thanks to an album rating system similar to movies, even the lyrics are squeaky clean. It's an ultra-sanitized version of rap, hip hop, and pop, scrubbed of any sex, drugs, or rock and roll. K-pop celebrities spend more time cultivating their "airport style," outfits carefully curated for waiting paparazzi, than engaging in scandalous behavior. Like Bollywood or *dizi*, K-pop songs are safe for family listening. There's no public dating or swearing—Amber Liu, a Chinese origin star formally of girl group f(x) and now a solo artist trying to crack America, told me she can't curse as "it's a public image thing." Aside from more recent scandals, involving K-pop stars investigated for procuring prostitutes and sharing clips of young women filmed without their consent over Whatsapp, for the most part, K-pop stars behave.

No music industry in the world invests so much in their singers before they debut; recoup is simply the price of business. Only when entertainers pay off their debt, returning what was spent on training, housing, and feeding them during their incubee days, do they start to earn a living as pop stars, though industry percentages are notoriously stingy. In other countries, record labels take 20 to 30 percent of album sales and the artist gets the rest. In Korea, the equation is flipped.

Not even dodgy accounting is enough to slow K-pop from breaking distribution barriers all over the world. But not all would attribute its astounding global success to the mythic severity of CT. "I'll put it in one word for you," Ingyu

174 Oh, a co-founder of the World Association of Hallyu, told me. "Glocalization."

Glocalization is the musical version of the emperor's new clothes. You import Western music, Oh explained, Koreanize it, localizing it to such a high standard that people in the West hear the music as fresh and unique, and quickly re-export it back to their countries. K-pop's triumph isn't globalizing music, he says, but localizing it. Oh defends "glocalization" against charges of being a sly bait and switch. "The process to Koreanize it is very delicate," he insists. "The beat is faster but also very soft, a feminine fastness. I don't think any other country can duplicate this stuff because it's very military, very strict in some sense, but also very affectionate."

At the SM office in Gangnam, sitting in the café surrounded by Girls Generation cupcakes, EXO nuts, TVXQ! Candles, and SHINee fabric spray, Marz, an indeterminately young white Californian songwriter dressed in chinos and a Jansport backpack, sits next to Rachel Lee, an equally young A&R manager at SM, chewing gum. He has the friendly, benign air of your neighborhood babysitter, and though he initially moved to Seoul to teach English and pay off his college debt, Marz is now the CEO of a production company called Marz Music. He and his writers have penned songs for just about everyone at SM, including NCT. NCT, an eighteen-member boy band whose name stands for Neo Cultural Technology, are SM's latest entertainers.

NCT, who *Billboard* described as "less of a band and more of an idea," have no set number of performers; new members are constantly being added. "NCT are the glocalization part of Cultural Technology," Lee explains in a nasal American twang—this

is the first time SM has experimented with limitless, glocal-
ized subunits. K-pop subunits are normally restricted to one,
perhaps two, units catering to Japanese and Chinese markets
by releasing albums in those languages and including members
from those countries. EXO, who performed at the Pyeongchang
Olympics' closing ceremony, are divided into EXO-K for Korean
and EXO-M for Mandarin, for example.

"We're creating NCT subunits for lots of places," Lee tells
me. "NCT Dream is made up of eighteen-year-olds, NCT 127 is
the Seoul subunit, and we'll have other city subunits, it could be
any city: LA, New York, Tokyo, Shanghai, Bangkok. . . . There's
no limit." She counts them down on her yellow and blue mani-
cured fingers. In the spring of 2019, amid what *Billboard* called
one of the "busiest North American touring seasons by Korean
artists ever," NCT 127—named after Seoul's longitudinal coor-
dinate and the purveyors of tracks like "Simon Says" and "Wel-
come to My Playground"—announced their first U.S. tour.

At the start of the K-pop bubble it was the Swedes who
dominated the songwriting business, but as K-hip-hop has
started to get trendier, the Euros have been displaced by the
Americans. Eighty percent of SM's music is written and pro-
duced by Westerners, Lee says, and more than half their slick
music video "choreo" is done by international talent. At the
same time, K-Pop seems to conquer more and more American
territory. Before 2019 had even hit the halfway mark, Blackpink
became the first K-Pop girl group to perform at Coachella, broke
YouTube's record for most-viewed music debut (56.4 mil-
lion views in twenty-four hours, unseating the previous record
holder, Ariana Grande), and set YouTube's record for the fastest
music video to reach 100 million views. In a sign of K-pop's

176 virality, it took BTS all of one week to decimate both of Black-
pink's records when they dropped their single "Boy with Luv."*

While music executives debate whether K-pop lifted the
idea from J-pop, taking large synchronized idol groups global,
which the Japanese were not interested in doing, or whether
the industry is pure Americana, there seemed to be almost uni-
form agreement on who represents the most dangerous threat to
K-pop. Marz shrugged sadly when I asked if K-pop would be able
to continue its upward climb. "No," he replied, "because China."

Did he think China was going to eat K-pop's lunch? Marz
smiled dolefully. "They already kind of are."

After South Korea installed an American anti-ballistic mis-
sile shield, the Terminal High Altitude Area Defense system
(THAAD), in 2016, China voiced its "strong dissatisfaction"
and retaliated by blocking K-pop from Chinese streaming plat-
forms, canceling concerts, and launching an unofficial boycott
of all Korean products.

The effect of China's displeasure was immediately felt.
China is not only Korea's largest trading partner but also
accounts for half of all visitors to the country. In the immediate
aftermath of China's cold shoulder, Hyundai's sales dropped 64
percent in 2017's second quarter. The loss of Chinese tourists
equaled a loss of nearly $16 billion for Korea. K-beauty products

* Not to read too much into the tyranny of positivity, but Blackpink's single
was "Kill This Love." BTS's was "Boy with Luv." RM—one of the main
singers and the only bilingual member of the group (he learned English
from watching *Friends*)—has spoken about how he wanted BTS to "lend a
shoulder for the youth." BTS's astronomical popularity has been largely
credited to the fact that, unlike many other K-pop bands, they sing and talk
about depression, anxiety, self-esteem, and the importance of having goals.

had previously been the kings of China's enormous beauty market, valued at $53 billion, but the Chinese government began backing its own cosmetics and skin-care brands, which quickly outsold the Koreans.

China's severe reaction might suggest that their global cultural aspirations were born of the THAAD crisis, though they had been set in motion at least a decade earlier. In 2007, Hu Jintao, then China's president, called for the country to "vigorously develop the cultural industry," and the Thirteenth Five-Year Plan for 2020 set its sights on turning cultural exports into a pillar of China's economy. By 2017, China's cultural exports amounted to nearly $90 billion, a 12.4 percent yearly increase, while their cultural imports decreased by 7.6 percent.

Though China remains a smaller music market than Korea due to piracy, it adapted to the digital future of the business with lightning speed. Today, 96 percent of China's musical revenue comes from digital sales and Chinese streaming platforms claim audiences numbering between 500 and 700 million. "The melody style the Chinese like is closer to what Western melody styles are," Marz told me. They, similar to the West, are a market for solo performers, not platoon-size bands. Though K-pop's popularity stems from its idol groups, the global trend veers toward solo artists. "They don't need all the sections like in K-pop. They have one guy so their music sounds closer to Western music. And they have the money."

Rachel Lee nodded gravely. "You can see China as the Wild West—there was nothing. *Nothing.* But there was so much opportunity and money coming in that everyone knew it was going to be booming soon." By 2017, Warner Music's Chief Executive for International and Global Services had predicted

that artists will want to break into China the way that they once sought to conquer America.

K-pop entertainers hoping to chart high on *Billboard* or receive Grammy nominations have to register with U.S. retailers. Digital streams on platforms like Spotify will get a star a top-fifty slot on *Billboard* but not first place. SM, for one, doesn't register with U.S. retailers, choosing to sell albums via Korean retailers because licensing their albums out means a significant drop in profits. If the label licenses an album to Target or Amazon, they would only make 10 percent of the profit rather than 100 percent, even though sales might stay the same or even increase. Between making money and becoming number one in America, SM choses the former.

"There's a reason every Hollywood movie is now financed by a Chinese company," Marz continues. "They have money and they want that recognition. Korea is not necessarily that interested in global recognition. Some are, like Big Hit [BTS's record label], but China wants the world to know they're good at music too. Same thing with the Beijing Olympics—they wanted to show the world, 'Look, we're a power.'"

SM and others understood this early on, Lee says, which is why they adopted Mandarin subunits for their entertainers in the hopes of staving off destruction in favor of coexistence. Though China initially rode alongside the Korean wave—after Japan, they were the second biggest market for K-pop acts and Alibaba was a significant investor in SM—today, China clearly has other plans. Chinese record labels are already bringing in American songwriters to write for their groups—including Marz who has worked with Chinese acts—and are launching a native "idol industry." *Produce 101*, the Chinese clone of a Korean

idol show, brought in more than 330 million viewers for its first episode.

Since 2009, many of K-pop's Chinese and Chinese-origin entertainers have quit Korea and moved back to China in order to launch solo careers on home turf. EXO, whose Mandarin subunit was hugely popular, took a big hit, losing three of its Chinese members. Ingyu Oh was the only person I met who dismissed the nativist fears of a Chinese takeover. "You can't write political, anti-social lyrics in China," he said with a frown. "And what's hip is always anti-social." But this doesn't seem to be stopping China.

Kris Wu, the Chinese rapper formerly with EXO-M, has notably performed at a Super Bowl Live concert in 2018 and collaborated on a single with Travis Scott since leaving his Korean-based band and returning to China to start his solo career. Wu's music video for "Deserve" has none of the bleached cuteness of a K-hip-hop video but attempts fidelity to the originals. Wu and Scott hang out in a nightclub with hot girls while stacks of money burn and Wu sings "Maybe it's the liquor but I swear I wanna French kiss," unimaginable visuals and lyrics for wholesome K-pop whose English lyrics are as rebellious as "How R U today?" and "Cheer up baby!"*

Besides pinching back their own K-pop talents, China is nurturing homegrown artists. TFBoys, "The Fighting Boys," is a wildly popular, cutesy-pie boy band whose songs announce themselves as "the future of Communism" and wax lyrical about winning Nobel Prizes. Acrush, a five-member androgynous girl group, was "tapping into the unique beauty of gender neutral," according to their entertainment company. The "A" in their

* By N.Flying and Twice, respectively.

180 name stood for Adonis. They were also tapping into perfect capitalist tie-ins by associating the band to a Fantasy Football Confederation, so their official name is FFC-Acrush. (Acrush has since changed its name to FanxyRed and left the FFC.)

"China learns everything and then are like, 'Okay! We don't need you!'" Marz exclaims, waving his hand in the air. "The same thing's gonna happen with music. They're still figuring it out, but they'll learn—learn, not like they don't know how to do it, but they'll learn the global way. It'll probably take five years and they'll be making a lot of money."

Afterword

On Sundays, Campo de Marte in the center of Lima is filled with music. Energetic dance groups, divided between K-pop break dancers, Latin salsa couples, and Bollywood enthusiasts, all come with their own boom boxes and loudspeakers to practice their moves in the park. It's a cacophony of beats, drums, and laughter and the district's mayor is forever threatening to shut the park down.

On my last weekend in Lima, I watched a group of teenagers in black leggings dancing to "Ishq Shava" ("Love Is a Cure") from Shah Rukh Khan's *Jab Tak Hai Jaan*. Across the green, Shah Rukh Khan FC held a Facebook Live session on the grass. One of their administrators speaks into a selfie stick like an anchor reading the news. Behind them they've set up a life-size SRK FC poster and laid their soft drinks and Lay's chips upon a smiling SRK picnic blanket. Ceci, a bilingual receptionist, tells me that she used to like Hollywood actors, but not since she's become a fan of Bollywood. "They are so cold," she says disappointingly of the gringos. "They don't express anything."

182 Two little girls, ten-year-old Jamyle and eight-year-old Vanessa, who are part of the Dilwale Dance group and gearing up for their own performance, tell me they need to speak with me privately.

"Have you been to Mumbai?" Jamyle asks me, bright pink lipstick smeared across her tiny lips.

"Yes," I say.

She flaps her hands in the air. "Oh my god, oh my god." Vanessa pretends to hyperventilate. "Do you have pictures?"

Jamyle takes a deep gulp of air. "When I dream," she confesses, "I imagine Mumbai."

Across the park, FC's nemesis, SRK Universe, are watching their own performers, careful not to be edged off their turf by limber, millennial K-pop dancers. Their dancing is racier, a lot more air humping and flash choreography, but unlike the Bollywood fans, the K-poppers don't get to dress up in costumes. One SRK U girl turns a shawl into a makeshift *sari*, another licks a sequin and sticks it to her forehead like a *bindi*. True to form, even from across the park, Angie, the translator, has been texting me nonstop. When we finally meet up, she pulls me excitedly to a patch of green: A twenty-nine-year-old woman has just been diagnosed with lymphoma, Angie relays right in front of said woman. Sending a video message to Shah Rukh Khan will surely extend her will to live, Angie diagnoses somberly, adding that she has already told the poor woman's mother that I will deliver the video.

For the five hours I am in the park, Lima feels like Bollywood. Not entirely, though, because for all its beauty and vibrancy, there is a sorrow in India that Bollywood masks. Homeless mothers begging at streetlights, little boys sleeping on

footpaths as ladies in high heels walk over them on their way to dinner, rioters armed with machetes and camera phones beating Dalits to death for the crime of drinking from an upper-caste person's well—they are all absent in Bollywood, neither seen nor felt. Today it is an industry devoted to nightclubs and love affairs, Delhiites transplanted to New York, and epics that feed an increasingly ravenous, jingoistic narrative. The India reflected in much of modern Bollywood has grown narrower and more grotesque, obscuring the true, terrifying landscape.

But here, in a downtown Lima park, all these fans do their best to reflect the surface spectacle of their favorite cinema. Children with dogs on leashes weave through the synchronized dancers, families picnic under the trees, sharing their pre-Christmas *panettone* with passersby, and to what I imagine must be the mayor's chagrin, the music only gets louder as evening falls. Of course, there is sorrow here, too, but this Sunday, Campo de Marti seems a world away from everything except the enduring promise of Bollywood: that the Gods bless the lonesome through music and dance.

I am eternally grateful to all the following people without whom this book would have been impossible.

For Bollywood and Pakistan: Shah Rukh Khan for being so generous with his time, Pooja Dadlani, Farhan Siddiqui, Bilal Siddique, Nandini Ramnath, Shobhaa De, Haitham Marzouk, Nasreen Munni Kabir, Mahesh Bhatt, Mohsin Sayeed, and Suhail Sethi.

Lima: Misael Wadros Avalos, Violeta Constantini, Gabriela Motta Yanez, Marlid Gamarra Zavala, Jhonzh Flores Matta, Wady Fulton Angulo Montoya, Angie Zusseth Yupangui Diaz, Shirley Diaz Ventura, Jhonzen Joel Tejada Vargas, Diana Avila Martinez, Rosa Marisabel Saenz Andagua, Maria Luz Huayhua Jara, Victoria Angelica Jiminez Rivas, Jay Patel and the staff at Mantra, Hector Abad, Alonso Cueto, Fernando Vivas Sabroso, Alberto Chicho Durant, Christopher de Vos Renato Cisneros, Amy Wong, Daniel Ugaz Sanchez Moreno, Erika Fabiola Varez Ruiz, Isabella Falco, Susanna and Fiorella, Arup Kumar Saha, Dr. Ayam Gupta, Felix Lossio, and Ricardo and Xennia Bedoya for the fascinating history of Peruvian neo-liberal adjustments and its consequences on cinema.

Beirut: Hilmi Ghandour, Mayssa and Hasan Karaky, Pira, Mira and Lola Kocache, Lara and Maysa Kocache, Mountaha Ismail, Aida Jamil, Diana al Jammal, Asma Abu Izzedine Rasamny, Maria Malas, Joyce Rizk, and Sheikh Abdo. Mohanad Mahmoud, Rania Mroueh, Roubina Arsalanian, Imane Mezher, Marie Nakhle, Sevim Tawil and Serena Kassis, Racil Chaloub, Elias el

186 Haddad, and Firas Abu Fakhr for his Um Kulthum primer and for taking the time to walk me through Arab pop culture.

Istanbul: Timur Savçi, Selin Arat, Izzet Pinto, Yagiz Alp Akaydin, Ayse Barim, Ayse Durukan, Halit Ergenc, Beste Dirican, Tuba Büyüküstün, Kivanç Tatlıtuğ, Gaye Sökmen, Emre Sökmen, Suzy Hansen, Eset, Can Remzi Ergen, BJ Cunningham, Pinar Celikel, Nur Hürge, Dr. Leslie P. Peirce, Arzu Ozturkmen, Selda Aciman, Mert Firat, Ece Yörenç, Hira Tekindor, Fatma Sapçi, Ece Temelkuran, Yamac Okur, and Tolga Kutluay.

Seoul: John Kim, John Seabrook, Mark James Russell, Dan Kim, Ashley Choi, Rachel Lee, Marz, Georgina Godwin, Han Ki-ryong, Kwon Jang-ho, Isak Kim, Ingyu Oh, and Mayssa.

Megha Mittal, Omar Abu Izzedine, Muhammad Ashraf, Myriam Samaniego, Jhonn Freddy Bellido Martinez, Veronica Ramirez, Iman Ghandour, Omar Ghraoui, Caroline Issa, Esra Eski, Gul Hurgul, Jeehae Kim, and Sophie Hackford: Your help was fundamental. Shukran, Gracias, Tashakurlar, Gamsahamnida.

My deepest thanks to Nicholas Lemann and Jimmy P. So for their support, enthusiasm, and many helpful conversations, David Davidar for his insight and notes, Pankaj Mishra, Carl Bromley, Camille McDuffie, Miranda Sita, Leigh Grossman, Jeff Farr, my wonderful agent Karolina Sutton, Lincoln Haagenson, Jackie Leonad, Ortensia, Cyril, Allegra, C, and as always my Baba, who taught me how to think and to see, and without whom nothing would be possible.

FURTHER READING

Bollywood's India: A Public Fantasy by Priya Joshi

The Secret Politics of Our Desires: Innocence, Culpability and Indian Popular Cinema edited by Ashis Nandy

Butter Chicken in Ludhiana by Pankaj Mishra

King of Bollywood: Shah Rukh Khan and the Seductive World of Indian Cinema by Anupama Chopra

Sueños de oriente: Consumo de cine de la India y telenovelas coreanas en el Perú by Felix Lossio

Honor Killings: Stories of Men who Killed by Ayşe Önal

Holy Lands: Reviving Pluralism in the Middle East by Nicolas Pelham

The Birth of Korean Cool: How One Nation is Conquering the World Through Pop Culture by Euny Hong

K-Pop: Pop Music, Cultural Amnesia, and Economic Innovation in South Korea by John Lie

NOTES

INTRODUCTION

15 **Gharbzadegi:** Valentine Moghadam, "Modernizing Women: Gender and Social Change in the Middle East" (Lynn Rienner Publishers, 2003), p. 158

17 **to cleanse "the film industry of all its non-Hindu elements":** Jaspreet Gill, "My Name Is Khan: Reinventing the Muslim Hero on the Global Stage." In *Shah Rukh Khan and Global Bollywood*, ed. Rajinder Budrah, Elke Mader, and Bernard Fuchs. (Oxford University Press, 2015), p. 127.

18 **Shah Rukh Khan, the world's most famous film actor:** "SRK's ancestral home traced to Pakistan." *The Times of India*, March 19, 2010.

20 **the most widely deployed army in world history:** Tim Kane, "Global U.S. Troop Deployment, 1950–2003." Heritage Foundation, October 27, 2004.

20 **deployed in fifty-four countries:** Tim Kane, "Global U.S. Troop Deployment, 1950–2003."

20 **just under 200,000 personnel:** Tim Kane, "Global U.S. Troop Deployment, 1950–2003."

20 **326,863 American troops in South Korea alone:** Tim Kane, "Global U.S. Troop Deployment, 1950–2003."

20 **a bigger market for American movies than Japan or China:** Mark

James Russell, *Pop Goes Korea* (Stone Bridge Press, 2017), L. 209.

21 **two brothers who set up the car company:** Bruce Cummings, "Korea's Place in the Sun" (Norton, 2005), p. 328.

21 **a mix of foxtrot and Japanese songs:** John Seabrook, "Factory Girls." *The New Yorker*, October 8, 2012.

22 **sociologist Jyotsna Kapur writes:** Jyotsna Kapur and Keith B. Wagner, "Introduction." In *Neoliberalism and Global Cinema*, ed. Jyotsna Kapur and Keith B. Wagner (Routledge, 2011), L. 186.

24 **watched by 10 million households across 190 countries:** "Netflix's first original Turkish series 'The Protector' boosts tourist interest in Istanbul." *Daily Sabah*, April 15, 2019.

24 **adapting *Runner* for their Hispanic audiences:** Nellie Andreeva, "Arms Dealing Drama 'Runner' Gets Fox Cast-Contingent Pilot Order." Deadline, Sept. 10, 2014.

25 **"Before, we couldn't even sell Turkish spaghetti to other countries":** Interview with Eçe Yorenç, March 9, 2018, London.

25 **was watched by a peak of 26.2 million people:** "Most Popular Daytime TV Soap" Guinness World Records, April 28, 2010.

25 **seen by upward of 200 million people:** "Turkey's TV drama exports exceed $250 million." *Hürriyet Daily News*, Jan. 13, 2016.

190 25 **moved from rural to urban areas within their own countries:** Alex Gray, "These Charts Show How Migration Is Changing Our Cities." World Economic Forum, October 25, 2017.

25 **double the speed of population growth:** Alex Gray, "These Charts Show How Migration Is Changing Our Cities."

25 **that number is expected to balloon to 60 percent:** "World Urbanization Prospects." United Nations, 2014.

25 **84 percent of the world already lives in urban areas:** Gregory Scruggs, "Everything We've Heard About Global Urbanization Turns Out to Be Wrong: Researchers." Reuters, July 12, 2018.

26 **between 1.5 and 3 million people move to cities every week:** Michael Collyer, "Three Million People Move to Cities Every Week: So How Cities Plan for Migrants?" City Metric, December 3, 2015.

26 **90 percent of whom will be in Asia and Africa:** "World Urbanization Prospects."

27 **"The United States is much weaker today":** *Democracy Now* broadcast, November 5, 2018.

CHAPTER ONE

29 **I think I'm able to fulfill each latent desire:** Interview with Shah Rukh Khan, April 18, 2017, Dubai.

30 **Every day, 14 to 15 million Indians go to the movies:** Rachel Dwyer, *All You Want Is Money, All You Need Is Love* (Cassell, 2000), p. 96, and Matt Rosenberg, "Bollywood." Thoughtco, March 3, 2017.

30 **India produces between 1,500 and 2,000 films a year:** "Indywood." Deloitte, September 2016, and Nial McCarthy, "Bollywood: India's Film Industry by the Numbers." *Forbes*, September 3, 2014.

30 **in 2012, India sold 2.6 billion tickets compared to Hollywood's 1.36 billion:** Nial McCarthy, "Bollywood: India's Film Industry by the Numbers."

30 **Bollywood boasts the highest growth rate in the movie industry:** Gyorgyi Vajdovich, "I Don't Need to do this but You've Got to Have Passion: Shah Rukh Khan's Manifold Economic Activities." In *Shah Rukh Khan and Global Bollywood*, p. 309.

30 **barreling ahead at 11.5 percent a year:** "Film industry in India to hit $3.7 billion by 2020, says report." *The Economic Times*, Oct. 9, 2017.

30 **Indian cinema, exported to over seventy countries, is expected to bring in close to $4 billion:** Gyorgyi Vajdovich, "I Don't Need to do this but You've Got to Have Passion," and "Indywood."

30 **sitting uncomfortably right in front of the screen:** Meher Tatna, "The Power of International Markets: In India It's Bollywood vs. Hollywood." Golden Globes, March 21, 2017.

31 **calling for the lead actress to be beheaded:** "Suraj Pal Amu, Who Called For Deepika Padukone's Beheading, Back In BJP." NDTV, Oct. 9, 2018.

31 **roll back state censorship of the film:** "'Padmaavat' to 'Raees': Top Bollywood films that got into trouble before release." Entertainment Times.

31 **which some consider to be the first feature film ever made:** "Hollywood vs Bollywood - Which Is More Successful?" The Infographic Show, YouTube, August 23, 2017.

31 **was released a full year before DeMille's:** Rachel Dwyer, *All You Want Is Money, All You Need Is Love*, p. 97.

31 **"we make singies":** Priya Joshi, *Bollywood's India: A Public Fantasy* (Columbia University Press, 2015), p. 21.

31 **films advertised as "dancicals" and "fighticals":** Ashis Nandy, "The Popular Hindi Film: Ideology and First Principles." *India International Centre Quarterly* 8:1 (1981), p. 92.

31 **films of the 1930s and '40s would have as many as forty songs:** Anupama Chopra, *King of Bollywood: Shah Rukh Khan and the Seductive World of Indian Cinema* (Warner Books, 2007), p. 7.

31 **the world record for most songs in a movie belongs to *Indrasabha*:** Anupama Chopra, *King of Bollywood*, p. 7.

32 **used the term in a detective novel:** Priya Joshi, *Bollywood's India*, p. 9.

37 **where *Disco Dancer* was the number one movie:** Rachel Lopez, "Take a Tour to See How Indian Cinema Has Found Foreign Fans." *Hindustan Times*, October 25, 2015,

37 **a hit from Brazil to the West Indies:** "Aap Jaisa Koi: Remembering Nazia Hasan." *Dawn*, August 13, 2014.

37 **multinationals swarmed India's previously closed borders:** Manfred B. Steger and Ravi K. Roy, *Neoliberalism* (Oxford University Press, 2010), p. 93.

38 **"a desperately sought after but infuriatingly unattainable modernity":** Pankaj Mishra, "Welcome to the age of anger." *The Guardian*, Dec. 8, 2016.

38 **an average of 2.5 films were released per day:** Ashis Nandy, "Introduction: Indian Popular Culture as a Slum's Eye View of Politics." In *The Secret Politics of Our Desires: Innocence, Culpability and Indian Popular Cinema* (Palgrave Macmillan, 1998), p. 1.

39 **India's migrants are often economically and politically powerful:** "International Migration Report 2017." United Nations, 2017.

39 **"living testimony of inappropriateness":** Ingrid Therwath, "'Shining Indians': Diaspora and Exemplarity in Bollywood." *Samaj* 4 (2010).

192 40 **Nanda was quickly acquitted, and released by the first court that tried him:** Ashok Kumar, "Sanjeev Nanda Held Guilty in BMW Hit and Run Case." *The Hindu*, September 3, 2008.

41 **"a lot of ingenious ways of smuggling narcotics and killing of people":** Ziauddin Sardar, "Dilip Kumar Made Me Do It." In *The Secret Politics of Our Desires: Innocence, Culpability and Indian Popular Cinema*, p. 63.

41 **mourned the loss of "poetry and refinement":** Ziauddin Sardar, "Dilip Kumar Made Me Do It," p. 58.

41 **Only 10 percent of India's population speaks English:** Vindu Goel, "Amazon's Plan to Reach 500 Million Indians: Speak Their Language." *New York Times*, September 6, 2018.

41 **"where we stand today is only a place of despair and sadness":** Ziauddin Sardar, "Dilip Kumar Made Me Do It," p. 58.

CHAPTER TWO

42 **fascist-inspired, paramilitary Hindu nationalist Rashtriya Swayamsevak Sangh:** Maria Casolari, "Hindutva's Foreign Tie up in the 1930s." *Economic and Political Weekly*, January 22, 2000.

43 **"a good lesson for us in Hindustan to learn and profit by":** Shrenik Rao, "Hitler's Hindus: The Rise and Rise of India's Nazi Loving Nationalists." *Haaretz*, December 14, 2017.

43 **The Sangh's objective:** Poornima Joshi, "The long and the shorts of it." *Business Line*, Oct. 12, 2018.

43 **two Lok Sabha parliamentary seats out of 543:** Kalyani Shankar, "The Story of the BJP's Growth." *The Statesman*, August 5, 2017.

43 **In the 1998 elections, the party bagged 198 seats:** "Statistical Report on General Elections, 1998 to the 12th Lok Sabha." The Election Commission of India, Volume 1. New Delhi, 1998.

43 **40 percent of India's "very high-class" voters:** Shankar Gopalakrishnan, "Defining, Constructing and Policing a 'New India.'" *Economic and Political Weekly* 41:26 (June 30–July 7, 2006), p. 2807.

43 **according to election data for 1999:** Shankar Gopalakrishnan, "Defining, Constructing and Policing a 'New India.'"

45 **fifth most successful non-English film of all time:** Rob Cain, "'Dangal' Tops $300 Million, Becoming The 5th Highest-Grossing Non-English Movie Ever." *Forbes*, June 12, 2017.

45 **is said to have "loved" *Dangal*:** https://thediplomat.com/2018/01/aamir-khan-indias-soft-power-in-china/.

47 **"to the growing 'anomie' in Indian society":** Pankaj Mishra, *Butter Chicken in Ludhiana* (Penguin, 1995), p. 239.

47 **"We don't have to like him, just the story he is telling":** Anupama Chopra, *King of Bollywood*, p. 128.

CHAPTER THREE

49 **in countries from Peru to Germany:** Interview with Farhan Siddiqui, CEO of SRK Universe, May 28, 2017, by email.

49 **including a title of Malaysian Knighthood:** Bernard Fuchs and Aradhana Seth, "The Don's World: Designing the Milleau of Shah Rukh Khan." In *Shah Rukh Khan and Global Bollywood*, p. 87.

50 **"Don't talk shit":** Anupama Chopra, *King of Bollywood*, pp. 71, 94.

50 **"strange mix of someone beautiful and slimy":** Anupama Chopra, *King of Bollywood*, pp. 51, 83.

50 **"wasn't chocolatey enough":** "Dr. Shah Rukh Khan—Life Lessons," University of Edinburgh, YouTube, Oct. 16, 2015.

51 **"The setting is not realistic, it's a lot of fantasy":** Interview with Nasreen Munni Kabir, May 30, 2017, London.

51 **"He is inclusive as well as expansive":** Interview with Nandini Ramnath, May 2, 2017, by email.

52 **"I'll take you only when your father gives me your hand in marriage":** Anupama Chopra, *King of Bollywood*, p. 133.

52 **stopped by American immigration at U.S. airports:** "Bollywood Star Shah Rukh Khan Detained at Airport Again." *The Guardian*, August 12, 2016.

52 **"I'm gonna say white":** "Shah Rukh Khan at Yale University as Chubb Fellow (official video)." Yale University, YouTube, April 15, 2012.

53 **was known in the Soviet Union as "comrade Awara":** Rajni Bakshi, "Raj Kapoor: From Jis Desh Mein Ganga Behti Hai to Ram Teri Ganga Maili." In *The Secret Politics of Our Desires: Innocence, Culpability and Indian Popular Cinema*, p. 93.

53 **Even Joseph Stalin was a fan:** Aseem Chhabra, "Raj Kapoor, the Relentless Romantic, Was India's First Crossover Filmmaker." *India Today*, September 15, 2017.

53 **"taught them how to love":** Priya Joshi, *Bollywood's India*, p. 105.

53 **Bollywood films were imported into Nigeria:** Anupama Chopra, *King of Bollywood*, p. 8.

53 **"without engaging with the heavy ideological load of 'becoming Western'":** Kaur and Sinha quoting Brian Larkin's 1997 ethnography, *Bollyworld: Popular Indian Cinema Through a Transnational Lens*, p. 21.

53 **"opening up a legacy of South Asian tourists":** "Swiss Government Honours Yash Chopra with Special Statue." *Times of India*, January 28, 2017.

53 **set cinemas on fire if his character dies in a film:** Andrew Buncombe, "Meet India's Biggest

194 Film Star." *The Independent*, October 2, 2010.

53 **run for twenty-three weeks in one Tokyo cinema alone:** Ashish Rajadhyaksha, "The Bollywoodization of the Indian Cinema: Cultural Nationalism in a Global Arena." *Inter-Asia Cultural Studies* 4:1 (2003).

53 *Amori con Turbanti,* or "love with turbans":** Monica Acciari, "Harlequining Shah Rukh Khan Through Media Patches." In *Shah Rukh Khan and Global Bollywood*, p. 273.

54 **has been screening it every single day since its release in 1995:** Anupama Chopra, *King of Bollywood*, p. 131.

54 **Cineplexes in London sold out shows of *Dil Se*:** Ann R. David, "King of Bollywood? The Construction of a Globalised Image in Shah Rukh Khan's Dance Choreography," p. 282.

54 **the first ever to reach the top 10 of a British film list:** Raminder Kaur and Ajay J. Sinha, "Bollyworld: An Introduction to Popular Indian Cinema Through a Transnational Lens." In *Bollyworld: Popular Indian Cinema Through a Transnational Lens*, p. 18.

54 **eighty separate cuts:** Ann R. David, "King of Bollywood? The Construction of a Globalised Image in Shah Rukh Khan's Dance Choreography," p. 283; *Shah Rukh Khan and Global Bollywood*; and Chopra, *King of Bollywood*, p. 191.

54 **first Bollywood film accepted to the Cannes Film Festival:** Gyorgyi Vajdovich, "I Don't Need to do this but You've Got to Have Passion," p. 315.

54 **281 print ads and another 200 commercials:** Anupama Chopra, *King of Bollywood*, p. 160.

54 **brands he had nothing to do with:** Anupama Chopra, *King of Bollywood*, p. 160.

54 **nearly 6 million euros toward the film's expensive budget:** Gyorgyi Vajdovich, "I Don't Need to do this but You've Got to Have Passion," p. 321.

55 **this globalization would happen, most definitely":** "Rajeev Masand Interview with Brad Pitt and Shah Rukh Khan," YouTube.

55 **"Actually, he believes in a new 'ism' every day":** Sudhanva Deshpande, "The Consumable Hero of Globalised India." In *Bollyworld: Popular Indian Cinema Through a Transnational Lens*, ed. Raminder Kaur and Ajay J. Sinha (Sage, 2005), p, 186.

55 **became the number-one foreign language film in the UK:** Anne Ciecko, "Superhit Hunk Heroes For Sale: Globalisation and Bollywood's Gender Politics," *Asian Journal of Communication* 11:2 (2001).

56 **in Durban it ran longer than *Titanic* and was seen by more people:** Thomas Blom Hansen, "In Search of the Diasporic Self: Bollywood in South Africa." In *Bollyworld: Popular Indian Cinema Through a Transnational Lens*, p. 240.

56 **"People identify with it and it conveys important themes of sacrifice, love, and non-violence":** Thomas Blom Hansen, "In Search of the Diasporic Self," p. 252.

57 **Arabic, Dutch, Spanish, and Hebrew:** Priya Joshi, *Bollywood's India*, p. 114.

57 **The Supreme Court ruling:** "Compulsory National Anthem verdict by SC: it started with Kabhi Khushi Kabhi Gham!" OpIndia, Nov. 30, 2016.

58 **including nontraditional Bollywood markets like Syria, Puerto Rico, and Taiwan:** Priya Joshi, *Bollywood's India*, p. 114.

59 **Khan featured in eleven:** Rachel Dwyer, "Innocent Abroad: SRK, Karan Johar and the Indian Diasporic Romance," p. 49. Raminder Kaur and Ajay J. Sinha, "Bollyworld: An Introduction to Popular Indian Cinema Through a Transnational Lens."

59 **Khan was second on *Forbes*'s list of the wealthiest actors in the world:** Nial McCarthy, "Bollywood: India's Film Industry by the Numbers."

59 **licensed his catalogue of films to Netflix:** "Shahrukh Khan signs Netflix deal; all his movies to be streamed on the service." *Financial Express*, Dec. 15, 2016.

59 **Bollywood, Pankaj Mishra told me, created the mood music for Narendra Modi:** Interview with Pankaj Mishra, October 2, 2018, by email.

59 **wiped 86 percent of Indian currency out:** Zeeshan Aleem, "India banned 86 percent of its cash in November. It's causing suffering for the poor." Vox, Jan. 25, 2017.

59 **caused a hundred deaths:** "CMIE's Mahesh Vyas says 3.5 million jobs lost due to demonetization." *Indian Express*, Sept. 15, 2018.

59 **called demonetization a disaster:** Sohini C, "The triumph of Modi propaganda in Bollywood." *South China Morning Post*, Feb. 5, 2019.

60 **"a pat on the head and a promotion":** Nandini Ramnath, "Film review: Was 'Commando 2' written by the demonetisation brigade?" Scroll.in, March 3, 2017.

61 **"COMPLETELY NON POLITICAL":** https:// twitter.com/akshaykumar/ status/1120701537821630464.

61 **"Does our Prime Minister eat mangoes?":** "'Mamata Didi Still Sends Kurtas She Picks Every Year': PM To Akshay Kumar." NDTV, April 24, 2019.

61 **meeting RSS leaders:** Subhash K Jha, "Exclusive: Is Akshay Kumar moving towards active politics?" *Deccan Chronicle*, June 12, 2017.

61 **cannot vote in the Indian elections:** Muskan Sharma, "Akshay, Alia, Jacqueline: Bollywood's 'Foreign' Voters." The Quint, April 29, 2019.

196 61 **absent on voting day:** "Akshay Kumar dodges question after he was criticised for not voting in Lok Sabha elections." *The Economic Times*, May 1, 2019.

61 **criticized and questioned:** "Akshay Kumar's Canadian clarification: Zor ka jhatka has everyone talking." *Entertainment Times*, May 5, 2019.

61 **"About the Canadian thing":** "Akshay Kumar's Canadian clarification: Zor ka jhatka has everyone talking." *Times of India*, May 5, 2019. "Is Akshay Kumar Really An 'Honorary Citizen' of Canada As He Claims?" *Outlook*, May 3, 2019.

61 **six honorary citizenships:** "Akshay Kumar's Canadian clarification: Zor ka jhatka has everyone talking." *Times of India*. "Akshay Kumar not listed as the Honorary Citizen of Canada; Did he apply for a Canadian citizenship?" Pinkvilla, May 3, 2019.

62 **"What an explosive morning!":** Shruti Shiksha, "'Bravo,' Tweet Rajinikanth, Kamal Haasan, Salman Khan, Akshay Kumar, Priyanka Chopra And Other Stars After IAF Air Strikes On Terror Camp Across LoC." NDTV, Feb. 27, 2019.

62 **Priyanka Chopra:** William Cole, "Priyanka Chopra is accused of 'glorifying war' with tweet supporting Indian army following country's stand-off with Pakistan, as people call for her to be stripped of UN Goodwill role." *Daily Mail*, March 1, 2019.

62 **"Pakistan destruction is":** Fatima Bhutto, "Hashtags for War Between India and Pakistan." *New York Times*, Feb. 27, 2019.

62 **the BJP tweeted its trailer:** Tanul Thakur, "When Bollywood Campaigned for Prime Minister Narendra Modi." The Wire, March 29, 2019.

63 **"a hagiography for dummies":** Tanul Thakur, "When Bollywood Campaigned for Prime Minister Narendra Modi."

63 **dressed as Modi:** "Vivek launches trailer as PM Modi." *Hindustan Times*, March 20, 2019.

63 **"I am a balanced person":** "'Respect Bhakts, Critics': Vivek Oberoi At PM Narendra Modi Trailer Launch." NDTV, March 21, 2019

65 **"I find this a very strange question, because no one can have a difference of opinion on terrorism":** "ShahRukh Khan's Speech at 'A Nation in Solidarity against Terror.'" YouTube, December 1, 2009.

65 **Khan was publicly rebuked by a general secretary of the BJP:** "Shah Rukh Khan in India, His Aatma in Pakistan: BJP Leader Kailash Vijayvarigiya." *Indian Express*, November 4, 2015.

65 **"a good initiative":** "Aamir Khan comes out in support of PM Modi's demonetisation policy." *Entertainment Times*, Jan. 29, 2017.

65 **cost India 3.5 million jobs:** "CMIE's Mahesh Vyas

says 3.5 million jobs lost due to demonetization." *The Indian Express*, Sept. 15, 2018.

65 **forty-five-year unemployment high:** "Unemployment in India at 45-Year High After Demonetisation, Report Stalled by Centre Shows." News 18, Feb. 1, 2019.

65 **"I make use of card, be it debit or credit card, when we buy something":** "Aamir Khan Comes Out in Support of PM Modi's Demonetisation Policy." *Times of India*, January 29, 2017.

66 **"the neighboring country":** "Karan Johar Says Goodbye To Pakistani Actors | Full Video Footage." *The Times of India*, YouTube, Oct. 18, 2016.

66 **amending the tagline from *K3G*:** "Narendra Modi bombards Bollywood with democracy-loving tweets." BBC News, March 13, 2019.

67 **"he is a responsible citizen":** Raka Mukherjee, "Jaa Simran Jaa: PIB Uses 'DDLJ' Meme to Encourage Citizens to Vote in Lok Sabha Elections." News 18, April 3, 2019.

67 **Johar squeezed . . . Bachchan responded:** "Aamir Khan, Akshay Kumar, Karan Johar And Others Respond To PM Modi's Request To Help Bring Out The Vote." NDTV, March 13, 2019.

67 **wasn't joining the BJP:** "Not contesting Lok Sabha elections, says Salman Khan." *The Economic Times*, March 22, 2019.

67 **"We—as proud Indians":** "Shah Rukh Khan congratulates PM Narendra Modi: Proud Indians have chosen with great clarity." *India Today*, May 24, 2019.

68 **"Pakistan will never go to war with India is because Shah Rukh lives there":** Anupama Chopra, *King of Bollywood*, p. 7.

68 **"only person in Bollywood who has made two flop films with Shah Rukh Khan":** Interview with Mahesh Bhatt, May 21, 2017, by phone.

68 **"What is so marvelous about the truth?":** Interview with Mahesh Bhatt, May 23, 2017, by phone.

CHAPTER FOUR

73 **"I'm watching all your films," I tell him:** Interview with Shah Rukh Khan, April 18 and 19, 2017, Dubai.

86 **"Shah Rukh Khan is an international star":** Interview with Haitham Marzouk, May 19, 2017, by phone.

CHAPTER FIVE

92 **"But Shah Rukh Khan is not my favorite," he confesses. "Rajinikanth is.":** Interview with Jhonn Freddy Bellido Martinez, November 27, 2017. Lima, Peru.

94 **Patelji shakes his head, his Indian accent thick and untouched by Spanish:** Interview with Jay Patel, November 27, 2017. Lima, Peru.

94 **didn't even have diplomatic relations:** Petra Hirzer, "Fandom

198 Beyond Borders and Boundaries: Peru in Love with SRK." In *Shah Rukh Khan and Global Bollywood*, p. 184.

94 **no more than four hundred Indians live in the entire country:** Interview with Arup Saha, November 28, 2017. Lima, Peru.

95 **"to feel empathy with the suffering of Christ":** Interview with Ricardo and Xenia Bedoya, December 2, 2017. Lima, Peru.

96 **"We are a post-colonial society, so we have racism incorporated":** Interview with Felix Lossio, December 1, 2017. Lima, Peru.

97 **Peru has ranked third in the world in the number of complaints regarding gender violence:** "In Peru, Gender Violence and Femicides Up in 2017: Report." Telesur TV, June 11, 2017.

100 **pirated Bollywood films subtitled in Spanish:** Interview with Misael Wadros Avalos, November 28, 2017. Lima, Peru.

100 **"Shah Rukh Khan prolonged my existence for five years":** Interview with Violeta Constantini, November 28, 2017. Lima, Peru.

100 **She nods her head in tragic confirmation:** Interview with Gabriella Motta Yanez, November 28, 2017. Lima, Peru.

101 **her husband went off and named him without her:** Interview with Katherine and Jhonz Flores Matta, November 28, 2017. Lima, Peru.

102 **"I don't see Shah Rukh as a man I want to be with":** Interview with Marlid Gamarra Zavala, November 28, 2017. Lima, Peru

103 **"We love Aishwarya":** Interview with Angie Zusseth Yupangui Diaz, November 28, 2017. Lima, Peru

104 **"I am hard":** Interview with Wady Fulton Angulo Montoya, November 28, 2017. Lima, Peru.

CHAPTER SIX

113 **[The military] overthrew multiple elected governments:** Stephen Kinzer, *Crescent and Star: Turkey Between Two Worlds* (Farrar, Strauss & Giroux, 2005), p. 176.

113 **only one television channel, TRT:** Kinzer, *Crescent and Star*, p. 168.

113 **"After the tanks come the banks," a foreign correspondent noted:** Ece Temelkuran, *Turkey: The Insane and the Melancholy* (London: Zed Books Ltd., 2016). pp. 53–58.

114 **Turkey is the second largest NATO army, after the United States:** Stephen Kinzer, *Crescent and Star*, p. 172.

114 **By the time Pakistan bought a series:** Dr. Farooq Sulehria, "Why Turkish Soap Operas are a Hit in Pakistan." *TRT World*, September 24, 2018.

115 **more than 55 million sufficiently unoffended people**

watched the show's finale: Sarmad Iqbal, "Turkish Soap Operas and their Rise in Pakistan will Leave a Legacy." *Parhlo*, March 5, 2017.

CHAPTER SEVEN

118 "don't call them soap operas": Interview with Dr. Arzu Ozturkmen, March 12, 2018, Istanbul, Turkey.

118 watch an average of a full hour more: William Armstrong, "What a TV Series Tells us About Erdoğan's Turkey."

118 today Turkey is second only to America in worldwide TV distribution: "Global Success of Turkish TV Dramas Set to Continue Into 2018." T-Vine, November 24, 2017.

119 which Russia bought in the 1980s and retitled *Lovebird*: Interview with Timur Savçi, March 13, 2018, Istanbul, Turkey.

119 though they didn't find many takers then: Interview with Fatma Sapçi, March 12, 2018, Istanbul, Turkey.

119 In 2007, foreign sales of *dizi* only brought Turkey a grand total of $1 million: Nathan Williams, "The Rise of Turkish Soap Power." BBC, June 28, 2013.

119 Ten years later, the value of *dizi* exports exceeded $350 million: "Turkish TV Series Exceed $350 Million in Exports." *Daily Sabah*, January 3, 2018.

119 traditionally closed markets like China, Korea, and even NBC

Universal: Alev Scott, *Turkish Awakening: Behind the Scenes of Modern Turkey* (Faber and Faber, 2014), p. 141.

119 today Chile is the largest consumer of *dizi* in terms of number of shows sold: Interview with Izzet Pinto, March 20, 2018, Istanbul Turkey.

119 Advertising seconds are cheap in Turkey: Interview with Eçe Yorenç, March 9, 2018.

119 can have up to fifty major characters: "The Sultan's Reign Ends with a Bang." *Majalla*, June 16, 2014.

120 "They also use real locations": Interview with Tolga Kutluay, March 16, 2018, Istanbul Turkey.

120 "We tell at least two versions of the Cinderella story per year": Interview with Eset, March 19, 2018, Istanbul, Turkey.

121 told me it all began with 2006's *Binbir Gece (1001 Nights)*: Interview with Izzet Pinto.

121 "the halal Brad Pitt": Nathan Williams, "The Rise of Turkish Soap Power."

122 people were rushing off to watch *dizi* during Ramadan: Alev Scott, *Turkish Awakening*, p. 124.

122 watched by 85 million people in the Middle East: Ibid.

122 close to eighty countries: Interview with Izzet Pinto.

200

122 **claimed one-third of the country's TV audience:** Andrew Finkel, "Erdoğan, the Not So Magnificent." *New York Times*, November 30, 2012.

122 **The foreign press called it an "Ottoman-era *Sex and the City*":** William Armstrong, "What a TV Series Tells us About Erdoğan's Turkey." *New York Times*, May 14, 2017.

122–123 **Every episode had up to three historical consultants:** "The Sultan's Reign Ends with a Bang." *Majalla*, June 16, 2014.

123 **once a concubine had a son, her loyalty to the sultan was divided:** Leslie P. Peirce, "Empress of the East" (Basic Books, 2017). pp. 100, 6.

123 **Turkey's Minister of Culture and Tourism even stopped charging certain Arab countries broadcasting fees:** Alev Scott, *Turkish Awakening*, p. 121.

123 **the show has been seen by over 500 million people worldwide:** Interview with Izzet Pinto.

123 **it became the first *dizi* ever bought by Japan:** Interview with Selin Arat, March 13, 2018. Istanbul, Turkey.

123–124 **Since 2002, more than 150 Turkish *dizi* have been sold to over 100 countries:** William Armstrong, "What a TV Series Tells us About Erdoğan's Turkey."

124 **They don't touch "the feelings that make us human," he told me:** Interview with Halit Ergenç, March 14, 2018, Istanbul, Turkey.

125 **the show rallied women from Argentina to Spain:** Alex Marshall, "Can Netflix Take Turkey's TV Dramas to the World?" *New York Times*, December 27, 2018.

125 **edging out its closest competitor by over a hundred thousand:** "Fatmagül Sets New Ratings Record in Spain." TTV News, January 31, 2018.

125 **scoring higher than *Modern Family* or *The Big Bang Theory*:** Juan Fernandez Gonzalez, "Turkish soap opera sees success in Spain." Rapid TV News, January 26, 2018.

125 **the best ratings it had seen since 2015:** Andy Fry, "Spain's Atresmedia secures Turkish drama Ezel from Eccho." Television Business International, April 16, 2018.

125 **seven more *dizi* have followed on the back of its success:** Pina Mezzera, "Spanish *Fatmagül* Remake for Antena 3 in the Works." TTV News, February 11, 2019.

125 ***Fatmagül* is soon to get the full Telenovela treatment in Spain:** Ibid.

126 **killed by their husbands or boyfriends:** "47 Women Killed in Turkey in February: Women's Rights Group." *Hurriyet*, March 5, 2018.

126 **One out of every two women killed in Turkey since 2010:** "Nearly 2,000 Women Killed in Eight Years

in Turkey." *Hurriyet*, November 26, 2017.

126–127 **report calculated that 40 percent of Turkish women suffer domestic abuse:** Ayla Jean Yackley, "Turkish Women Take to Streets to Demand Equality." *Al Monitor*, March 8, 2018.

CHAPTER EIGHT

131 **he wished "all religions [were] at the bottom of the sea":** Stephen Kinzer, *Crescent and Star*, p. 47.

131 **emblematic of "hatred of progress and civilization":** Stephen Kinzer, *Crescent and Star*, p. 42.

131 **"spectacle that makes the nation an object of ridicule":** Stephen Kinzer, *Crescent and Star*, p. 42.

132 **Women in hijabs are almost never shown in television ads:** Interview with Ece Temelkuran, May 4, 2019, Sydney, Australia.

132 **"It would be life-threatening if we knew who they were":** Interview with Selin Arat.

134 **they held more land in Europe than they did in Asia:** Andrew Wheatcroft, "The Enemy at the Gate" (Pimlico, 2009), p. 5.

134 **Lord Byron famously died fighting the Ottomans in Greece:** Stephen Kinzer, *Crescent and Star*, p. 5.

134–135 **The Ottomans had no word for "minority" in Turkish:**

Nicholas Pelham, *Holy Lands: Reviving Pluralism in the Middle East* (Columbia Global Reports, 2016), p. 7.

135 **was Europe transformed from a "regional backwater":** Peter Frankopan, *The Silk Roads* (Bloomsbury, 2015), p. xvii.

136 **Erdoğan sold *simit*:** Ayse Alibeyoglu, "From Street Seller to Global Businessman." *Al-Jazeera*, June 13, 2011.

136 **was a semi-professional football player:** "Recep Tayyip Erdoğan Fast Facts," CNN World, March 4, 2019.

136 **"destroying the Turkish language":** "Turkish Should be Taught in Schools Erdoğan Says." *Hurriyet*, March 15, 2018.

136 **revived the teaching of Ottoman Turkish in schools:** Ece Temelkuran, *Turkey: The Insane and the Melancholy*, p. 20.

137 **Turkey's humanitarian aid to Sudan exceeds that given by the United Nations:** Suhaib Qalalwa, "Turkish Aid to Sudan Exceeds That of UN: Sudan Official." Andalu Agency, November 6, 2017.

137 **"again tie Sarajevo to Damascus, Benghazi to Erzurum and to Batumi":** Elif Batuman, "Ottomania." *The New Yorker*, February 17–24, 2014.

137 **"I am Sultan Suleiman,"** the letter begins: Elif Batuman, "Ottomania."

202 138 **Cultural pundits scrambled to position Turkish culture:** Alev Scott, *Turkish Awakening*, p. 122.

138 **claimed to have received over 70,000 complaints:** Susanne Fowler, "The Dirt, and the Soap, on the Ottoman Empire." *New York Times*, March 17, 2011.

138 **a parliamentary petition to legally ban the *dizi*:** "AKP Deputy says Muhtesem Yüzyil Will Be Off Air in 2013." *Hurriyet*, December 8, 2012.

139 **the most popular show to air on state TV:** Yeni ؛ Safak, "Erdoğan Praises Ertuğrul TV Series for Reacquainting World with Ottoman History." Yenisafak.com news service, April 24, 2019.

139 **who wore a Turkic hat for the occasion:** "Maduro Visits Set of Turkish TV Series." *Hurriyet*, July 11, 2018.

139 **"Until the lions start writing their own stories":** William Armstrong, "What a TV Series Tells us About Erdoğan's Turkey."

139 **tuned in as the sultan staved off rebellions:** Aykan Erdemir and Oren Kessler, "A Turkish TV Blockbuster Reveals Erdogan's Conspiratorial, Anti-Semitic Worldview." *Washington Post*, May 15, 2017.

139–140 **"The main reference point of this political movement is obedience":** Interview with Ece Temelkuran.

140 **"or it could be the fact that this is about an Islamic state at** the end of the day":** Interview with Timur Savçi.

141 **a question of values or conservatism:** Interview with Kivanç Tatlıtuğ, by email, April 18, 2018.

CHAPTER NINE

144 **nearly half of them settling in the northern hamlet of Akkar:** Interview with Joyce Rizk, August 22, 2017, Akkar, Lebanon.

144 **has the largest per capita refugee population in the world:** Eric Reidy, "Will Lebanon Force a Million Syrian Refugees to Return to a War Zone?" *The Nation*, January 24, 2018.

146 **"But isn't it more important to clear the sewage?":** Interview with Asma Abu Izzedine Rasamny, October 21, 2018, by phone.

146 **"We were trying to teach them not to speak in a violent way, not to fight":** Interview with Sheikh Abdo, August 22, 2017, Akkar.

147 **using the Arabic names for two Turkish *dizi* actors:** Interview with Fatima and Muna, August 22, 2017, Akkar.

152 **"I'm the one who opened Turkish culture through TV to the whole world":** Interview with Fadi Ismail, August 23, 2017, by phone.

155 **"Americans have been conquering us with Mickey Mouse":** Interview with Elias el Haddad, August 21, 2017, Beirut.

155 **it was fertile ground for the development of Arab nationalism:** Philip Mansel, *Levant: Splendour and Catastrophe on the Mediterranean* (John Murray, 2011), p. 149.

155 **"the despotism of the husband to the despotism of the Sultan"**: Philip Mansel, *Levant: Splendour and Catastrophe on the Mediterranean*, p. 301.

156 **Six *dizi* were pulled, costing MBC $25 million in losses:** Ben Hubbard, David D. Kirkpatrick, Kate Kelly, and Mark Mazzeti, "Saudis Said to Use Coercion and Abuse to Seize Billions." *New York Times*, March 12, 2018.

156 **"I can't confirm who took the decision":** "MBC Stops all Turkish TV Drama." Al Jazeera, March 6, 2018.

156 **were among those locked up in the Riyadh Ritz-Carlton by the kingdom's crown prince:** Ben Hubbard, "Saudi Arabia Frees Media Mogul, but His Company's Fate Remains a Mystery." *New York Times*, January 26, 2018.

156 **[he] found Waleed's $3 billion asking price too high:** Ibid.

156–157 **"the sellers had been detained by the buyer":** Ben Hubbard, David D. Kirkpatrick, Kate Kelly, and Mark Mazzeti, "Saudis Said to Use Coercion and Abuse to Seize Billions."

157 **MBS was infuriated by Turkey's brazen flouting of his 2017 blockade of Qatar:** "Erdoğan to Saudi Crown Prince: You Don't

Own Islam." Press TV, November 11, 2017.

157 **"Islam can only be one thing":** "Erdoğan to Saudi Crown Prince: You Don't Own Islam."

157 **included Turkey in what he bizarrely called a "triangle of evil":** "Erdoğan Trying to Build New 'Ottoman Caliphate'—Saudi Crown Prince." *Ahval News*, March 7, 2018.

158 **but expects a digital future for the Middle East:** Interview with Fatma Sapçi.

159 **a family business, has kept the Mahmouds in dubbing and subtitling:** Interview with Mohannad Mahmoud, August 23, 2017, Beirut, Lebanon.

160 **"There's a part of it that's *moda*":** Interview with Rania Mroueh, August 23, 2017, Beirut, Lebanon.

EPILOGUE

162–163 **to pique their interest in "Korean cool":** "Bang Bang Bang! The K-Pop Songs Being Blasted into North Korea." *The Guardian*, January 8, 2016.

163 **threatened to blow up all the speakers:** Simeon Paterson, "Korean Loudspeakers: What are the North and South Shouting About?" BBC, January 12, 2016.

163 **Kim Jong Un became the first North Korean leader to attend a K-pop concert:** Jim Michaels, "Kim Jong Un Likes K-pop Music,

204 Banned in North Korea. That Could Be a Diplomatic Breakthrough." *USA Today*, April 3, 2018.

163 **the first non-Western country to "meaningfully export almost all its cultural forms":** Dal Yong-Jin, *New Korean Wave* (University of Illinois Press, 2016), L. 50.

163 **the value of Korea's cultural exports surpassed their cultural imports:** Dal Yong-Jin, *New Korean Wave*, L. 127.

163 **K-dramas were dubbed into indigenous languages like Guarani:** "Imagining the Korean Wave's Future in Iran." *Korea Daily Us*, May 5, 2016.

163 **are responsible for bringing Korea 1,200 percent more revenue:** Euny Hong, *The Birth of Korean Cool* (Picador, 2014), p. 214.

163 **global K-pop sales pull in $5 billion a year:** Jim Michaels, "Kim Jong Un Likes K-pop Music, Banned in North Korea. That Could Be a Diplomatic Breakthrough."

164 **were watched 24 billion times on YouTube:** Sohee Kim, "The $4.7 Billion K-pop Industry Chases Its 'Michael Jackson Moment.'" Bloomberg, August 22, 2017.

165 **became the first K-pop group to top the *Billboard* 100 charts:** Xander Zellner, "BTS Becomes First K-Pop Act to Hit No. 1 on Billboard Artist 100 Chart." *Billboard*, May 30, 2018.

165 ***Love Yourself: Tear* became the first album sung in**

a non-English language to top American charts in twelve years: Benjamin Haas, "Korea's Other Summit: K-pop Album Tops U.S. Charts for First Time." *The Guardian*, May 28, 2018.

165 **number one on iTunes in over sixty-five countries:** Adele Roberts, "K-pop: Korea's Secret Weapon." BBC 1 Radio, January 18, 2018.

165 **beat out Justin Bieber to win the *Billboard* Social Artists:** AJ Willingham, "BTS! We Haven't Seen Boy-Band Fandom Like This Since the Beatles." CNN Entertainment, April 14, 2019.

165 **"the goal is to produce the biggest stars in the world":** John Seabrook, "Factory Girls."

165 **South Korea had a lower per capita GDP than Ghana and North Korea:** Euny Hong, *The Birth of Korean Cool*, p. 2.

165 **it wasn't until the 1970s that they slowly crept past their Northern neighbors:** Bruce Cummings, "Korea's Place in the Sun," p. 316.

166 **was invaded more than four hundred times:** Euny Hong, *The Birth of Korean Cool*, p. 51.

166 **the Koreans burned it to a crisp and killed all its crew:** Bruce Cummings, "Korea's Place in the Sun," pp. 88, 97.

166 **changed only after liberation from Japan in 1948:** John Lie, *K-pop: Pop Music, Cultural Amnesia and*

Economic Innovation in South Korea (University of California Press, 2015), pp. 19–20.

167 **popular music of the last century has been "national music":** John Lie, *K-pop*, p. 111.

167 **With no valuable resources or agricultural land:** Euny Hong, *The Birth of Korean Cool*, p. 96.

168 **Korea's IMF bailout was the largest ever given at that point:** Michael Breen, *The New Koreans* (Rider Books, 2017), p. 374.

168 **"creating flexibilities in the labor market":** Bruce Cummings, "Korea's Place in the Sun," p. 334.

169 **internet connections two hundred times faster than the average connection in North America:** Euny Hong, *The Birth of Korean Cool*, p. 6.

170 **to design and strictly monitor every aspect of their incubees' lives:** John Lie, *K-pop*, pp. 124–125.

170 **"the exact hand gestures he or she should make and the camera angles to be used in the videos":** John Seabrook, "Factory Girls."

171 **"has more to do with *Das Kapital* than with Korean culture or tradition":** John Lie, *K-pop*, pp. 129, 141.

171 **"I was one of the first halfies to come into SM":** Interview with Isak Kim, June 8, 2018, Seoul, South Korea.

172 **may lead to unhealthy perceptions of beauty:** Rob Picheta and Yoonjung Seo, "South Korea Government Backtracks After Saying K-Pop Stars Look 'Too Similar.'" CNN World, February 20, 2019.

172 **"In Korean they're not called 'artists'":** Interview with Ashley Choi, June 6, 2018, Seoul, South Korea.

172 **Korea's two military dictators often banned Korean songs for "thoughtlessly following foreign trends":** Mark James Russell, *Pop Goes Korea*, L. 3340.

172–173 **the stock value of Psy's father's company doubled:** Euny Hong, *The Birth of Korean Cool*, p. 27.

173 **"it's a public image thing":** Interview with Amber Liu, June 6, 2018, Seoul, Korea.

174 **"Glocalization":** Interview with Ingyu Oh, June 10, 2018, Seoul, Korea.

174 **"less of a band and more of an idea":** Tamar Herman, "Examining NCT and Its Various K-pop Units." *Billboard*, September 2, 2017.

174 **"NCT are the glocalization part of Cultural Technology":** Interview with Rachel Lee, June 7, 2018, Seoul, Korea.

175 **"busiest North American touring seasons by Korean artists ever":** Tamar Herman, "NCT 127 Set to Tour North America for the First Time: Exclusive." *Billboard*, February 19, 2019.

206

176 it took BTS all of one week to decimate both of Blackpink's records: Todd Spangler, "Korea's BTS Shatters YouTube Record for Views in 24 Hours With 'Boy With Luv' Featuring Halsey." *Variety*, April 13, 2019.

176 China voiced its "strong dissatisfaction": Lindsay Maizland, "The Surprising Reason Why China is Blocking South Korean Music Videos and TV." Vox, March 3, 2017.

176 Hyundai's sales dropped 64 percent in 2017's second quarter: David Josef Volodero, "China Wins its War Against South Korea's US THAAD Missile Shield Without Firing a Shot." *South China Morning Post*, November 18, 2017.

177 had previously been the kings of China's enormous beauty market: Song Jung-a, "South Korean Beauty Brands Lose a Little Glamour." *Financial Times*, January 1, 2018.

177 the Thirteenth Five-Year Plan: George Gao, "Why is China So . . . Uncool?" *Foreign Policy*, August, 3, 2017.

177 China's cultural exports amounted to nearly $90 billion: Sun Wenyu, "China's Cultural Exports Hit $90 Billion in 2017." *People's Daily*, February 9, 2018.

177 Chinese streaming platforms claim audiences numbering between 500 and 700 million: Erica Martin, "China's Music Industry to Break Through Internationally." CKGSB Knowledge, February 13, 2018.

178 artists will want to break into China the way that they once sought to conquer America: Xinning Liu and Louise Lucas, "Western Artists Eye Changing Beat of China's Music Market." *Financial Times*, November 17, 2017.

178–179 *Produce 101*, the Chinese clone of a Korean idol show: He Keyao, "Popular Chinese Idol Survival Show Finds Success Through Fan Participation." *Global Times*, April 18, 2018.

179 androgynous girl group: Marian Liu and Serenitie Wang, "China's All Girl Boyband." CNN, May 12, 2017.